A HISTORY AND GUIDE TO
SCOTTISH CASTLES

Dedication

For my little explorers, Sabrina and Thomas

Contents

Preface

What's not to love about castles? They're grand, mysterious, and even a little magical. Living in Scotland, I'm spoilt for choice. The country is thought to be home to around 4,000 of them, dating from different eras and in various states of ruin – that's one for around every square mile. Scotland is also home to some of the most iconic castles in the world, including the majestic Dunnottar Castle in Aberdeenshire, perched atop a 160ft rock overlooking the North Sea, the fairy-tale style structure of Balmoral Castle in the Highlands, a favourite of Queen Victoria and, possibly the most famous of all, Edinburgh Castle – a magnificent structure that dominates the capital city's skyline.

Before I started writing this book, if you'd asked me what my favourite Scottish castle was, I would have said Edinburgh, without missing a beat. Having lived here my whole life, I'm very familiar with the celebrated structure and, although I have been visiting from a young age, I'm always discovering something new.

But I've learned that Scotland has so much more to offer, and now when asked that question, I honestly can't give an answer. My journey took me right down to Dumfries and Galloway and the Scottish Borders and then to the great heights of the Highlands and Islands to discover the history of some of Scotland's most impressive castles which leave tourists and locals alike awestruck.

They have inspired some of the world's best-loved stories, including Harry Potter, Dracula and Peter Pan. Even Disney World owes a debt of thanks to a Caledonian castle.

Someone asked me what the difference is between a castle and a palace. The answer is that castles are only known as castles if they have, at some point, been used for defensive purposes. Many today look like, and are, stately homes, but these have usually been built over older fortresses and retained their names. Lauriston Castle in Edinburgh, Caerlaverock Castle in Dumfries and Galloway and Inveraray Castle in Argyll, for example, are all newer buildings built over the remains of ancient defensive structures.

Some of my explorations were more hair-raising than others, with plenty of tales of ghostly goings-on, unexplained sightings and things that go bump in the night. It's hardly surprising given the bloody histories of many of the fortresses, but I'm delighted to say I didn't encounter any first-hand.

It's also no surprise just how many of these attractions have been used for filming television shows and big-budget Hollywood movies. Fans of *Outlander*, in particular, will find a trip to Scotland full of familiar places.

My research and explorations took place with my young children – one of whom was in the womb for most of it – so I hope that, as well as providing an insight for adventurers and history buffs, this guide will help families plan fun days out and create memories that last a lifetime.

Aberdeenshire

Huffing and puffing down and then up a total of 219 steps, we finally reached the entrance to the stunning Dunnottar Castle near Stonehaven. Luckily my 5-year-old daughter had her tablet-flavoured ice cream that we bought in the car park food van to keep her going, but I was completely breathless. This was partly down to the steps but mostly due to the magical views. I had seen Dunnottar in numerous adverts and promotional videos for Scotland and, although it looks amazing on screen, nothing could have prepared me for the vistas that greeted us when we arrived. It's easy to see why it's such a marketing staple.

When starting this project, Aberdeenshire was one of the regions I was most excited about visiting. It boasts more than 300 castles, stately homes and ruins and is known as 'Scotland's Castle Country' so seemed like the perfect place to start. Full of gothic seacliff structures and fairy-tale fortresses, it truly is a castle lover's dream and Dunnottar was first on our trip.

Sitting atop a 440-million-year-old rocky outcrop that juts into the North Sea, the surviving parts of the castle date from the 15th and 16th centuries, although the site is thought to have been fortified in the early Middle Ages. It was built for the Great Marischal of Scotland – an earl whose job was essentially to protect the king's person when attending parliament. The three-acre site holds the traditional L-plan tower house, gatehouse, chapel, hall, and priest's house. The place is steeped in history. It was once visited by King Charles II, covenanters were held prisoner and died there, and there is a famous story of the Honours of Scotland, otherwise known as the Scottish

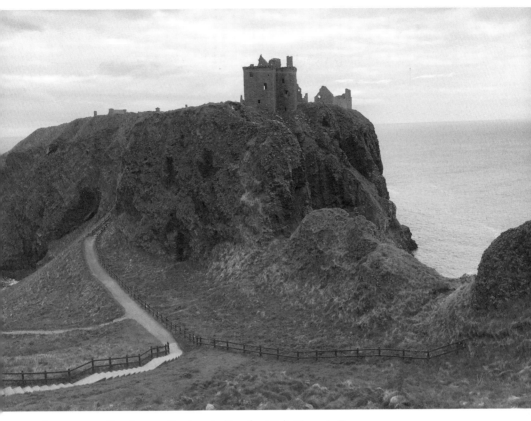

Dunnottar Castle was the inspiration for Walt Disney's Brave.

Crown Jewels, being smuggled out beneath the skirts of the women who worked there.

When the castle was surrounded by Oliver Cromwell's forces, women of the castle managed to sneak the jewels to safety. The idea was to throw them into the sea rather than let the English have them so they were smuggled out in their garments and hidden in sacks of wool until they could eventually be buried a few miles away in Kinneff Old Church. The plan was a success and that's where the jewels stayed for nine years until the monarchy was restored.

It's hard to believe how many stories there are when exploring the castle today. One of the first things we noticed after passing the dungeons to the entrance was the lion's den. Although not

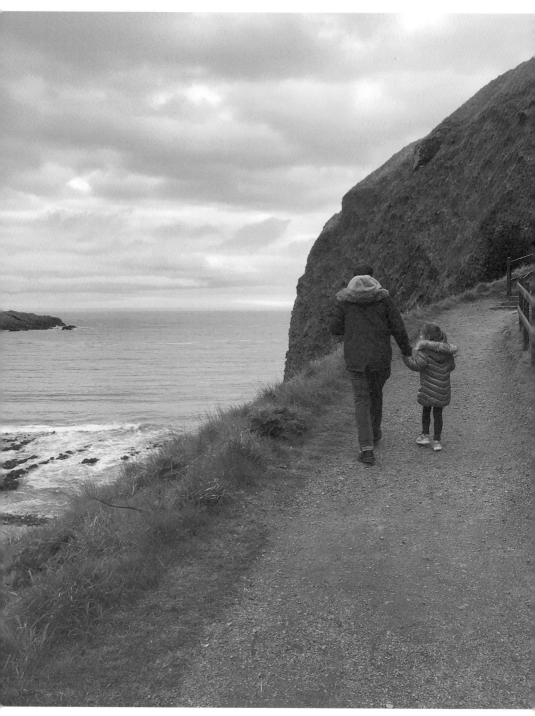

Clifftop views around Dunnottar Castle.

the only Scottish castle to have hosted a wild animal, Dunnottar was once home to the Earl Marischal's pet. According to the stories, the lion didn't live there very long as its loud roars kept the countess awake. Like many powerful families in Scotland at the time, the lion was used as a symbol of wealth and used as a mascot for the earl.

Something else that grabs your attention when you first enter the castle is the grates in the ground which reveal the once-secret underground passages. It's thought that William Wallace used these to access the castle in 1297 with his untrained army to attack the English garrison inside. However, other accounts say that the passage was built 400 years after Wallace's death. It now serves as a wishing well, with all donations going to good causes.

As we ventured further into the ruins, we emerged into an almost village-like area sitting on the cliff top. Employees of the castle and other inhabitants would have had the most amazing views of the Scottish coastline as they went about their day. In the middle of this village area sits a cistern which provided the water for the castle's inhabitants. The roof is gone but it's still a strong centrepiece.

I was surprised at how well preserved most of the rooms were. The ovens in the kitchen and bakery looked as if you could easily just light a match and bake some bread or, as my daughter pointed out, cook a couple of pizzas. The drawing room, which has been restored, is particularly impressive and is so well kept that you wouldn't be shocked if some earls and countesses wandered in.

The other place not to miss is the chapel which holds much mystery and is guaranteed to send shivers down the most sturdy of spines. 'We had a girl who worked here who was very spiritual and absolutely refused to go near the chapel,' I was told by an employee on the day I visited. 'I don't usually believe in ghosts, but I was working here once with only one other person and

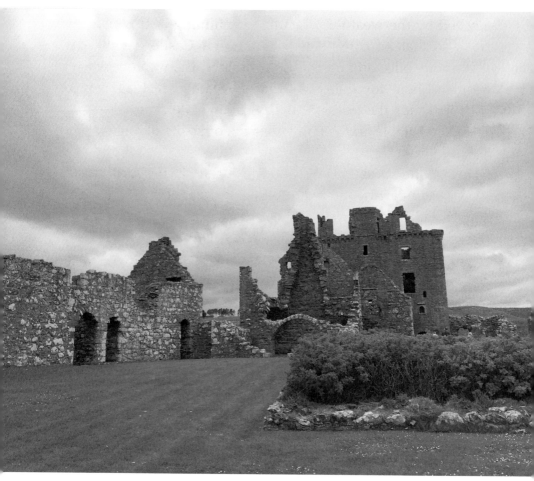

The village-like centre of Dunnottar.

we both kept hearing footsteps. That can't be explained. There was no-one else there.' I can see why the young employee was cautious. Legend has it that William Wallace trapped English troops in the chapel in 1297 – after gaining entry through the secret passage – as they were looking for sanctuary. He then set fire to it, killing everyone inside. The friendly employee also told me that in 1990 Mel Gibson was filming *Hamlet* at the castle and the story of the chapel spoke to him so much that he pitched his film *Braveheart*, the Oscar-winning box office smash that so colourfully depicted the life of Wallace. Gibson was apparently

shocked by the weather when he was filming at the castle. So much so that he commented, 'Dunnottar Castle got the part of Elsinore. Nice and eerie. The trouble is, the weather wasn't. We came here for dark and angry weather, instead we got Miami.' That's the problem with Scotland Mel, the weather is never predictable and usually does the opposite of what you're looking for.

The castle was also used for the 2015 film *Victor Frankenstein* starring James McAvoy and – one of my favourites – Daniel Radcliffe. The clifftop setting lends itself perfectly to Mary Shelley's creepy classic.

On a less gruesome note, Disney fans will recognise the castle from the 2012 film *Brave*. The team from Disney travelled to Scotland to map out the castle, and Princess Merida's home in the movie is almost identical to Dunnottar.

Dunnottar is not the only castle in the area that has inspired the House of Mouse. Craigievar by Alford is a pink-hued, fairytale tower that is thought to have inspired Walt Disney himself when designing the centrepiece for his famous theme park.

Being pink, the castle is a popular choice for Instagrammers. It even got its own augmented-reality Instagram filter in 2020 – the first of this scale in Scotland. I couldn't resist dressing my daughter up in a Cinderella gown and myself in a pink tulle skirt for my own Instagram page when we visited.

The castle is a great example of Scottish baronial architecture and was completed in 1626 by the merchant William Forbes. Forbes bought the castle from the Mortimer family in 1610 when it was unfinished and he continued its construction. Today, it is recognised as one of the best preserved and most authentic tower houses in Scotland. This is partly due to Forbes' son Sir John, who inherited the castle from his brother and commissioned architect John Smith to refurbish the tower. It was John Smith's recommendation that the harling should

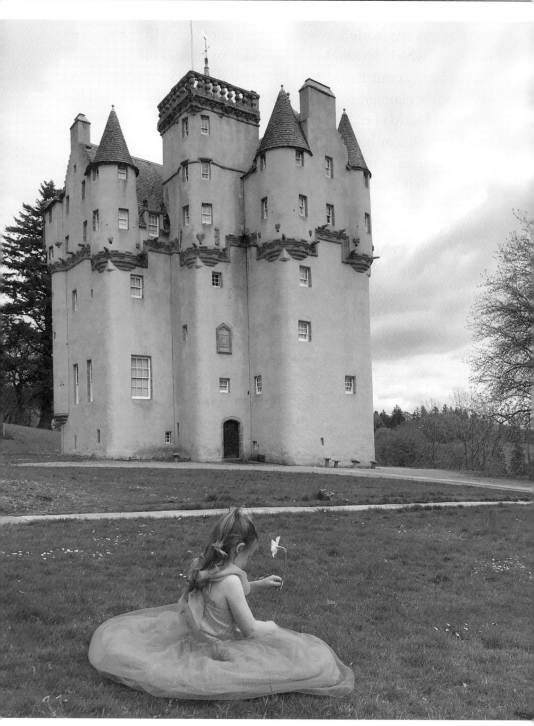

The fairytale look of Craigievar required a princess photo shoot.

have pigments added to it to match the colour of the granite detailing which resulted in its famous pink colour.

The story about its inspiring Disney is a tricky one, however. It is widely claimed to have been the inspiration for Cinderella's Castle in Florida but, try as I might, I couldn't find any definitive proof that Disney himself saw the castle. I even contacted a Disney biographer to confirm the rumour, but he knew less than me, claiming that Walt never even visited Scotland. However, I soon corrected him as there is evidence that the big cheese travelled to Edinburgh in 1960 in advance of the filming of *Greyfriars's Bobby*, so I like to think that he might have taken a few hours out of his schedule to see the pink tower for himself. The timing would have worked out perfectly as plans for Cinderella's Castle in Walt Disney World were in the early stages.

But like most fairy tales, the castle has had some darker moments. Sir John was often known as 'Red', which referred to his hair as well as his violent personality. Legend has it that Red Sir John's daughter fell in love with a member of a rival family – the Gordons. The suitor climbed up to her window on the fourth floor to see her but, unfortunately for him, met her father instead. Red Sir John plunged a sword into his throat, causing him to fall from the window to his death. To this day, visitors have reported hearing ghostly footsteps crossing the girl's bedroom.

After learning this story, we ventured to an even eerier castle just outside Cruden Bay. Slains Castle, or New Slains Castle as it was originally called to distinguish it from nearby Old Slains Castle, is not to be confused with the Dracula-themed Aberdeen pub of the same name. It overlooks the North Sea from its cliff-top site. You can no longer drive right up to the castle, which is probably a good thing as those steep cliffs are no joke. Although in ruins, you can explore various staircases and hidden rooms. Some were too large and dark for my torch to light them, so I opted to stay in the doorway.

Built in the 16th century by the 9th Earl of Erroll (try saying that five times quickly!), the castle was a tower house to replace the Old Slains which had been destroyed on the orders of King James VI after Erroll was declared a traitor due to his conversion to Catholicism.

As I was visiting with my acrophobic husband and young daughter, I couldn't explore the cliffs as much as I would have liked to. But, sitting on the cliff top, watching the sea crash into the castle's stone, and listening to seagulls squawking was a magical experience.

It's easy to see how Bram Stoker's imagination ran wild and came up with the immortal *Dracula* while staying nearby.

The Irish author's most famous work was partly inspired by the castle when he used to visit Cruden Bay in around 1892 to get away from his busy theatre manager job in London. Apparently, he loved this spot in Scotland so much that he brought his family along to join him, saying that he had found the perfect writing retreat. Sitting in the garden of his lodgings, he would gaze across at the intimidating Slains and begin to pen his legendary tale. At the heart of the building is an octagonal hall room – the very same can be found in Dracula's castle, so it is safe to say that the author did roam the castle itself, and it wouldn't have been as much of a ruin in Stoker's day. As well as the famous *Dracula*, the castle is also mentioned in Bram Stoker's locally set novels, *The Watter's Mou'* and *The Mystery of the Sea*.

I was not surprised to learn that there have been many mysterious sightings and incidents reported at Slains. Even when visiting on a sunny day, the atmosphere is an unnerving one. I would never be brave enough to venture there in darkness. Some apparent hauntings include sightings of Victor Hay, 21st Earl of Erroll, who died at the beginning of the 20th century. Having said that, I suppose I'd still rather see an apparition than bump into a blood-sucking vampire.

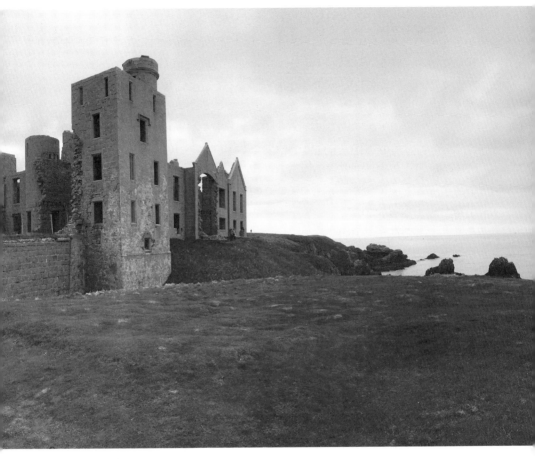

New Slains Castle was the inspiration for Bram Stoker's Dracula.

A more family-friendly castle that we visited while in the region was Crathes Castle. Complete with gorgeous grounds and gardens, Crathes is currently home to Go Ape Aberdeen where older kids and adults can zipline through the trees and walk among the branches. It also has an adventure playground which my daughter, Sabrina, particularly enjoyed.

The first thing I noticed about Crathes was how similar it was to Craigievar. If it was pink, I think many would struggle to tell them apart.

Located near Banchory, the castle is another 16th century tower. Built by the Burnetts of Leys, the family owned it for almost 400

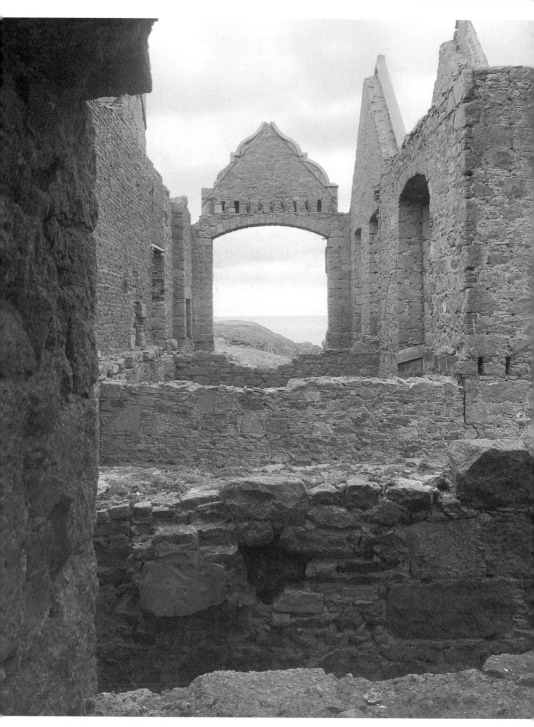

The inside of New Slains Castle as it looks today.

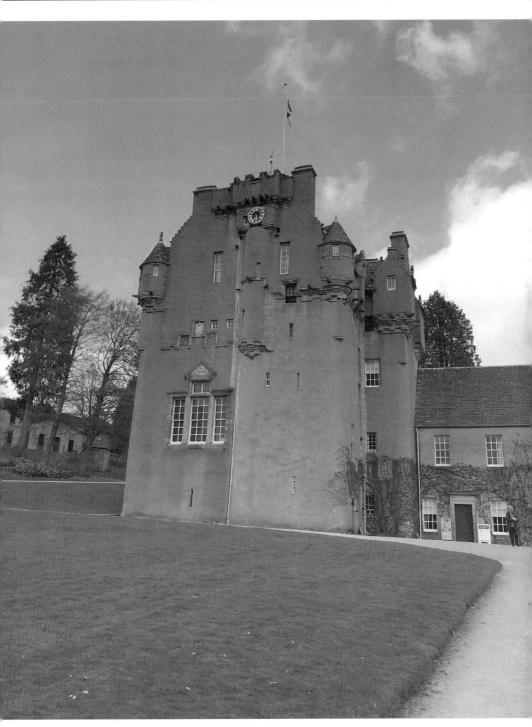

Crathes Castle has a similar look to Craigievar.

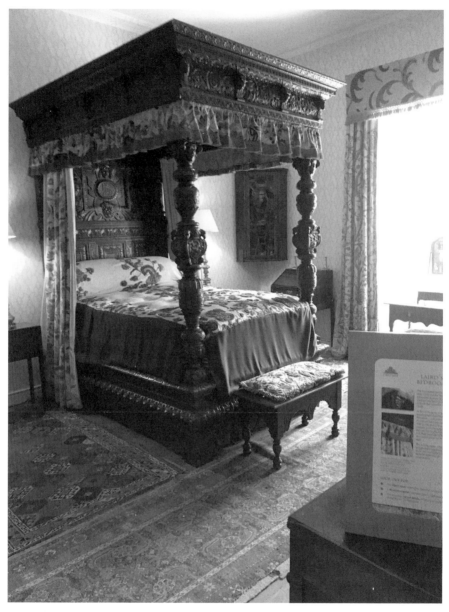

One of the possibly haunted rooms at Crathes.

years. The castle and the grounds are now owned by the National Trust for Scotland and visiting is a lovely family day out. We were able to tour inside the beautifully preserved building and see exactly how the Burnett family lived over the centuries.

Among the highlights is the Green Lady Room, which is just as well-preserved and grand as the rest. But it was only later I discovered how the room got its name. The Green Lady is apparently the ghost of a servant girl who appears in the room pacing in front of the fireplace, sometimes with a child in her arms. Even Queen Victoria has reported this phenomenon and the story is a sad one. The girl was thought to have fallen pregnant out of wedlock and fled to the castle. Her fate is not known but, at some point in the 1800s, workmen found the skeleton of a woman and child behind the same fireplace where she is often seen. I'm relieved we didn't meet her.

One thing that visitors can't explore, however, is the series of pits believed to date back around 10,000 years. In 2004, an archaeological dig of the site discovered these pits, which are thought to be the world's oldest known lunar calendar dating from 8000 BC to around 4000 BC. It's hard to imagine that while you're wandering around the rose garden.

From Crathes, it's less than an hour's journey to the Queen's summer house, Balmoral Castle and estate. Nestled in the splendour of Royal Deeside, the large estate house has been a royal residence since 1852 when the estate was purchased from the Farquharson family by Queen Victoria's husband, Prince Albert. Finding the castle too small, the Royals hired architect William Smith of Aberdeen to start from scratch – although many of his designs were amended by Albert. Completed in 1856, it is now a superb example of Scottish baronial architecture and a category A listed building. The old castle was destroyed.

Over the years, various members of the Royal family have added to the castle and estate and it now covers around 50,000 acres. It is also a working estate with animals and farmyard, and certain areas are open to the public.

Fans of *The Crown* will recognise it as the setting for Lady Diana Spencer to pass 'the test' before Prince Charles can propose to her. Although the hugely popular series was able to use the real

castle for filming, substitute locations were used for the 1997 film *Mrs Brown* and 2006's *The Queen*.

In *The Queen*, starring Dame Helen Mirren, the nearby Castle Fraser in Inverurie was used as the exterior for Balmoral. Castle Fraser is another that's similar in style to Craigievar and Crathes. It was originally known as Muchall-in-Mar. Construction began in 1575 for the 6th Laird of Fraser, Michael Fraser, and is a Z-tower plan house. It was completed in 1636, built by the mason John Bell, and was modernised in the late 18th century in classical style. It is one of the largest tower houses in all of Scotland.

The castle remained in the Fraser family until 1897 and the death of the last Fraser. The National Trust for Scotland has owned it since 1976 but the castle is still full of family portraits, ornaments, and mementos from the Fraser family.

Braemar Castle, near the village of the same name, is the chief seat of Clan Farquharson – the same family which once owned Balmoral. There has been a castle on the site from the Late Middle Ages and it was once a stronghold of the Earls of Mar. The current castle was built in 1682 as a hunting lodge for John Erskine, Earl of Mar, and this replaced the older structure. The Earls of Mar were some of the earliest rulers of Scotland and the castles were built to signify their importance in the community. However, they were challenged by the rebel Jacobites and the castle was burned in 1745 during the first Jacobite rising in 1689. Then, in the second rising in 1715, the Earl of Mar joined the rebellion. This ended in defeat for the Jacobites after a few months and the castle was seized by the Crown, allowing the Farquharson family of Invercauld to buy it.

In 1830, after government troops watching for more rebellions finally left, the Farquharsons turned the castle into their family home. It is still well preserved and now open to the public and is operated by the local community.

Like almost all the castles in the region, this one also comes with a haunting story. There have been ghostly sightings of

a newlywed bride who apparently awoke on the morning after her wedding with her new husband nowhere to be found. Assuming she'd been dumped, the girl jumped out of her bedroom window to her death. Her husband returned a short time later from an early morning hunting trip and was devastated by what he found. Reports of sightings are usually made by newlyweds staying or visiting the castle. A horrifying start to any marriage!

Over near Turriff sits Delgatie Castle on a site where a castle has been since AD 1030. The castle that stands today is a bit of a mishmash, with the earliest parts dating from around 1570, and newer wings, as well as a chapel, added much later in 1743. The castle was owned by Henry de Beaumont, Earl of Buchan. He was stripped of his earldom after he was disgraced at the Battle of Bannockburn in 1314 and his castle given to the Earls of Erroll, who were at the time known as Clan Hay.

The interior is known for its extremely wide turnpike staircase and the fabulous painted ceilings date back to the 16th century in many of the rooms. Mary Queen of Scots, visited in 1562 after the battle of Corrichie. When you visit today, there are extensive grounds and gardens to explore, as well as a café and the castle itself, and, if you like, you can rent a cottage on the estate.

Another castle I was excited to find out more about was Fyvie – mainly as Fyvie was my grandmother's maiden name. It's a stunning, 800-year-old fortress in the village of Fyvie and has been home to many clan families including the Prestons, Meldrums, Setons, Gordons and Leiths, with each clan adding a new tower, to make it one of the largest castles in Scotland.

The castle, supposedly one of the most haunted in Britain, was featured in a 2005 episode of *Most Haunted*. In 2020 during the global pandemic and lockdown (who can forget?), the poor gardener and his family were the only ones living on the estate for months. The family were featured in a national newspaper at the time talking about their strange experience and reported

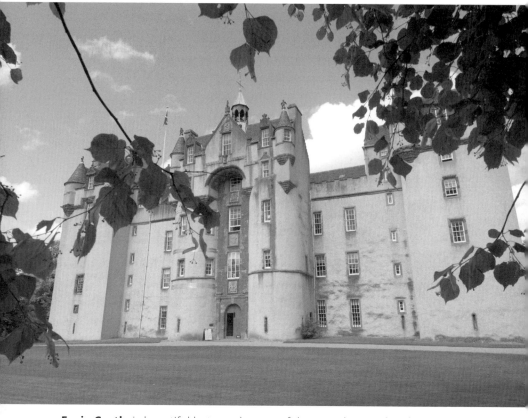

Fyvie Castle is beautiful but may be one of the most haunted in the UK.

an uneasy feeling in the library. 'It's just a feeling that I want to get out of there,' said gardener Stuart Stockley.

Drum Castle near Drumoak is also supposed to be haunted and staff at the 700-year-old building even managed to catch what is supposedly a ghost on camera. In 2014 it was reported that a strange image was captured on the webcam set up in the old stable block; it was described as a 'strange mist'. As the webcam is motion-activated, something must have set it off. Other spooky occurrences reported over the years include sightings of a female figure believed to be Anna Forbes, wife of the 20th laird, and some visitors have heard women laughing near the stable block when there was no-one to be seen.

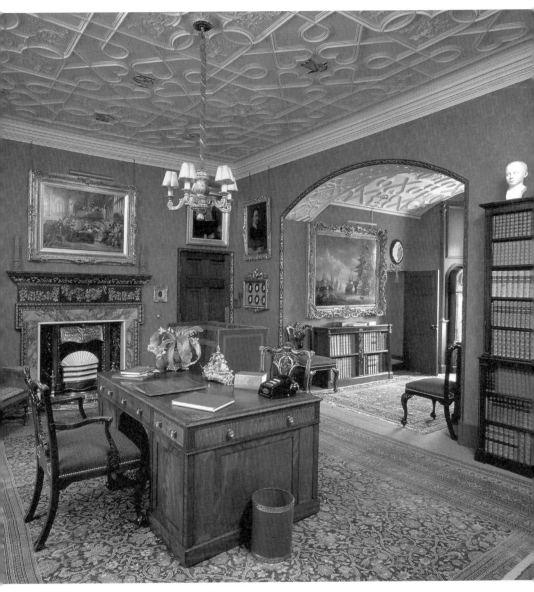

The spooky library in Fyvie Castle.

The castle is thought to be one of the three oldest tower houses in Scotland. It was built in the 13th century by the medieval architect Richard Cementarius, who also built the first Bridge of Don in Old Aberdeen. In 1619 a wing was added by the 9th laird, and additional changes were made in the Victorian

era. The castle was granted to William de Irwyn – of the Irvings of Bonshaw clan – in 1325 by Robert the Bruce and was kept in Clan Irvine for centuries until 1975, when it was taken over by the National Trust for Scotland. The site was once used as a train station on the Deeside Railway, but the service was discontinued in 1951.

Thankfully, the diligent upkeep and popularity of the region's castles means they won't reach the end of the line for many years.

Dumfries and Galloway

'Ah, I heard there were Maxwells coming today,' the woman at the gift shop smiled as I showed her our booking.

'Oh, does that mean we get a discount?' I asked.

'No, but I can send you the bill for the upkeep if you like?'

We were about to enter Caerlaverock Castle, which was built and owned by the Maxwell family for over 400 years. Clan Maxwell is a lowland Scottish clan recognised Lord Lyon King of Arms and the castle served as the seat of the chief of the clan. Located a few miles south of Dumfries, this marked our first castle visit in the region, and sharing the name with the famous local family certainly got us noticed.

Caerlaverock's shape is unusual in that it is triangular, and it has a moat. As we walked across the bridge, our eyes were drawn up to the large red stone plaque bearing the Maxwell coat of arms. My young daughter soon got used to proudly telling staff her last name and one guide assured us that we were likely descended from the aristocratic family. Well, my husband and daughter are at least. As my maiden name is Raffaelli, I can kiss goodbye to finding any castles attached to that name unless I go to Italy. Although, I have heard that the only other triangular castle in Europe is Italian. Fortezza di Sarzanello was constructed fifty years later in 1320 and is not a million miles away from where I'm descended from in Tuscany, so you never know! Still, it is cool to share my married name with a family that once lived in such a magnificent medieval fortress.

And it really is one that takes your breath away. On the drive up to the castle, you travel through rows of trees before reaching

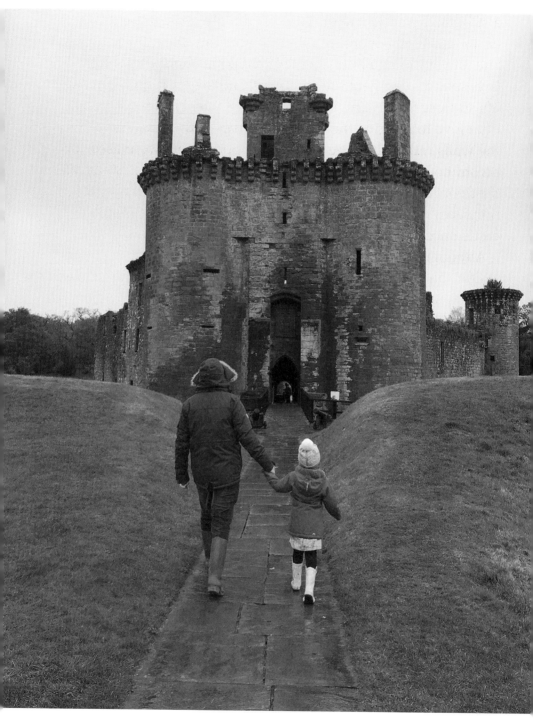

Two Maxwells visiting the fortress home of their ancestors.

a stone archway where the castle suddenly reveals itself sitting on its glistening moat. It's a sight you can stare at for hours and let your imagination run wild thinking about the lords and ladies who lived here and the wars and sieges it has seen. As it's so close to the English border, it's a keenly defended spot, but I love to imagine the day-to-day lives of the families within the walls rather than the wars. The upper floors were used for accommodation and entertaining and living spaces. Many of the floors are long since gone, but it was fascinating to see stone fireplaces on top of each other to show how many rooms the castle once held.

Although Caerlaverock's design is still a mystery, once you're inside you can see how the triangular shape works for luxurious living quarters as well as defensive purposes, and even prisons. In 1300 it took King Edward I's full army two whole days to overcome the garrison of just sixty men when they defended it, so they must have done something right in the design. It was finally rendered defenceless 340 years later when the Maxwells sided with Charles I. The south wall was torn down, which marked the end of its days as a fortress.

Murdoch's Tower was an interesting area of the castle to explore. The round tower gave a glimpse into the grim pit-prison that it once was. It was reportedly the holding cell of Murdoch, Duke of Albany, before his execution in 1425. As a cousin of James I, Murdoch governed Scotland for a period while the king was being held captive in England. He apparently didn't do much to ensure the king's speedy release. He obviously liked ruling a bit too much. When the king returned, Murdoch was arrested in Perth and confined at Cearlaverock until his execution at Stirling Castle.

One cool feature I noticed when we visited was a way for guests to help monitor the castle. At the entrance bridge, there is a sign encouraging guests to become citizen scientists by taking a photograph of the front of the castle and submitting it to a

dedicated Instagram page or by emailing it in. By doing this, the algae, lichen and moss growth can be monitored to help with conservation. This is an initiative with Historic Environment Scotland and, when I uploaded my own post, I could see that over a thousand others have done the same. Hopefully I've helped in some way.

We were in for a surprise during our visit, as the site actually holds two Caerlaverock Castles. The older one is in the woods behind the first and was built in 1220. It was deemed too small and was prone to flooding so the family only lived there for fifty years before building the new one that still stands today. Only the original's foundation remains. Visiting today is great for families. As well as the gift shop and picnic area, there is also a small castle-themed playpark where my daughter adorably asked, 'Is this where the Maxwell children used to play?'

The castle is just one of around 100 fortresses in Dumfries and Galloway. Some in ruins, some private residences and some ticketed tourist attractions like Caerlaverock. I've always found Dumfries and Galloway interesting. The region is so far south that it feels like it should be part of England. It's even further south than my English husband's hometown of Berwick-upon-Tweed and is almost parallel to Newcastle on a map. But it belongs to Scotland and is one of the most stunning spots in the country. I came to the region knowing that the Maxwell family had owned Caerlaverock but soon found out that they owned many more.

From Caerlaverock we made our way to our campsite in Dalbeattie, which happened to be a stone's throw away from Threave Castle. Located near the aptly named Castle Douglas, it is another must-see in the area. Once the stronghold of the ancient Lords of Galloway, the dominating tower was built by Archibald 'the Grim', 3rd Earl of Douglas, in 1370 and sits in the middle of the River Dee.

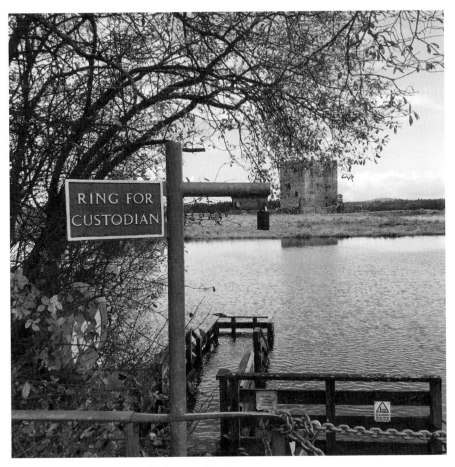

A boat is required to reach Threave Castle.

After 1455 it became a royal castle, and then was given to the Lord Maxwells (there we are again!). The English took it in the 1540s for a while before it found its way back to the Maxwells. In 1640 it withstood the Bishops' Wars. The Covenanter Army laid siege to Threave for thirteen weeks until the garrison was given permission to surrender by Charles I. The castle was then partially dismantled to prevent more military use.

Once extra creepy feature at Threave is the Gallows Knob, where the Douglases would hang their enemies. It hangs over the doorway and some visitors to the castle have reported unexplained breathing noises and voices nearby.

It's hard to imagine such a bloody history now. As the castle is on an island, you need a boat to get across, which is always a mini adventure. Once parked, there is a ten-minute walk to the boats. Wellies are a good idea on this excursion as you're walking through a lot of mud and pass a few friendly cows (behind fences) on the way. The island is incredibly serene and you might be lucky to spot some osprey chicks. A boat ride is the only way to get to the castle today but, for those in the know, there was once a secret underwater causeway to reach the island.

Tower structures like Threave always strike me as being quite lonely. I imagine noblemen living in isolation and in constant fear of attack. But when Archibald 'the Grim' lived in the tower, it was anything but isolated. In the 1970s, the remains of a great hall and chapel were discovered on the island, so it appears to have been a lively community.

MacLellan's Castle was built in 1582 opposite the River Dee, neighbouring Threave. It was built and designed by Thomas MacLellan of Bombie and, despite never being fully completed, it was home to descendants of MacLellan until it was sold in a state of ruin to Sir Robert Maxwell in 1752. He sold it again thirty years later. Today it's owned by Historic Environment Scotland and guests can venture down into the dark vaults to see the working conditions of the servants. Guests can also see the Laird's Lug, which was a secret spy hole for the Laird to listen in on his visitors' conversations.

Another tower-like structure that reminded me a lot of Threave is Cardoness Castle in Kirkcudbrightshire (even as a Scottish person, I find that hard to pronounce). It's perched on a hill just off the A75 so you can't miss it. The castle is a 15th century, large and impressive tower which was held for years by the MacCulloch family. It's another to have some spooky tales associated with it. Apparently, there was a curse on the castle which afflicted each of the owners and left every family who

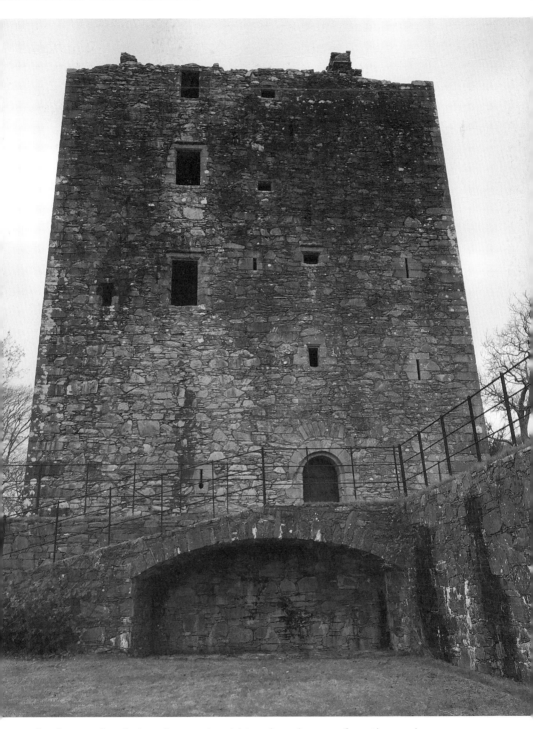

Cardoness Castle is an impressive sight and can be seen from the road.

owned it ruined. There have also been reported apparitions within the walls, one thought to be the ghost of a man who was hanged in the prison area.

Drumcoltran Tower is a late-16th century tower house that is also located in the hard-to-pronounce Kirkcudbrightshire. It was built by a branch of the Maxwell family around 1570 and they passed the estate to the Irvings in 1668.

One more in the area is Kenmure Castle which is described as a spooky and atmospheric ruined 16th century mansion house. It sits in the town of New Galloway and the site has been occupied since the Middle Ages. The early castle was thought to have been destroyed by opponents of Mary Queen of Scots in 1568. In the 17th century the castle went through extensive work after Sir John Gordon was created Viscount of Kenmure in 1633. The castle has gone through many changes over the years. It was a hotel for a short time in the late 1940s. In the early 1950s the roof was removed and the interior gutted. Although one castle not to have been used as a location for filming *Outlander*, it did once serve as a playpark for one of the actors. Sam Heughan, who plays Jamie Fraser in the hit show, lived in the grounds of Kenmure Castle as a child and used to play in the castle ruins. Probably not the safest childhood activity as parts of it are crumbling dangerously.

An interesting fact about Kenmure is that Scotland's national bard, Robert Burns, once visited and was inspired to write his song *Scots Wha Hea*.

Near Dalbeattie we found Scotland's only circular tower house, Orchardton Tower. The tower was built by the Carins family around 1450 and no-one knows why it was built in such an unusual shape. Circular towers were generally used in castles from around the 13th century but had been out of style for over 200 years and replaced with rectangular ones when Orchardton was built. The circular style was still popular in Ireland, which makes some people think that John Cairns, who

built the tower, had some connection. Like many castles in Dumfries and Galloway, it eventually fell into Maxwell hands. Robert Maxwell took some stone from the tower and created Orchardton Castle, a comfortable Baronial-style mansion not far from the original tower. The castle was later extended by William Douglas in the 1800s and, at the time of writing in 2021, was up for sale for a cool £1.7million. For that, the new owners would get superb views, over 40 rooms including 20 bedrooms and 15 bathrooms, extensive lawns and a hedged garden. For some reason, the current owners are having trouble selling it. It was even offered as a raffle prize in 2017.

Directly north of Dalbeattie is Drumlanrig Castle which looks like something out of a fairy tale. Known as the 'pink palace', it was constructed of pink sandstone and is an example of late 17th century Renaissance architecture. It was built for William Douglas, 3rd Earl of Queensberry, and he slept in it for a grand total of one night. In a move that's almost like a scene from *Blackadder*, the earl decided on a whim that he didn't like it after all and skipped back along the road to Sanquhar Castle. One reason for his brief stay was that he was so horrified by the tremendous cost, but I like to think that it was just another flight of fancy à la Miranda Richardson as Queen Elizabeth I.

The castle today is a popular tourist attraction and is the Dumfriesshire home of the Duke and Duchess of Buccleuch and Queensbury. For *Outlander* fans, it may be recognised as the Duke of Sandringham's estate from the series two episode *Vengeance is Mine*. And it's not the first time the castle has graced the screen. It was also used in Don Sharp's acclaimed 1978 version of *The Thirty-Nine Steps*.

From grand Renaissance-style castles to tower ruins takes us to Dunskey Castle in the seaside village of Portpatrick. This structure sits on a clifftop and creates a magical backdrop against the sea. From the village it's a good ten-minute walk uphill to the castle ruins, but it's worth it for the view. Due to

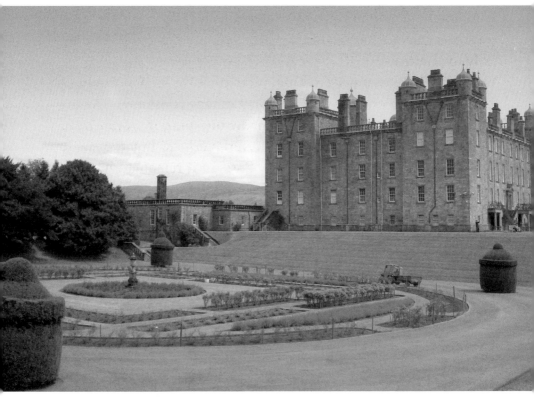

Drumlanrig Castle is the Dumfriesshire home of the Duke and Dunchess of Buccleuch and Queensberry.

its clifftop location, it's deemed unsafe for visitors to enter, but you can get pretty close.

The small, L-shaped castle has sat in ruins since 1684. It was built in the 16th century but there was once an older fortification on the site that burned down. It was the filming location for Robert Louis Stevenson's *Kidnapped*.

Across to Stranraer and the Castle of Saint John is one that felt most familiar to me. As an Edinburgh native, I'm used to having a towering structure as part of the city landscape and that's exactly what this is to Stranraer. It was built by the Adairs of Kilhilt around 1510 and has been used as a home, a court, a police station and a military garrison. It is now a fascinating free museum and provides a great view of the whole town.

A hidden gem in the area is Morton Castle, which once formed part of a chain of castles along Nith Valley which runs from the Solway Firth north to the Clyde Valley. Within the ruins, the rooms are still distinctive. There was a castle on the site built in 1307 but the one that is intact today was constructed in the mid-1400s by the Earls of Morton. At one time it would have been as large and impressive as Caerlaverlock, but the castle was captured and burned in 1588. Parts of it remained liveable until around 1714, but then it was abandoned.

Visitors have described it as one of Dumfries and Galloway's best-kept secrets as it not as well-known as Caerlaverock or Threave but is just as interesting and never as busy. It was another castle to belong briefly to the Maxwell family. The marshlands that surrounded the structure were flooded to create the artificial loch which now surrounds it on three sides.

Sanquhar Castle was built in the 13th century by the Crichton family.

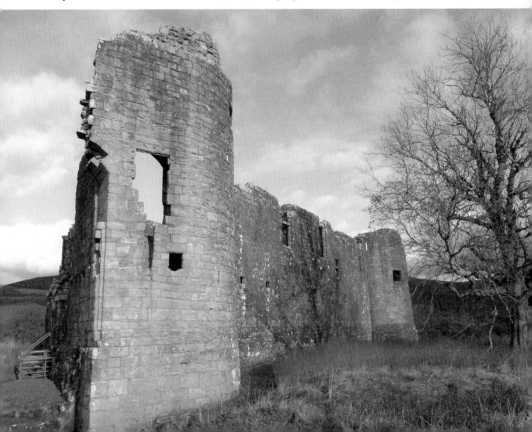

Film fans may note that it another location in the 1978 version of *The Thirty-Nine Steps* as well as in season two of *Outlander* as a backdrop for when Jamie and Claire travel through Scotland.

Also near the River Nith is Sanquhar Castle, which is in a ruined state and thought to have been built in the 13th century. It was once an important stronghold for the Crichton family and was visited by both William Wallace and Robert the Bruce. It's been unoccupied since around 1690 and is thought to be haunted by a couple of ghosts. The 'White Lady' who has been seen there is thought to be the spirit of a young woman called Marion of Dalpeddar who disappeared in 1590 and whose skeleton was discovered during excavations in the 19th century. Another ghostly figure is thought to be the spirt of John Wilson who was wrongly hanged by the Crichton family. His moans have been heard along with the rattling of chains. If those stories weren't enough to put you off visiting, the castle is also in such a derelict state that it's unsafe to explore.

Over in Lochmaben there is a very interesting ruin to discover. Lochmaben Castle was built by an English occupying force in the 1300s as part of the plan to control Scotland. The English tried hard to hang on to it until the Scots finally stormed it in 1385. It became a royal possession in 1445 when James IV carried out major renovations to make it his own. Mary Queen of Scots visited it with Lord Darnley. It was often a site in wars with the English but was eventually abandoned in 1700, the stones being taken away and used for other buildings. There isn't much to see today, but along with the ruins there is a popular loch-side woodland walk.

Torthorwald Castle just outside Dumfries is a large ruined rectangular tower from the 14th century, although there was a castle on the site from the 12th century. The castle served as a stronghold for the Kirkpatrick and Carlyle families. There isn't much to see of the castle today, but it can be spotted from public roads.

If you're looking to actually stay overnight in one of these fascinating fortresses, you're in luck. Buittle Castle in the valley of the River Urr near Dalbeattie offers tours, afternoon tea and even bed and breakfast. It was built by Roland, Lord of Galloway, in the 12th century. After changing hands various times it eventually made its way to the Maxwells (of course). My namesakes hung onto it until 1984 and then gifted it to Balliol College. Visitors can stay in one of two rooms, the Munches Room and the Lady Maxwell Room, with a Scottish breakfast included. I'll definitely be returning to stay in the Lady Maxwell room.

Another option used to be Comlongon Castle, south-east of Dumfries, but it was never for the faint of heart. The 15th century tower house is reportedly crawling with ghosts, which have been spotted in the tower house and some even caught on film. The hotel was put up for sale recently after the owners filed for bankruptcy – or was it because of something paranormal? The tower house is thought to have been built in the early 16th century. It was extended around 1900 making it a baronial style mansion. It remained in the Murray family until 1984 and then was used as a hotel and wedding venue. The castle has been described as Scotland's 'spookiest property'. It is apparently haunted by the ghost of Marion Carruthers, the daughter of Baron Simon Carruthers of Mouswald Castle. Marion was due to marry a powerful baron called James Douglas against her will so fled to Comlongon Castle where her uncle, William Murray, allowed her to hide. To persuade Douglas not to marry her, she signed away her estate to uncle William so Douglas couldn't have it. However, Douglas sued both Marion and William and won. Marion was then ordered to marry Douglas immediately at Comlongon Castle and was so distressed that she jumped off the roof, killing herself. Ever since, there have been sightings of a women crying around the castle and no grass ever grows on the spot where she fell. Maybe it's a good thing this place is

no longer open to guests, but who knows what the future may hold.

Marion's home of Mouswald Tower is nearby in the rural village of Mouswald and now stands within a holiday park. There is not much to see today of the ruins of this 15th century tower. Only a small section of wall which has given way to nature. A cottage has been built up against it and the ruin is within the grounds of Mouswald Lodge Park Holiday estate where holiday makers will walk past day after day, never knowing its history.

When planning a trip to Dumfries and Galloway, there are countless fortresses to explore, so it's a good idea to choose what attractions you want to visit in advance. It was illuminating to see just how many the region hosts and how many my husband and daughter may be descended from – I wish they still had a portfolio of castles in their name.

Edinburgh and the Lothians

When you think of Scotland's capital, there is one image that immediately springs to mind. You can't Google the city without photos of Edinburgh Castle popping up and its looming turrets can't be ignored on any trip to the city. Even after years of living and working here, I still marvel at it every time I walk along Princes Street.

Although obviously a thing of beauty and a permanent fixture of the skyline, Edinburgh Castle is one of the most interesting places I've ever come across. It's little wonder that it is Scotland's most popular attraction, with more than two million visitors a year. I went on several school trips there as a child, I've proudly shown it off to visiting relatives across Europe and have even enjoyed concerts by such diverse bands such as The Proclaimers and Girls Aloud on its famous esplanade. But no matter how many times I go, I always discover something new.

'What is this black rock-type thing?' I asked while browsing the National War Museum located within the castle walls.

'They're actually the toenails of the elephant who used to live in the stables of the castle,' replied a helpful staff member.

'Oh. Sorry, come again?'

And that's how I learned of the big grey Sri Lankan (then Ceylon) mascot of the 78th Highlanders who paraded the city and even sampled the local beer. His name has been forgotten – it's a shame there aren't more elephants around to remember it – but the tale lives on. He lived in the castle stables and was cared for by a Private McIntosh. He was so beloved that a memorial to the 78th Highlanders on the esplanade features a stone carved elephant underneath the Celtic cross upon a

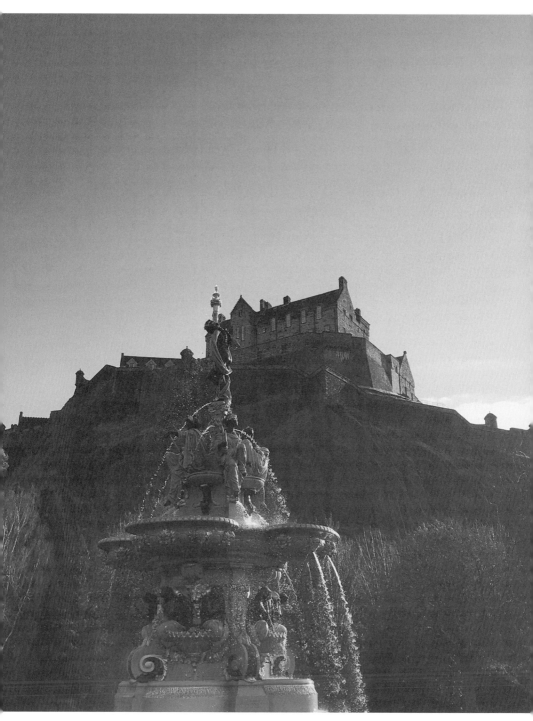

It's hard to take a bad photo of Edinburgh Castle.

plinth. That's what I love about Scottish history, you never know what you're going to learn next. Forget London, we have our own Elephant and Castle right here.

But aside from the elephant toenails that had me flabbergasted for about half an hour on our latest trip, a whole book could be written on Edinburgh Castle alone.

It's one of the oldest fortified places in Europe and has served as a royal residence, military garrison, prison, and fortress. On every visit, I imagine all the kings, queens, soldiers – and now elephants – that have walked before me. Parts of it are still in military use but most areas are open to the public.

Human occupation of Castle Rock, where the tower sits, has been established by archaeologists since at least the Iron Age, which is 600 BC, although no one knows the earliest settlement. There has been a royal castle on the rock since David I ruled in the 12th century, and it continued to be a royal residence until 1633. It's surreal to think that no-one has called the castle home since the 16th century.

For locals, the daily gunfire at precisely one o'clock will be very familiar. The one o'clock gun has been fired from the castle every day (except Sundays, Christmas Day and Good Friday) since 1861 when the idea was brought to Edinburgh from Paris. You can always spot the tourists on Princes Street by their reaction to the noise: residents tend to just glance at their watch while a tourist is likely to jump out of their skin. The rumour is that the gun fires at one o'clock rather than midday in order to use eleven fewer rounds – thrifty Scots. The gun itself has changed over the years and is not to be confused with the other famous gun within the walls – Mons Meg. This six-ton gun is one of the biggest cannons in the world – big enough to fit a fairly large child in its barrel – and was built in 1449 on the orders of Philip the Good, Duke of Burgundy, as a gift for James II, King of Scots, in 1454 to help fight the English. Largely responsible for reducing Norham Castle in

Northumberland to ruins, she hasn't been used in combat since the 16th century.

The castle is also the place to see the Honours of Scotland, also known as the Scottish Crown Jewels. As the oldest crown jewels in Britain, they are steeped in history. The crown was made for James V, and Mary Queen of Scots was the first to be crowned with it in 1543. The jewels had to be rehomed from 1651 to 1660 to keep them from Oliver Cromwell's army, and in 1707, after an Act of Union between England and Scotland, they were locked in a chest and sealed away. Sir Walter Scott was the one who rediscovered the Honours, along with a mysterious silver wand in 1818.

Aside from the cannons and crowns, the Scottish National War Memorial commemorates Scottish soldiers lost from the First World War and every British war since. Each bay is dedicated to a different regiment and books of remembrance list the names of the fallen.

The National War Museum – where those bizarre toenails are kept – covers four centuries of Scottish military history and showcases the journey of how the kilted Scottish warrior changed from fighting the English to fighting alongside them.

One of the most famous residents of the castle was Mary Queen of Scots. When she returned to Scotland from France in 1561, the royal procession was held there. Over the years she hosted many grand feasts and it is also where she gave birth to her son, King James VI, in 1566.

Simply known as 'the castle' by locals, practically everyone who has grown up in the city will have visited it at least once. The same can't be said for the capital's 'other' castle, Craigmillar. On my recent visit on an extremely rainy Sunday, I posted some photos on Instagram and received several messages from old school friends and colleagues who admitted that, despite living in Edinburgh all their lives, they had never been. Tucked up on a low hill to the south side of the Craigmillar district of the

city, the ruins are run by Historic Environment Scotland and are fascinating to explore.

When visiting Craigmillar Castle, the first thing you notice is the fantastic views of Arthur's Seat – the extinct volcano that sits in a group of hills which form most of Holyrood Park. As it's a bit further out of the city centre, it can often be overlooked by tourists, but it is definitely worth a trip.

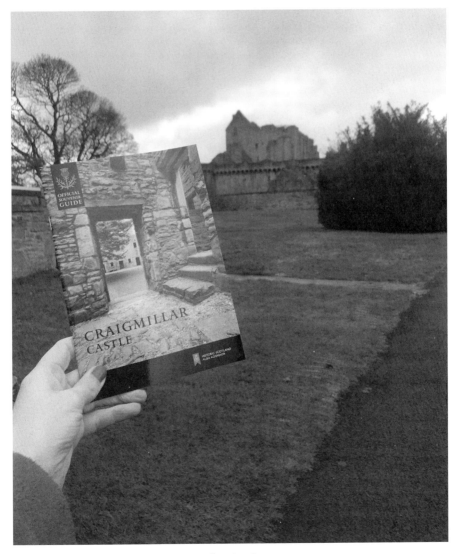

Edinburgh's 'other' castle is Craigmillar Castle.

When you enter the main courtyard, you're greeted by a pair of large yew trees that are thought to have been planted in Queen Mary's honour. Yew was the best wood for bows for archery, one of the Queen's favourite hobbies. It's thought that Mary visited many times, although only two stays were recorded. One was in 1563 and the other in 1566, when she came to recuperate following an illness after the birth of her son (who was born in Edinburgh Castle), the future James VI. Before she left, a pact called the Craigmillar Bond was made to execute her husband Henry Stuart, Lord Darnley. No-one knows if the Queen of Scots was in on the plan or not.

Another fascinating story from the castle is that it was once a prison for a supposed witch. King James III's brother, John Stewart, Earl of Mar, was accused of treason and for practicing witchcraft. Little is known about the case, but John died shortly afterwards in mysterious circumstances.

Fans of *Outlander* might recognise the castle from the season three episode, *All Debts Paid*. It serves as the prison where Jamie is held with other Jacobites. It was also used in the 2018 film *Outlaw King* about Robert the Bruce, as well as the 1997 BBC TV production of *Ivanhoe*.

Some of the castles in Edinburgh can't be ignored, but there are a couple that hundreds of people walk past every day without realising what they are; and I am one of those people. For four years I attended Edinburgh's Napier University (an honours degree in journalism, in case you were wondering) and never once noticed the big castle slap bang in the middle of the Merchiston campus, and another, admittedly smaller, in the Craiglockhart campus. I was clearly preoccupied with my studies – or going to the union.

Merchiston Tower was likely built by Alexander Napier, second Laird of Merchiston, and the tower was the seat of his family's clan. It was also home to famous mathematician

and philosopher John Napier from 1550 until he died in 1617. Napier was best known for inventing logarithms to simplify calculations, and my old university – where I walked past his former home every week for four years – was named in his honour.

Craiglockhart Tower is a lot easier to miss for preoccupied students. It was once a four-storey tower but now only a stump of its ruins remains. No-one is quite sure who built it originally, with some sources saying the Lockharts of Lee in the 15th century, others claiming it was the Kincaid family in the 12th century. Either way, I'm sure I'm not the only student who has failed to notice it.

Another hidden gem I learned about in Edinburgh is Granton Castle Walled Garden, which is only a short distance away from where I live. I found out about it as my florist friend grows flowers within the walled garden. The castle is sadly no more: it stood from the 1400s to the 1920s and was destroyed entirely by accident. It was supposed to be a scheduled monument and was confirmed as such in 1920, but the official letter never made it to the correct address and demolition had already begun. This discovery was made by the charity organisation which keeps the garden intact, Friends of Granton Castle Walled Gardens. It's a disgrace that the castle has been destroyed, but the gardens, which are sometimes open to the public at weekends, are superb.

A great place in Edinburgh to castle-spot is Cramond. I love to wander along Cramond beach in the hope that I might bump into my favourite author, J.K. Rowling, who lives nearby. It also reminds me of another of my favourite books and films, *The Prime of Miss Jean Brodie*. As you walk along the prom, you will spot a foreboding-looking tower across the water. This is Barnbougle Castle and was the filming location for Mr Lowther's home in the Muriel Spark classic. It was built in the 13th century originally to protect a noble Norman family

from enemies. The castle you see today looks nothing like the earlier version and is now used as a grand wedding venue. The castle was once home to Archibald Primrose, the 5th Earl of Rosebery and prime minister from 1894 to 1895. The initial structure was entirely reconstructed and extended to suit Rosebery and he practised his speeches in his purpose-built gallery hall. The castle is still owned by the Rosebery family.

Another fortress nestled among the trees in the area is Cramond Tower. This is another one I'm guilty of walking past without noticing as it's right by the car park at the beach. It's thought to have been built in the late 15th century as a defensive feature. It was briefly the home of an Edinburgh merchant in 1622 but was then abandoned for 300 years until it was restored to become a private residence. It's now owned by a local taxidermist who will gladly stuff your beloved pet on the premises.

Lauriston Castle, also near Cramond, is another stately home-style property that has seen many states. A castle stood on the site in medieval times but was destroyed in the raids on Edinburgh in 1544. The tower house was rebuilt around 1590 by another Napier – Sir Archibald, John's dad – for his other son, also called Archibald.

The castle has gone through various renovations over the years and has extensive gardens which are open to the public free of charge. It's a popular spot for families as there are marvellous views of the Firth of Forth from the back of the castle and even a small coffee and cake shop to refuel explorers.

Anyone looking to live in a castle in Midlothian is in luck as, at the time of writing this in 2021, Gogar Castle was up for sale for offers over £2.3 million.

The castle dates back to the 1600s and potential buyers will be delighted with its seven bedrooms, a library, gym, huge garden grounds and even a crypt. Set over four floors, it also comes with a sauna, riding arena and boat house. It was built in

Freepost Plus RTKE-RGRJ-KTTX
Pen & Sword Books Ltd
47 Church Street
BARNSLEY
S70 2AS

Lauriston Castle is a 16th century tower house that overlooks the Firth or Forth.

1625 but was extended afterwards to include Scottish baronial features such as the turrets and tower. It was owned by the Steel-Maitlands for over 200 years until the last family member died. The price tag might seem eye-watering, but it's actually been reduced by £1m since going up for sale. It's been listed for sale many times, and one wonders why it hasn't been snapped up. I would put in an offer if I had the budget.

Just outside Edinburgh, in South Queensferry, lies a castle that has become very popular for tourists in recent years. Midhope Castle is a 16th century tower house, and *Outlander* fans may

know it as Lallybroch. The castle serves as the ancestral castle home of Jamie Fraser in the show. The castle is in the wider Hopetoun Estate, which is a working farm so wasn't a tourist attraction until the show took off. It now welcomes visitors seasonally. The castle was originally built for John Martyne who was the laird. It was then passed to Alexander Drummond of Midhope who was the Master of Work to the Crown of Scotland, which means he was in charge of maintaining the royal palaces and castles. By the 19th century the castle had a thriving community surrounding it, but it had fallen into decline by the 20th century and is still abandoned today. It was quite unknown until the *Outlander* team picked it to serve as Lallybroch in 2013.

Over in East Lothian you'll find countless fortresses and towers. There are almost ninety castles in the region. One of the most popular is Tantallon Castle, which is a ruined mid-14th century castle just outside the hugely popular seaside

Tantallon Castle is just east of North Berwick.

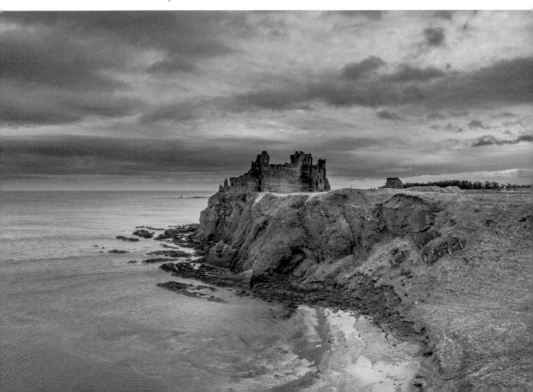

town of North Berwick. It sits on a sea cliff opposite Bass Rock and looks out onto the Firth of Forth. It was the very last castle with a medieval wall curtain built in Scotland (a defensive wall between the towers). The fortress was built by the 1st Earl of Douglas, William Douglas, and was then passed to his illegitimate son, George Douglas. It survived many sieges and remained in the Douglas family until 1699, when the Marquis of Douglas sold it to Lord North Berwick.

The reason the castle survived so many sieges may be down to the soft stone outer casing of the battlement walls. Most of the impacts from incoming projectiles were absorbed into the stonework so, even after 700 years, much of the building is still intact. Like many castles in Scotland, the ruin is now in the care of Historic Environment Scotland.

Near Tantallan is Dirleton Castle, in Dirleton just west of North Berwick. The oldest parts of this castle were built in the 13th century and it was left to ruin in the 17th century. It is a fun

Hailes Castle is about a mile from East Linton and has a fine riverside setting.

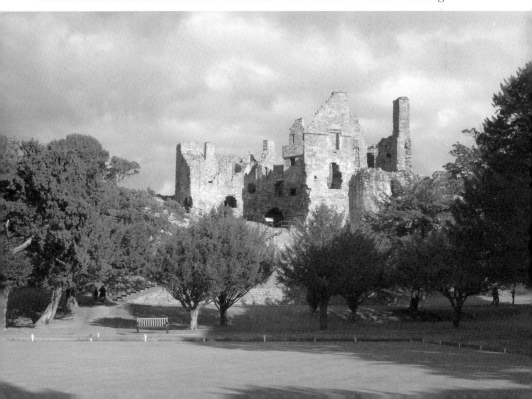

one to explore, with bridges, hidden chambers and dungeons. The first structure you notice is the 16th century Doocot (or dove house) which at one point held 2000 pigeons; the inside of it resembles a huge wine cellar and it's hard to imagine rows and rows of grey birds rather than dusty green bottles.

Many ancient castles in Scotland are thought to be haunted, but this one has an especially murky history. During the Scottish witch hunts of 1649, accused women – and some men – were held in the castle's pit prison. They were accused by witch hunter John Kincaid, who claimed they all had the mark of the devil, and were held in the pit until they were strangled or burned to death. Some say the devil himself visited the castle at this time in the form of a 'shadow man'. This apparent sighting fuelled mass hysteria at the time. To this day, electronic equipment has been known to malfunction in the walls of the castle and especially in the pit prison. Visitors have also reported cold spots and the feeling of someone watching them when no-one is there. To think of those poor people waiting for a terrible death in cold stone cellars chills me to the bone. I hope we are a bit more civilised now.

Another haunt (apologies) in the area is Hailes Castle. The ruins stand in a defensive position overlooking the River Tyne. It is thought to be Scotland's oldest stone castle and dates back to the early 12th century. Although it's one of many she visited in the area, the ghost of Mary Queen of Scots is thought to haunt the grounds. A lady in white has been reported by visitors over the years. The ruins are open to the public for those brave enough.

Winton Castle is considered a masterpiece in Scottish Renaissance architecture and is classed as a category A listed building. King David I granted lands in East Lothian to the Seton family, which included Winton, and the estate has passed through several families since. The castle is thought to have been built in 1480 when George, 4th Lord Seton, began the building

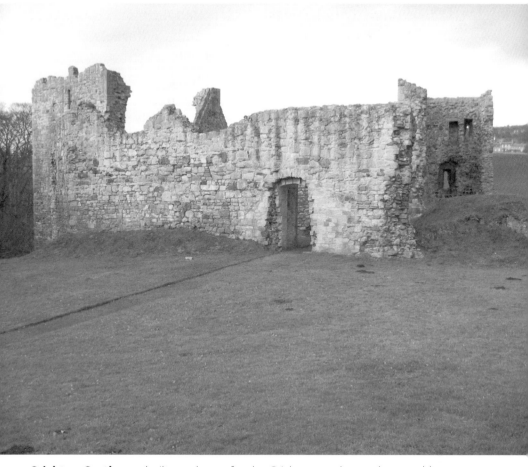

Crichton Castle was built as a home for the Crichtons and served as a noble residence from the late 1300s.

of Wintoun Castle, which was a four-story tower surrounded by a defensive curtain wall. This castle was destroyed in 1544 during the war of the Rough Wooing and was restored again in 1620. The new castle was more luxurious than defensive and Prince Charles, future King Charles 1 of Scotland and England, was said to have visited.

Another on the 'most haunted' list is Yester Castle. The castle was built in the village of Gifford during the 13th century by Hugo de Gifford who was nicknamed the Wizard of Yester as he was thought to practice magic by communicating with the

dead and to carry out mysterious rituals in the underground hall. The vast cavern hidden beneath the ruins of the castle, known as the Goblin Ha', have been plagued with reports of hauntings. These caves can be visited today – if you can find them. The gothic style chambers lie beneath the ground and can be accessed through a doorway at the castle's northern end. I was keen to visit these spooky chambers for myself and tried to persuade my friend to join me. However, after reading several people's traumatising accounts of the creepy caves, my friend and I decided to give it a miss. There have been countless stories of people feeling a sinister presence and feeling not welcome. Others believe that something terrible will happen if they venture into the caves. We were not brave enough.

Midlothian also has its fair share of towers and structures with two of the biggest being popular options for weddings. Dalhousie (or Dalhoosie as it is pronounced by locals) and Melville are within spitting distance of each other and call themselves 'castle hotels' with wonderful grounds that will give all brides and grooms a day to remember. Dalhousie is just outside Bonnyrigg while Melville sits outside Dalkeith. It takes less than five minutes to drive between the two.

Another castle thought to be haunted by the lady in white, Mary Queen of Scots, is Melville. The castle was used as her hunting lodge when she was alive, and an apparition of a woman has been seen to walk through walls.

One that doesn't offer luxury rooms however is Crichton Castle near Pathhead. A tower house was built in the late 14th century by John de Crichton for his family to live in and expanded as the family grew. His son, William, did a lot of the extending and built an entire courtyard around his dad's original tower. It was apparently the first castle in Scotland to have a straight staircase. William became the Lord Chancellor of Scotland and was partly responsible for organising the 'Black Dinner' where William Douglas, 6th Earl of Douglas, was

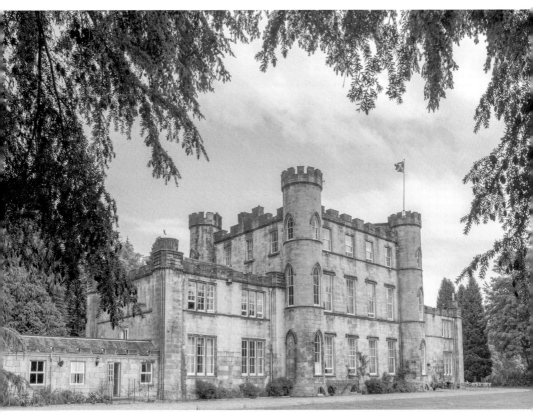

Melville Castle is now an award-winning wedding venue.

murdered. The Douglas clan were one of the most important families in lowland Scotland during this time and considered a threat to rival families. The 'Black Dinner' served as inspiration for 'The Red Wedding' featured in George R.R. Martin's novel *A Song of Ice and Fire* which was later adapted into the TV show *Game of Thrones*. Although the murder took place at Edinburgh Castle rather than Crichton. After murdering the Earl of Douglas, William claimed another castle, Bothwell, for himself. Crichton Castle has been seen on screen in the 1995 film *Rob Roy* starring Liam Neeson and the 2011 film *The Wicker Tree* with Christopher Lee.

Scotland is famous for a pink-hued castle in Aberdeenshire (skip back to that chapter to find out more) but I recently

discovered that there is another one in East Lothian that anyone who watched children's television in the 2000s might recognise from Balamory. While most of the show was filmed on the Isle of Mull, Archie the Inventor's pink castle was actually in East Lothian, and even mere mortals can stay overnight. Although not quite as pink as the TV show depicts, Fenton Tower is a traditional 16th century tower house and is actually more of an off-white up close. It was visited several times by James VI of Scotland, who was a guest of Sir John Carmichael who built the castle. Today you can either book a private room or suite within the castle, or the whole tower so you can pretend to be Archie for a night or two. What's the story?

Glasgow and the Clyde Valley

For as long as there's been a Scotland, there's been a rivalry between Edinburgh and Glasgow.

As the bigger of the two cities, some Glaswegians feel that the honour of being Scotland's capital should fall to them, as is the case with most European countries. However, Edinburgh has had the title since 1437 and that's not likely to change anytime soon.

Despite there being less than fifty miles between the two cities, there are distinct differences between their residents. Glaswegians are known throughout the world as being very friendly and hospitable, while people from Edinburgh are thought to be a bit more stand-offish (although I like to think this has never been applied to me). Ever heard the expression, 'You'll have had yer tea'? I thought this was a rumour until I started going shopping in Glasgow as a teenager, when I immediately noticed the friendliness. No-one gave me a dirty look when they felt I had been browsing for too long, and instead of being shouted at for bringing in a hot coffee to a fancy shoe shop, the security guard at the door offered to hold it for me while I had a look inside. I must admit that I have never witnessed that in Edinburgh. The old saying 'You'll have more fun at a Glasgow funeral than an Edinburgh wedding' finally started to make sense.

However, in my experience, the people of Glasgow have more of a problem with Edinburgh than the other way around. Most friends I have from the West are always quick to dismiss Edinburgh's charms and list all its faults whereas my Edinburgh friends genuinely like Glasgow and will freely admit that it's miles ahead in terms of shopping and music venues.

When working in a Glasgow newsroom straight out of university, I remember a conversation with a Canadian colleague when he found out that I was from Edinburgh. 'I bet you're wondering why I choose to live in Glasgow and not Edinburgh,' he said. I wasn't. 'Well, if I wanted to live in England, then I would.' I'm still not sure why a man I'd only just met felt the need to slander my hometown but it's not the first time I've heard this. Edinburgh seems to have the reputation of being 'less Scottish', which is crazy to me. Indeed, an English neighbour said to me, 'Edinburgh is quite an English city, isn't it?' but she has obviously never been to Leith. One of my favourite comedians, Limmy, has also made comments about Edinburgh not being Scottish but, because he makes me laugh, I'll forgive him. We'll just have to agree to disagree.

But rivalries aside, the one thing that Edinburgh thinks 'trumps' Glasgow in terms of tourist appeal, history and beauty is the massive castle smack bang in the middle of the city centre. No-one can argue that Edinburgh probably wins in the castle stakes, but we mustn't write Glasgow off. Although not known for its fortifications, there is evidence of some impressive old structures which have been knocked down to make way for the new. But the city and the surrounding areas is still home to a fair few intact towers, each with a story of their own. As a devout Edinburger, I must confess that I had visited very few west coast castles until recently, but I'm glad I did.

Unfortunately, Glasgow's most prized palace is one that is no longer in existence. Glasgow Castle, also known as the Bishop's Palace, was the residence of the bishops and archbishops of Glasgow Cathedral until around 1560, when the last Catholic archbishop fled to France. The castle was demolished in the 18th century to make way for the Glasgow Royal Infirmary. It is thought to have been built in the 12th century and was once taken back from the English by William Wallace in 1297. When architects examined the site in the 1980s they found that the

layout of the castle was a low mound within a ditch, something common in castles built at the time. The site appeared to be 180ft wide and 300ft long with a large tower in the middle and a drawbridge on the northern side. The architects also discovered the remains of a corner tower and surrounding wall. One piece of stone had a mason's mark and another has a dog's paw print, so we do know that the 12th century residents had a four-legged friend. In the 15th century a large corner tower was added by Archbishop Beaton and a round-towered gatehouse added by Archbishop Dunbar. It was known as Bishop's Palace then as it was used as the Bishop's residence. The castle came into play in political battles of the 16th century, including the fight between supporters of Mary Queen of Scots and her enemies. It was occupied by French soldiers some time between 1513 and 1570. By the 17th century the castle had fallen into disrepair and was gradually dismantled for its stone, and then in 1789 it was demolished to make way for the new Glasgow Royal Infirmary. Today an original stone from the castle with a modern plaque is on display in Cathedral Square, marking its old location.

Also no longer with us is Cathcart Castle, which once stood on the Southside of what is now Linn Park. It was built in the 15th century for the Earl of Cathcart but an earlier fort on the site was home to clan chief Alan de Cathcart, a big supporter of William Wallace and Robert the Bruce. In 1927, Glasgow Corporation bought the castle ruins and, unfortunately, any planned restorations never happened. It was deemed dangerous and was demolished in 1980.

Partick Castle was once a country retreat for the Bishops of Glasgow. At the time, Partick was a rural village outside the city, but it merged with Glasgow in 1912. Built in the 12th century, it is believed that the kings of Strathclyde used the site all the way back in the 9th century. The castle is still represented in the old Partick Burgh coat of arms. The bishops used the castle as a

residence until 1560 and the castle is thought to have sat on the west bank of the Kelvin near the Clyde.

A second Partick Castle was built in 1611 by George Hutcheson, a wealthy merchant, but it was abandoned by 1770 and fell into ruin soon after. Both Partick Castles have now been demolished with the site of both now being used to house blocks of student flats. In 2015, before the flats were built, experts from Guard Archaeology were hired by Scottish Water to see what they could find. They discovered some pottery, metalwork, leather and animal bones, along with the foundations of both castles. Today Partick is known for its museums, shops and Partick Thistle Football Club, and few will realise that it used to be home to not one but two castles.

As sad as it is that these castles no longer exist, Glasgow is home to many more towers nestled in pockets around the city.

Something that's a bit more 'Glasgow' is Johnstone Castle, which sits in the middle of a housing estate in Renfrewshire. Building a housing estate around a 16th century castle might not go down too well with the Edinburgh crowd, but for Glaswegians it was apparently no big deal.

The castle was originally called the Easter Cochrane tower until George Houston of Johnstone acquired it for his residence and renamed it Johnstone Castle. He took the name from his other tower in the nearby Milliken Estate; this was the original Johnstone Castle. The Milliken tower still stands today and is so tall and fairy tale-like that I doubt anyone would be surprised if they saw long golden hair cascading from the window waiting to be climbed.

But back to the housing estate. The castle is only a fraction of the sprawling mansion that it once was. The more modern additions have been removed and now only the 16th century tower house remains. Polish composer Frédéric Chopin stayed in the tower before performing in Glasgow's Merchant Hall. In the Second World War it housed prisoners.

But what's most interesting about it is that it is now privately owned. The castle was advertised for sale in 2014 for £450,000 – less than the price of a studio apartment in London or a modest flat in some parts of Edinburgh. We've all heard of keeping up with the Joneses, but living in a four-bedroom castle complete with library and great hall in the middle of a housing estate may be taking the concept a bit far.

The castle and surrounding land had fallen into disuse and was acquired by Johnstone Burgh in 1956. The housing estate surrounding the tower was created to provide much-needed homes for residents of Glasgow after homes were destroyed during the war. The 7th Laird of Johnstone ensured that the tower was preserved and the 8th Laird of Johnstone spent the next fourteen years renovating it and turning it into a stunning family home.

Far away from the inner-city housing estates, in South Lanarkshire lies Bothwell castle – a huge ruined structure and courtyard dating back to the 13th century. The castle was torn down many times – once on the instructions of none other than Robert the Bruce. The medieval castle was constructed by Walter of Moray in the late 1200s but constant invasion and repeated siege – most likely on the outbreak of the Wars of Independence in 1296 – meant that the original design of the castle never came to fruition. It was eventually completed by the Earls of Douglas around 1400. It was also briefly owned by William de Crichton – who owned Crichton Castle in Midlothian – after he murdered the 6th Earl of Douglas in what is now called the 'Black Dinner' at Edinburgh Castle. After the murder, de Crichton obtained the property of Bothwell Castle for himself. Douglas supporter John of Corstorphine stormed and damaged the castle in retaliation but de Crichton reconstructed and extended it.

The ruins are spectacular, especially the remains of the huge circular donjon, which is a tower for residents to use in the event of a siege. This would normally contain a well, quarters,

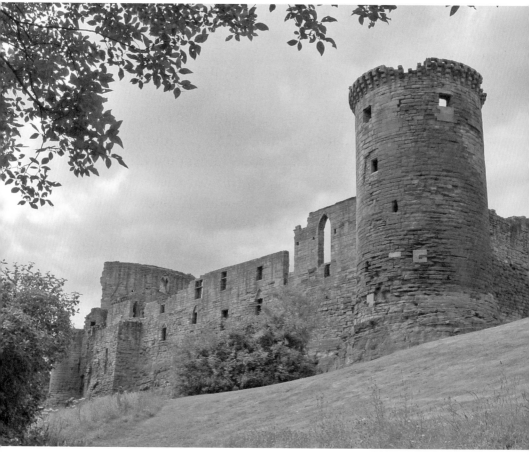

Bothwell Castle is a huge medieval castle above the River Clyde.

offices, and service rooms. The donjon is in the west end of the castle and comes complete with its own moat.

In the east end, visitors can wander round the remains of the great hall and the south-east tower. Behind the great hall was the north-east tower, which was built to replace the siege-damaged donjon and was taller than the remaining south-east tower. However, the base is the only part still standing.

During construction, Edward I invaded Scotland and captured Bothwell Castle while it was still only a donjon and prison tower connected by a curtain wall. The Scots besieged the English garrison in the castle for fourteen months in 1298-9 and

in 1301. Edward I came again to Bothwell bringing an army of 6,800 men and a siege tower, which was used by attackers to get men over the walls.

The English surrendered the castle to the people of Scotland after the Battle of Bannockburn in 1314 but took it again in October 1336 and it became the headquarters of King Edward III when he invaded Scotland. Finally, in 1337 Sir Andrew Murray (no, not that one) of Bothwell decided he wanted his ancestral home back and led an army to recapture the castle. They were successful but destroyed the western side of the donjon in the process, leaving us with how it looks today.

An excellent spot to enjoy sweeping views over the south-east of Glasgow is Crookston Castle. It's the only surviving medieval castle in the City of Glasgow and was built by the Stewarts of Darnley around 1400. It's considered unusual as it sits in the earthworks of an earlier version built in the 1100s. The first incarnation was built by Sir Robert de Croc, an Anglo-Norman knight who gave Crookston its name.

The tower was used to keep watch during the Clydebank Blitz in the Second World War. As it's on a hill, the views from the top can be breathtaking if you're brave enough to climb the narrow metal ladder. It's made up of one central high tower with four square corner towers surrounding it, and the north-east tower is completely intact.

Crookston is another that's hidden away in a housing estate in the Southside and is known as Glasgow's last true castle. At least it isn't used as a residence for the neighbours to be jealous of. Although they might have more to worry about as there have been reports that Crookston Castle is haunted. An unofficial paranormal investigation took place at the castle in 2008 and claimed to make contact with a ghost. Talk about neighbours from hell.

Haggs Castle in Pollockshields was once home to Glasgow's Museum of Childhood but was sold as a private home in 1998

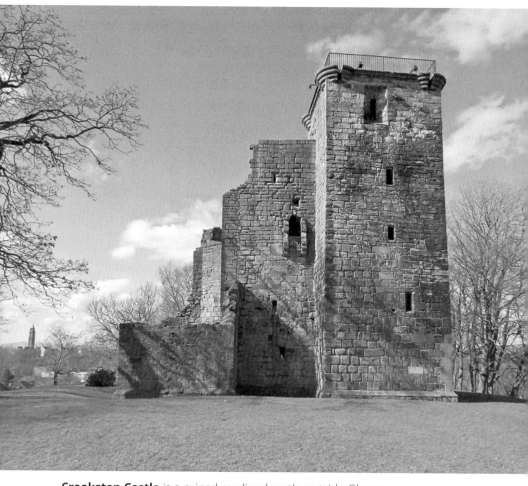

Crookston Castle is a ruined medieval castle outside Glasgow.

when the museum closed. The castle was built in 1585 by Sir John Maxwell of Pollock as the family's main residence and was named after the haggs (like bogs) that were nearby.

A few miles outside Glasgow in the original capital of the Kingdom of Strathclyde lie the remains of Dumbarton Castle. The medieval fortress sat on top of Dumbarton Rock, a volcanic mound thought to have been created 334 million years ago and which looks out over the banks of the River Clyde. It was once an important royal castle, home to David II and his wife Joan of the Tower after the Scottish defeat at Halidon Hill in 1333.

The castle has the longest history of any stronghold in Scotland. Looking at photos from 1800, the castle was an impressive one, with its silhouette dominating the town's skyline. Mary Queen of Scots lived there for six months before fleeing to the safety of France in July 1548. Today, much of this once imposing structure has disappeared. Although the castle is no more, visitors can still climb the 557 steps up Dumbarton Rock to see what remains and take in the beautiful views of the Clyde. As the castle once sat in the capital of the ancient Kingdom of Strathclyde, its name comes from Dun Breatann which means fortress of the Britons.

Lying not far away, between Renton and Dumbarton on the north side of the Clyde, and still very much intact, is Dalmoak Castle. The land it was built on is thought to have once been owned by Robert the Bruce and the estate holds the remains of the Palace of Cardross, where King Robert the Bruce died.

The remains of Dumbarton Castle sits on a Dumbarton Rock.

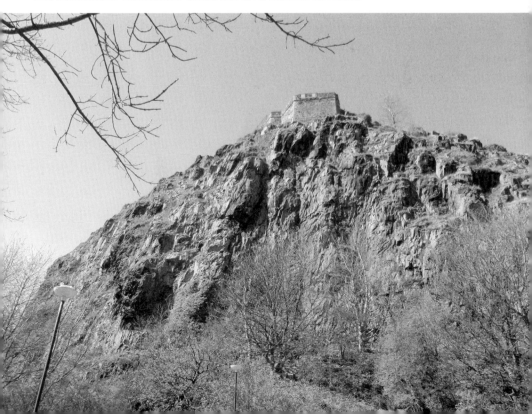

It was built around 1866 for John Aiken of Glasgow in Scottish baronial style on foundations from an earlier structure. It is thought there has been a castle on the land since medieval times.

It was once used as a royal manor as well as a hunting seat. In 2016, the 14-bedroom castle was put up for sale for £1.7 million, but this price was slashed in 2019 to £675,000. The company which purchased it is currently seeking planning approval to turn it into a venue for events, functions and holiday lets so castle buffs like myself may yet get a peek inside.

From a 14-bedroom mansion to another ruined castle is Craignethan Castle in South Lanarkshire. It sits above the River Nethan and was built in the early 16th century as a defence fort. It was constructed by James Hamilton of Finnart and is thought to be the inspiration for Sir Walter Scott's Tillietudlem in the 1816 novel *Old Mortality*. Sir Walter visited the castle in 1799 and stated in the revised magnum edition of 1830 that although the castle of Tillietudlem is fictional, the ruins of Criagnethan has something of the character of the description of the text. The castle today is a great one to explore and offers good access to tiny staircases and cellars. It is owned by Historic Environment Scotland.

Another HES property in the region is Newark Castle in Port Glasgow. It was built in 1478 by George Maxwell (it's a good name). It originally had a tower house within a walled enclosure and probably a hall and weaponry buildings. In the late 16th century Sir Patrick Maxwell inherited the castle. A powerful friend of King James VI of Scotland, Maxwell was notorious for the murder of two rival family members and beating his wife, who left him after bearing him sixteen children. This is one man I hope I have no family connection to. Sir Patrick expanded the building and created a three-storey Renaissance mansion. The last Maxwell died in 1694 and the castle had a few owners who didn't actually live there until it came into state care in 1909. It is now a popular visitor attraction.

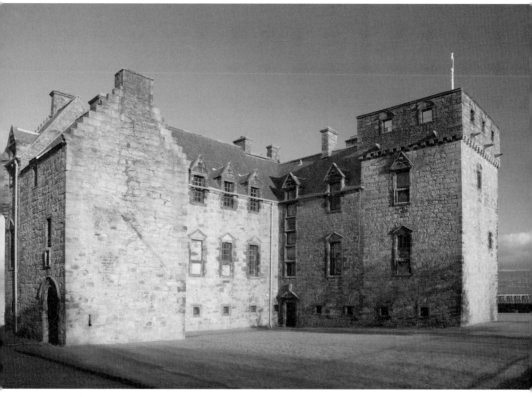

Stunning views of the Firth of Clyde can be seen from Newark Castle in Port Glasgow.

Another attraction nearby that's popular with families is Chatelherault Park and Cadzow Castle in Hamilton. Known as the hidden castle in the woods, it sounds like something from *The Blair Witch Project*. Now in ruins, the castle was another built by the powerful Hamilton family above their chief seat in the valley, Hamilton Palace, between 1475 and 1550. It is no accident the castle is hidden: it was to be used as a last resort for the family. The unusual name of Cadzow comes from the original name of the estate and parish of Hamilton.

Mugdock Country Park is around ten miles outside Glasgow next to Milngavie (part of it is actually in Stirlingshire so I had a bit of a debate over which chapter to put it in – Glasgow won in the end). The castle within the park is also called Mugdock

Cadzow Castle is now in ruins and only the exterior can be seen.

and sits in ruins. Built by the Graham family, it dates to the 14th century. Like many castles in Scotland, it's been the star of a TV show, but this time not *Game of Thrones*. The castle was used as a location shot for a 1960/70s TV show starring Sir Michael Gambon. That's right, Dumbledore himself walked the halls of Mugdock when filming *The Borderers*.

Another castle on the grounds is Craigend Castle. The lands where the castle sits was owned by the Barony of Mugdock in medieval times but was sold in the 17th century to the Smith family. The castle started as a modest house but was extended to become the Gothic Style castle we see today. A strange fact about Craigend Estate is that is used to house a miniature zoo in 1949. The zoo was home to an elephant, lions, monkeys and crocodiles but closed in 1954 due to low visitor numbers. The

grounds eventually became part of the Mugdock Country Park and the castle is now in ruins.

Strathaven, to the south of Glasgow in South Lanarkshire, also has a ruined castle. The 16th century Strathaven Castle was built on a rocky mound in the centre of the village. There isn't much left of this one except a single tall wall and round tower from the larger tower house and a few more sections of wall. Although the castle dates to the 16th century, it was built on the site of a much earlier castle. It changed hands on a number of occasions over the years before it was finally abandoned in 1717. Like any good castle, this one comes with a good ghost story. For hundreds of years, people have reported sightings of a 'woman in white' roaming the castle and its grounds. Legend has it that the wife of a laird was walled up by her husband and left to starve to death. The ghost of the woman is the one seen. Many locals dismissed this story for years until, in the 19th century, part of the wall fell down to reveal human bones inside. The castle wasn't open to the public at the time of writing. This might be due to safety concerns as there have been recent reports of locals climbing to the top of the tower and taking selfies, something that wasn't a problem in the 20th century, let alone the 19th.

The Kingdom of Fife

Fife is home to around 167 castles. When you consider the fact that Glasgow and its surrounding areas has fewer than 20, is does seem that 'the Kingdom' has more than its fair share. With so many to choose from, it was difficult to decide which one to visit first. For this chapter, I turned to trusty TripAdvisor to find out what the public considered to be the top ten.

I always enjoy driving over the spectacular Queensferry Crossing to explore Fife and, as it's less than an hour from Edinburgh, it's something I plan to do more often. Over the years we've enjoyed many family holidays in the East Neuk, staying in beautiful villages such as Elie, St Monans and Pittenweem. It really is a gorgeous part of the country.

St Andrews Castle was no.1 and it's easy to see why. It's one of the most interesting structures I've come across and is a delight to explore. Sitting in ruins on a rocky peninsula overlooking Castle Sands beach and the North Sea, the castle is one of St Andrews' most visited attractions. There has been a castle on the site since 1189 – a time that predates even Jack Nicklaus's first visit to the famous golf capital – and was always used as a residence for the wealthy and powerful bishops. It was a fun place for me to test my burgeoning Instagram skills and create a reel walking down the steps to the beach with the castle by my side. It got a whopping 36 likes!

Once known as 'Kilrymont' which means 'church on the head of the King's mount', one of the best things to explore in the ruins are the fascinating siege tunnels. A major siege took place in the 1540s and evidence of this can still be seen today.

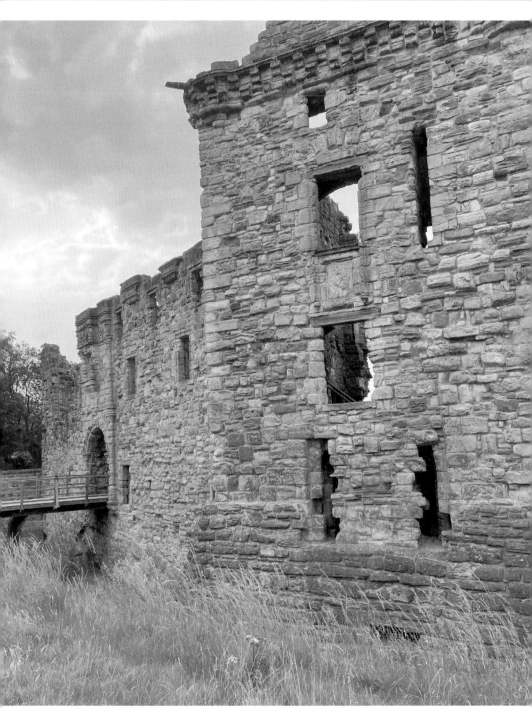

St Andrews Castle overlooks a small beach and once housed the burgh's wealthy and powerful bishops.

Rebels against the Catholic church in Scotland, including John Knox, the future founder of the Presbyterian Church of Scotland, planned to overthrow the Church by attacking the Archbishop of St Andrews and head of the Catholic Church, Cardinal David Beaton. The cardinal was a prime target as he had previously sentenced rebels to be burnt at the stake and was well known for his corruption. In May 1546, protestant conspirators disguised themselves as stonemasons and entered the castle where he stayed. They killed the cardinal and hanged his body outside the window before locking themselves in, awaiting a response from the Earl of Arran who was regent of Scotland on behalf of Mary Queen of Scots.

Arran planned the siege to take back the castle from the conspirators – his own son had been at the castle at the time of the cardinal's murder and was taken hostage. Many weapons were fired for two days but the conspirators stayed put, so Arran decided to dig tunnels beneath the castle. These 16th century tunnels remain today along with the counter mines dug to foil the attempts.

Eighteen months later and the rebels were still occupying the castle, but they finally surrendered to a French naval force after artillery bombardment. The garrison were all taken to France and used as galley slaves.

The story is fascinating, and non-claustrophobic visitors today can visit the creepy tunnels. The mines have mostly low-slated ceilings and, although lit, are still dark and damp.

Some say the tunnels are haunted by the ghost of Cardinal David Beaton. I'm thankful to say I didn't come across him. On the day we visited, during a mini break to the fishing village of Crail, the sun was shining and glistening on the water below. It was hard to imagine such a dark past and bloody past.

When visiting St Andrews, you can stay in a castle just fifteen minutes outside the town. Dating back to the 12th century, Dairsie Castle once housed secret Scottish parliaments, survived sieges,

and was a sanctuary for James VI in 1583 when he escaped from the Raid of Ruthven. It was mainly used as a residence for the local archbishops of St Andrews, and it fell into run in the 19th century.

Archbishop of St Andrews John Spottiswoode bought the castle in the 17th century and he built the Dairsie Old Church next door. It fell into ruin in the 19th century but was brought back to life in the 1990s as a family home and now serves as a unique self-catered property. It has been beautifully restored to the original medieval character and guests can admire the interesting artwork and sculptures which tell the story of the castle. With six bedrooms, a great hall, open gallery space and six acres of grounds, it's not your standard flat or room to rent for a break away. As much as I love castles, the thought of sleeping in one can be a little unnerving. With all the sieges and slaughters that have taken place, I wouldn't be surprised to find a disgruntled spirit or two roaming the halls.

Another castle on the top ten list, according to TripAdvisor, is Ravenscraig in Kirkcaldy.

Reading the reviews, many locals reminisce about playing and exploring the building as children but many areas are no longer accessible. People visit today for the fantastic views over Pathhead Beach and the Firth of Forth. The castle was originally built as a residence for Queen Mary of Gueldres in 1460. However, the Queen died just three years later and the castle was given to the Sinclair family who completed the construction. Because of its exceptionally thick walls, it is considered to be the first in Scotland to withstand cannon fire – even that of Mons Meg. In the 1650-51 invasion of Scotland by Oliver Cromwell and his English forces, the thick walls were put to the test, as Ravenscraig was attacked and damaged. In 1929 the castle and most of the surrounding estate was given to Kirkcaldy to use as a public park and has been owned by Historic Environment Scotland since 1971. This explains how some children would

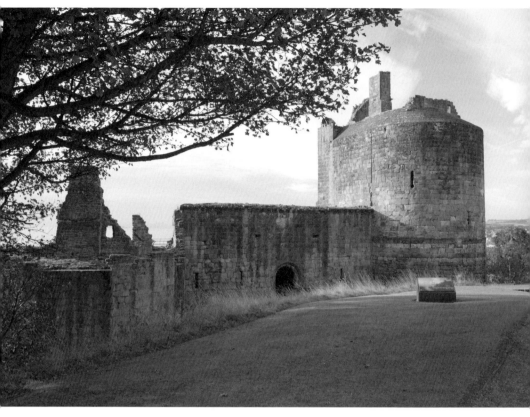

Ravenscraig Castle in Kirkcaldy dates back to around 1460.

have had the run of the place in the 1950s and 60s. The estate has a large playpark and plenty of woodland walks and so it's still a good place for families to explore.

Another castle which provides a day out for the family is Lochore Castle, by Lochore Meadows Park. The ruined structure sits at one of the entrances to the park. I say 'one of' because, on our first visit, we chose the wrong one and faced a 40-minute trudge around the loch in the scorching heat before we reached our destination. The main entrance, which takes you straight to the loch-side activities and is where the castle is located, is near the town of Crosshill, and is definitely the one to shoot for. The other, much smaller, entrance is just past the town of Kelty. We were at first baffled by the tiny car park when my SatNav

took us to the Kelty entrance, but assumed the castle and park wouldn't be far away so set off on foot. With me being heavily pregnant and with a walking-averse 5-year-old in tow, the trip seemed to take hours. When we finally (finally) arrived, we realised our mistake, and after a day of exploring and playing we ordered a taxi to take us back around the loch and to our parked car. It was probably the best £14 I've ever spent.

The castle itself is a ruined 14th century tower house and sits on a mound that used to be an island in what used to be Loch Ore or Inchgall Loch, so it is sometimes known as Inchgall Castle. The loch was drained at the end of the 18th century.

It's probably one of the earliest castles in Scotland and was built in the motte-and-bailey style which would usually be a wooden or stone tower on a raised area of ground called the motte along with a walled courtyard and protective ditch. A community dig took place in 2015 and discovered that the site is the first crannog – a man-made island – in Fife. Visiting today, there are still many nooks and crannies to explore.

Over to the East Neuk of Fife lies Kellie Castle near Pittenweem, which is another on the top-ten list. It's easy to see why it's popular. Its history spans almost seven centuries. It started off as a tower house in the 1360s and was extended massively over the next 300 years. It was once home to Robert the Bruce's daughter.

The castle was saved from its abandoned state in the late 19th century when the Lorimer family, who were artists, sculptors, and architects, bought it and restored it to its former glory.

The castle is open to the public and visitors can see how lovingly it has been restored. The different rooms show the various eras of the building and the walled gardens are beautiful.

Another dramatic structure in the East Neuk, just west of St Monans, is Newark Castle, which sits overlooking the North

Sea. A building on the site is thought to have existed since the 13th century where Scottish King Alexander III spent some of his childhood. However, the ruined building that stands today was built in the 15th century by the Kinloch family before being passed to David Leslie, otherwise known as Lord Newark, a prominent figure in the English and Scottish Civil Wars. The castle has been known by other names over the years including Inverie, St Monans and St Monance. It was used as a residence until the 19th century and has since been left to ruin. Its silhouette against the North Sea is still an impressive sight.

The name Ardross Castle can cause confusion. A huge, grand baronial style castle in the Scottish Highlands bears the same name as the much smaller 14th century ruin in Elie. This smaller namesake was built by the Dishington Family and then sold to Sir William Scott of Elie in 1607. The ruin sits on sandstone cliffs overlooking the Firth of Forth.

Aberdour Castle is number five on the TripAdvisor list and *Outlander* fans will recognise it as the setting of the monastery in season one. It is fantastically well preserved inside and, even in the ruined areas, you can clearly see what the rooms were used for and the different levels of the building. There are also lovely walled gardens and even a bowling green.

One of the more chilling stories I read about Aberdour before our visit concerned moving furniture in the great hall, and I'm not talking about Pickfords. The stables are one of the first places you enter when visiting the castle and it was there, some years ago, that a group of stonemasons were gathered in the early hours waiting for the custodian to arrive to let them into the rooms that needed work. They all heard furniture being dragged in the hall above them and wondered if they should phone the police as the castle was locked up. In the end they decided to wait for the custodian to arrive, and when she did they all ventured upstairs to unlock the doors. They were shocked to find that every item of furniture in the room had

been dragged to the middle of the floor. The furniture in the room is replica medieval and incredibly heavy, requiring more than one person to move it. This story is too much like the film *Poltergeist* for my liking so I was quite wary going into this room, but thankfully on our visit the furniture stayed where it was. This story has been shared a great deal and has even been investigated by the Scottish Paranormal team.

Parts of the castle date back to 1200 and it started life as a small hall house. Over the next 400 years it underwent considerable expansion, and the architecture changed to suit the eras. The old hall house became a tower house in the 15th century, and this was twice extended in the 16th century. Added in around 1635, the gardens surrounding the castle are among the oldest in the country and offer stunning views over the Firth of Forth and Edinburgh.

The castle as it stands today was constructed mainly by the Douglas Earls of Morton, who held Aberdour from the

Parts of Aberdour Castle, in Easter Aberdour, date from around 1200.

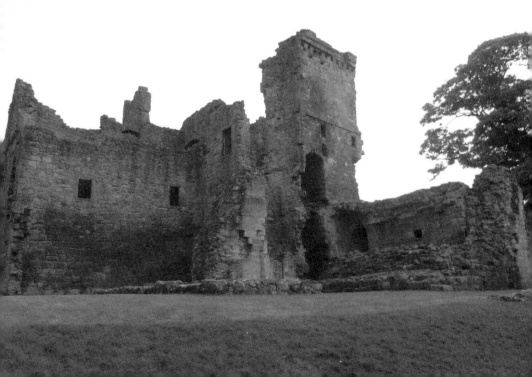

14th century and used it as a second home until they purchased the nearby Aberdour House in 1725 and the castle was left to ruin. The castle is now mainly in ruins, apart from the restored East Range. It is owned by Historic Environment Scotland and is a fun place to explore. It's also been seen on screen as the Benedictine monastery Abbey of Sainte Anne de Beaupré from the television show *Outlander*. It is here where Jamie recovers from his injuries inflicted by 'Black Jack' Randall.

If ghosts and poltergeists don't faze you, then there are plenty of castles to stay in all over Scotland. In Fife, one of the most popular is Fernie Castle, near St Andrews in Cupar. The 480-year-old building once belonged to the Earl of Fife, Duncan the 13th. Today it has been converted into a comfortable hotel sitting within seventeen acres of woodland. In terms of hauntings, the castle has had reports of a 'Green Lady' who is thought to have jumped to her death from the high tower many centuries ago. Guests have complained about lights flickering and televisions switching off whenever she's around. Although, if you happen to be watching *Love Island*, you can hardly blame her.

Another ruined tower house that's high on the list is Creich Castle. Located on the outskirts of Creich, it can be found opposite Creich Farm. It's an L-shaped tower thought to have been built in the 16th century, although there is believed to have been a castle on the site since the 13th century. It's around four storeys tall and thought to have been constructed to provide defence against Viking raiders who would attack rich farms. There are remains of a small round tower nearby. This is likely to have been a courtyard as well as the doocot, which is category A listed and dates to 1723.

Right beside Creich is the lesser known, ivy covered, Mountquhanie Castle. Many visitors stumble across it when exploring Creich. The castle was originally a three-storey 16th century fortified house that was left to ruin on purpose when

the owners, the Wedderburn family, built the Mountquhanie mansion house in 1830.

Seafield Tower is an interesting one. This 16th century L-shaped tower is right on the Fife coastal path and was built by the Multrare family, whose main seat was in Edinburgh but, at the time, it was wise to hold another castle across the Firth of Forth since Edinburgh was so often attacked. Today it creates an extremely picturesque silhouette against the sea, but has seen better days. As the castle is made from red sandstone, which is notoriously vulnerable to the elements, it may not last much longer with its constant battering by storms and the sea.

MacDuff's Castle in Kirkcaldy is a ruined structure associated with the MacDuff Earls of Fife. Many will know that Lord Macduff was the Thane of Fife in Shakespeare's *Macbeth* and the one who eventually kills the eponymous character in the final act. In 'The Scottish Play', he has a castle and although it would be nice to think that this castle was built by the real Macduff, no one knows for sure, though a castle is thought to have been built on the site by the MacDuff Earls of Fife in the 11th century around the time of King Macbeth of Scotland. The castle as we know it now was built in the 14th century by the Wemyss family who were descendants of MacDuffs. Sir Michael Wemyss joined forces with Robert the Bruce and ordered the castle to be destroyed. It eventually found its way back to the Wemyss family in 1637.

Today, like many castles and structures on the Fife coastal path, it is in a ruined state, but visitors can still explore. There are around eighty steps that lead up to the ruins. It's supposedly haunted by a 'Grey Lady' who was found guilty of theft and left to die in the castle. Luckily we didn't meet her on our trip, but I could see how exploring would be spooky at night. The castle also stands above the famous Wemyss Caves, which I definitely wouldn't want to explore after dark. These ancient sea caves hold Britain's biggest collection of Pictish rock carvings. The

caves were featured on an episode of *Time Team* in 2005 and excavations found evidence of prehistoric, Middle Iron Age, Pictish, Medieval and post-Medieval activity.

Another castle once owned by the MacDuffs is Dunimarle in Culross (pronounced coo-riss). The castle sits above the Firth of Forth and was originally built to take advantage of the defensive, coastal site by the MacDuffs. In the 18th century, a mansion house called Castlehill was built further east, and the Blaw family owned the estate from the 16th century until 1830. The castle merged and expanded to become a grand home for Magdalene Sharpe Erskine, who was sister and heir of a local nobleman, Sir John Drummond Erskine of Torrie.

Today, the castle is a popular venue for weddings. St Serf's Chapel, built in 1870, is within the grounds and still has many of the original features.

Another wedding venue just east of Glenrothes is Balgonie Castle, which dates to the 14th century, although most of the remaining structures are from the 18th. Parts of this castle are currently in ruins, although the tower is home to the Laird of Balgonie & Edergoll. At the time of writing, the castle is not open to the public, although the Laird and his wife have been known to give private tours and allow some couples to be married there. *Outlander* fans will know it from season one as MacRannoch's home, where Dougal and the MacKenzies rest before their raid of Wentworth Prison. The castle is also said to have served as an inspiration for the Red Wedding Scene in *Game of Thrones*.

Rosyth Castle sits on the perimeter of Rosyth Naval Dockyard and wouldn't look out of place on *Games of Thrones* either. It once sat on a small island in the Firth of Forth and was only accessible at low tide. Built around 1450, it was created for the Baron of Rosyth, Sir David Stewart. Like many castles built around that time, it was extended and enlarged in the 16th and early 17th centuries and remained in the Stewart family until the late 17th century. It was attacked in 1572 by men from Blackness

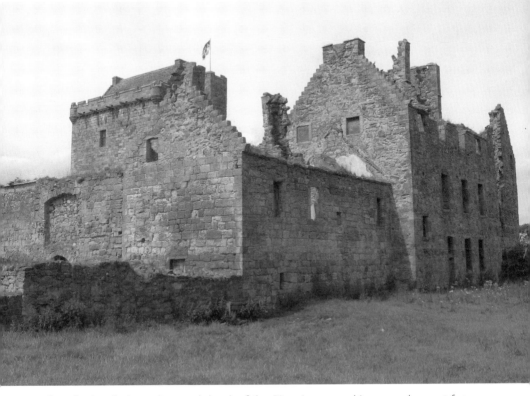

Balgonie Castle is on the south bank of the River Leven and is a popular spot for weddings.

Castle and occupied in 1651 by Oliver Cromwell's army after the Battle of Inverkeithing. From the 18th century onwards it was abandoned and much of the stone was used elsewhere. The island it sat on eventually became part of the land and the castle was essentially marooned within the dockyard. Nevertheless, it is very well preserved.

Ballinbreich Castle is another ruined structure overlooking the Firth of Tay. It was built in the 14th century by the Leslie Clan and has been rebuilt many times. In 1563 and again in 1565 it played host to Mary Queen of Scots and is now a scheduled monument.

With so many interesting towers and castles in the Kingdom, it's impossible to visit them all in one trip, but it's definitely

worth noting another that is thought to have been visited by Mary Queen of Scots. Collairnie Castle is in Dunbog and was owned by the Barclay family until 1789. It's unclear when the original structure was created but it was extended in the 16th century with the tower now forming part of a 19th century farmsteading. It is protected as a scheduled monument. The famous queen is thought to have stayed for two nights on her way to St Andrews in 1564.

Another of note is Couston Castle, an L-shaped tower house at the edge of Otterston Loch near Dalgety Bay. Like many others, this castle was built on the site of another in the late 16th century. The original castle was built on Robert de London's land in 1199. De London was the illegitimate son of King William the Lion. By the 16th century, King James V gave the castle to James Logan of Couston and it was remodelled to look similar to how it does today. It continued to expand, and the north wing is thought to date to the 18th century. Parts of the castle were destroyed for stones to use in farm buildings in the 1830s, and in 1980 a Dunfermline business bought it and turned it into a family home with the help of architect Ian Begg. In 2004 the castle was up for sale for £1.2 million. I shudder to think of the price over fifteen years later.

Stirling and Loch Lomond

Like Edinburgh, the city of Stirling boasts a towering fortress that dominates the skyline. And, just like the capital, you've got to have plenty of air in your lungs to make it to the top.

Sitting on the appropriately named Castle Hill, it's surrounded on three sides by steep cliffs which, at one time, gave it an excellent defensive position. The main buildings of the castle date back to the 15th and 16th centuries, although a few structures remain from the 14th.

The castle is located next to the old town jail and, if you manage the climb, the views are impressive. From here you can see the whole city, as well as across to the Ochil Hills. It also affords a terrific view of that other magnificent Stirling landmark, the Wallace Monument.

As one of the largest and most important castles in Scotland, Stirling was used as a royal residence as well as a fortress. Many

Stirling Castle was once a favoured residence of the Stewart kings and queens who would hold grand celebrations there.

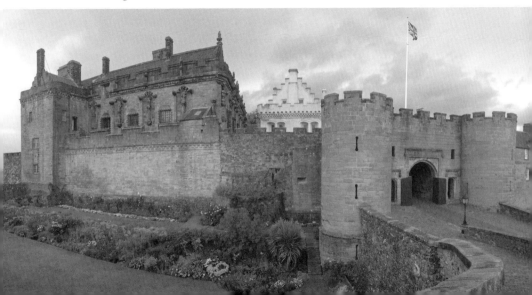

Scottish kings and queens were crowned there, including a very young Mary Stuart who become the Queen of Scots in 1542 in the Chapel Royal. Bonnie Prince Charlie tried and failed to take the castle in 1746 in the last of the eight sieges, some of which took place during the Wars of Scottish Independence.

Like Edinburgh, Stirling Castle was once home to an animal more usually found in a zoo. The story goes that James V kept his pet, a fully grown lion, within the castle's courtyard which is now known as the lion's den. The symbol of the King of Scots was the King of the Jungle and James V kept one as a pet within the castle walls.

Perhaps even more unexpected than learning the castle was home to a lion was the fact that the world's oldest football was found there. In 1981, during some mundane maintenance work, the ball was discovered stuck in the rafters of the Queen's Chamber. It was gifted to the Stirling Smith Art Gallery and Museum.

It looks as if the ball was kicked high at some point in the 1540s and got lodged in the rafters during James V's reconstruction of the castle between 1537 and 1542. As it was made of a pig's bladder, it was robust enough to survive through the centuries – and was obviously not used as a plaything for the pet lion. As the oldest football in the world, it predates even the career of Cristiano Ronaldo.

Another bizarre thing that happened there was that John Damian – or Giovanni Damiano de Falcucci – an Italian at the court of James IV, once attempted to fly from the walls with feathered wings. He crashed landed into the dunghill below, and survived.

My most vivid memory of Stirling Castle is when I worked as an intern at the Scottish Fashion Awards in my early 20s. The awards themselves were held in this spectacular setting, and seeing half-naked models run around backstage among the towers and turrets was quite surreal. The imposing fortification

made for a fantastic backdrop to what was on show on the catwalk.

Some ladies I'm glad did not appear that night were some of the many colourful ghosts of Stirling Castle. There have been reports of a 'White', 'Black, 'Green' and even a 'Pink' lady haunting within its walls. The most reported seems to be the 'Green' lady, who has reportedly been seen gliding down steps in the old military base. The woman was apparently a superstitious servant of Mary Queen of Scots who was convinced that a fire would break out in the Queen's room on 13 September 1561. She vowed to stay awake to protect her but in doing so accidentally knocked a candle onto the Queen's bedcurtains, setting them on fire, thereby fulfilling her own prophesy of an inferno. She died in the blaze but the Queen survived. The castle is also thought to be haunted by a traditionally dressed Highlander who has been mistaken as a tour guide.

As well as playing host to various ghosts and modern-day fashion shows, Stirling Castle has also been a star of the silver screen. In 1960 it was used in the gritty Alec Guinness drama *Tunes of Glory*, as well as in Delbert Mann's *Kidnapped* in 1971 and *To End All Wars* with David Cunningham in 2001.

Film fans will also recognise nearby Doune Castle. It is known by comedy fans around the world as Camelot, 'a silly place' where the knights of the round table sing about eating ham and jam and spam a lot in the Great Hall. At the time of filming, the crew of *Monty Python and the Holy Grail* (1975) tried to squeeze as much production value out of the location as possible, as filming permission was withdrawn from the National Trust leaving them no time to find new locations. Instead, the crew relied on different rooms and features of Doune Castle to give the illusion of many different places so they could keep on filming.

Despite being a big Python fan myself, it wasn't until I was in my 30s that I realised that one of my favourite films was shot

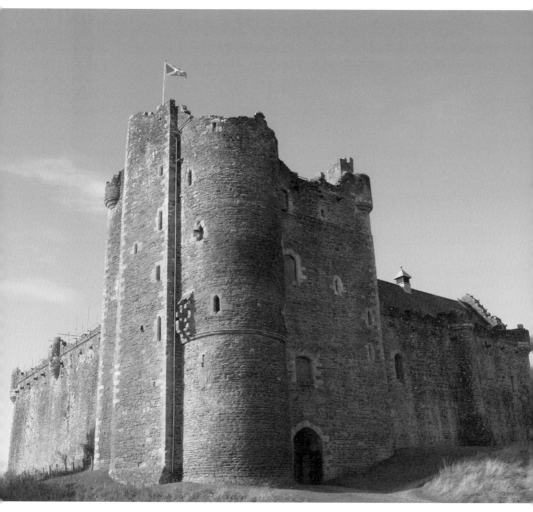

Doune Castle is known to comedy fans as Camelot from the 1975 film Monty Python and the Holy Grail.

only an hour or so from where I lived. The castle also plays host to the annual Monty Python Day. I'm thinking about dusting off the old chainmail for the next time it's held.

Around eight miles north-west of Stirling, Doune sits on a wooded bend where the Ardoch Burn flows into the River Teith. It is thought to have been constructed in the 13th century originally but was badly damaged in the Scottish Wars of Independence. It was rebuilt in the 14th century and owned by

Robert Stewart, Duke of Albany, son of King Robert II. When Albany's son was executed, the castle was passed to the Crown and used as a royal hunting lodge and dower house – a house available for use by the widow of the previous owner of the estate. It then belonged to the Earls of Moray in the 16th century. It saw military action in the Wars of the Three Kingdoms, in Glencairn's rising of the 17th century, and in the Jacobite risings. By 1800 the castle was in ruins, but it was restored later in the century and is now owned and preserved by Historic Environment Scotland.

Doune was built as a typical royal castle with a courtyard and ranges of buildings on either side. There is a large tower house over the entrance which would contain the rooms of the lord and his family, and another tower which would accommodate the kitchen and guest rooms. These are linked by the great hall. Almost all the stonework dates from the late 14th century.

As well as the monarchy, Doune has also been frequented by more modern royalty. Dame Elizabeth Taylor filmed the British-American historical adventure film *Ivanhoe* here with her husband Robert Taylor in 1952. More recent TV shows such as *Game of Thrones* and *Outlander* have also used the site for filming.

Another castle in the area, also used as a location for *Outlander*, is the 15th century boat-shaped Blackness Castle neat Linlithgow. The site was used to represent Fort William, where hero Jamie was violently punished by Captain Randall in season one, and is known among fans as one of the most impressive locations of the show. Dubbed the 'ship that never sailed' due to its unique angular shape and the fact that it sits almost directly on the south shore of the Firth of Forth, in certain photographs it looks as if it is sailing out on the water.

The castle was built by Sir George Crichton, a member of one of the most important Scottish families at the time. It was

passed to James II of Scotland in 1453 and has been crown property ever since. It was once used as a state prison and held many religious rebels who opposed the king's interference with Church affairs, as well as the 6th Earl of Angus. Angus was the one who negotiated the marriage between Mary Queen of Scots and Edward VI. The following year, after a struggle between Angus and the regent Arran, Angus was captured and imprisoned in the castle.

In 1650, the castle was one of the most advanced artillery fortifications of its time, but this was not enough to stop Oliver Cromwell's army.

Barracks and officers' quarters were added in the 1870s, and the castle was used as an ammunition depot until 1912. Like Doune, it is now in the care of Historic Environment Scotland.

Blackness Castle's unique boat shape makes it look like it is about to set sail.

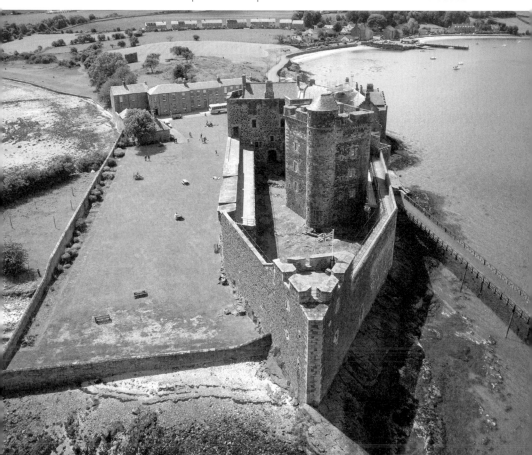

Considering its bloody history, it is no wonder that Blackness is home to a couple of spooks. In the late 1990s one visitor claimed to see a knight dressed in full armour in the central tower. Other reports from guests have included objects moving and being dragged across the floor above.

Also near Stirling is Menstrie Castle in Clackmannanshire. A three-storey manor house established in 1560, it was originally built for the Alexander family and is where the poet Sir William Alexander was born. Alexander became the Earl of Stirling in 1633 and was instrumental in founding the Canadian colony Nova Scotia. However, he failed to populate the territory and Nova Scotia was returned to its original 'owner', France.

The castle started life as a small L-plan tower house and was extended in the 17th century into a U-plan home. The castle was burned in 1645 in the English Civil War and was sold to James Holborne of Menstrie in 1648.

In 1719 it was bought by George Abercromby of Tulibody. His family kept the estate until 1924, although the castle had been abandoned long before that.

In 1957 it received a new lease of life when Scottish actor and presenter Moultrie Kelsall – who starred in 1950s hits such as *Last Holiday* and *The Battle of the Sexes* – began a campaign to restore it. The building was then converted into flats and a courtyard of new homes, although it retained the 16thcentury arch and kept the general look of the original castle and there are still some parts which are open to visitors.

Aside from its castle, the city of Stirling is famous for its higher education. Founded in 1967, the University of Stirling was the first new university to be established in Scotland in almost 400 years and the campus has been described as one of the most beautiful in the world. So beautiful, in fact, that a historic castle serves as the administrative centre. Airthrey Castle sits in the parkland campus and is an 18th century building with 19th century additions. The castle was designed in 1791 by

architect Robert Adam, who also transformed the surrounding estate by creating the loch at the centre of today's campus and added trees and plants. In the 19th and 20th centuries the castle and estate were further developed by the Abercrombie and Graham families with extensions added and a bridge built over the loch. The castle became a maternity hospital in 1939 and was bought by the council in 1946. It became part of the university when the campus was built, and the maternity hospital was still in operation until the late 60s. It's funny to think that past students may also have been born on site. The castle is magnificent and can be hired out for weddings – although it might be best to avoid getting hitched during freshers' week.

One more castle where you can study in Stirlingshire is Ballikinrain Castle, which is now an independent school. The castle was originally built in 1868 for politician Sir Archibald Orr-Ewing. The Scottish baronial-style building is now a non-denominational independent school run by the Church of Scotland's Crossreach – a social care agency for young people aged 6 to 16 who are experiencing social, emotional and behavioural difficulties.

There are also castles you can live in rather than study in in Stirlingshire. A 16th century tower house built on the southern shores of Loch Earn near Balquhidder, Edinample Castle, is now a private residence. The striking white building was built for 'black' Duncan Campbell, a vicious man who is thought to have thrown the architect off the roof on discovering that the castle was built without a parapet. And it seems that he's still not over it – the ghost of the architect is said to haunt the roof, where the parapet should have been. It was most likely built on top of a former castle on the land after the land was acquired by the Campbell family. It was extended in the 19th and 20th centuries before falling into a state of disrepair in the early 1970s. It's now fully refurbished and used as a private residence – let's hope the family don't have to deal with the scorned old architect.

Until recently there was a L-Plan tower house in Fintry that was used as a hotel, but unfortunately Culcreuch Castle stopped welcoming guests in 2020. It was built in 1296 by Maurice Galbraith to be used as the seat of Clan Galbraith. It was once owned by the son of John Napier, the 8th Laird of Merchiston, and remained in the Napier family for five generations. In 1654 the castle was used to garrison Oliver Cromwell's troops. In the 18th century it was owned by various families, the last being the Menzies. In 1984 it was bought by Arthur Haslam, who turned it into a popular hotel. The closure of the hotel was a blow to many couples who planned to marry there. The future of the castle remains unclear but I hope guests will have a chance to stay again.

Plane Tower is also known by another name, Cock-a-bendy Tower – a much better name in my opinion. The amusing moniker was derived from Thomas Menzies who lived at the tower in the early 20th century. The Menzies family were described as a bit eccentric, and Thomas, the most flamboyant of the lot, had the nickname 'cock-a-bendy' and the name has stuck to the castle ever since.

The castle was likely built in the 15th century by Lord Sommerville who owned the lands of Plane. The Barony of Plane was granted by King Robert to John D'Erth after his father was killed at the Battle of Bannockburn which resulted in the much more boring name, Plane Tower. I think I'll stick to calling it cock-a-bendy.

Dundaff, too, is known by another name. Sir John de Graham Castle, or simply Graham's Castle, is a ruined 12th century structure in the motte and bailey style. It served as the chief seat for the Barony of Dundaff. Sir John de Graham was a William Wallace supporter but was killed in the Battle of Falkirk in 1298 when Wallace was defeated by the English. There isn't much of this castle left today, but the perfectly square foundations can still be seen from above, along with the stairs that would have

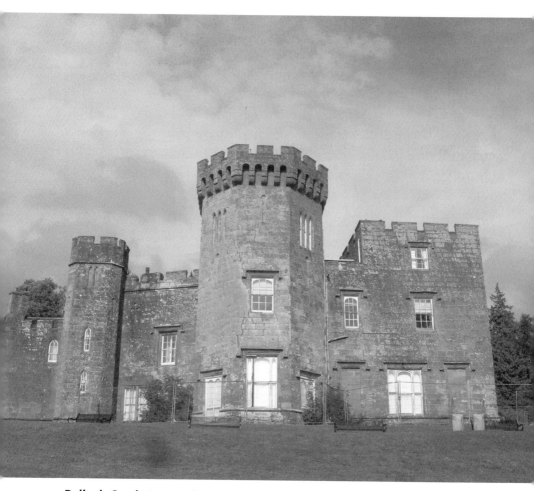

Balloch Castle is an early 19-century country house at the southern tip of Loch Lomond.

led to the entrance. The square shape of the moat was quite unusual for this time.

Over in Loch Lomond, Balloch Castle is a popular spot for families mainly because of the Country Park. Balloch Castle Country Park is one of the best public spaces in the West of Scotland, with views over Loch Lomond and its bonny, bonny banks. The park lies on the shores of the loch on the northern edge of Balloch and comprises 200 acres of woodland, gardens, play park and shoreline. There is a fairy trail to explore as well

as a secret garden. Balloch Castle Country Park is a popular venue for music events and has hosted some huge gigs over the years, with everyone from R.E.M. to the Bootleg Beatles having performed there – so take some time out to wonder at its walls.

The property of the Lennox family from the 11th century, the grounds and castle were developed by John Buchanan, a partner in the Glasgow Ship Bank, in the 19th century. Buchanan demolished the old ruins. It was built in the Tudor Gothic style by London-based architect Robert Lugar (1773-1855). The stately turrets and battlement architecture are decorative only. During refurbishment work in 2017, thieves stole £20,000 worth of lead from the roof. However, the refurbishments went on as planned and the castle was soon returned to its former glory.

Robert Lugar helped to develop the picturesque form of the castle house in Scotland. He was also responsible for building Tullichewan Castle in 1792, the first example of an asymmetrical Gothic house. The castle was located in the Vale of Leven near Loch Lomond. The grounds of Tullichewan were laid out by Alexander Naysmith, a landscape gardener and artist famous for his portrait of Robert Burns – Scotland's national bard. The castle, which has been demolished, was originally called Tulloch Eoghain, which translates to 'the hill of Eoghain'. It was owned by the Colquhoun family in the 17th century. The castle's final owner was J. Scott Anderson, who bought it around 1930. During the Second World War the castle and estate were requisitioned by the Royal Navy, which used it throughout the conflict. After the war, Anderson returned, but the upkeep proved too much and so he abandoned it. It was destroyed in 1954. Today there is a modern development on the site, but a fragment of the original tower and the former stables can be seen from the A82. Many locals remember the castle being demolished with explosives and still can't believe it's gone.

Buchanan Castle near the village of Drymen is a ruined country house built in the Scottish baronial style. It was built

for the 4th Duke of Montrose, James Graham, as a home for his family. The site had been in the possession of the Buchanan Clan since 1231 and there would have been an earlier castle on the site. The estate was sold to the Graham family in the late 17th century. The castle was abandoned after the Second World War but is still officially the seat of Clan Graham. Today it is a popular spot for would-be explorers – although strictly speaking they shouldn't. The ruins are now covered in overgrown trees and plant life and create a perfect spooky atmosphere. Although once you're inside you might feel like the only person in the world, you're not far from civilisation – the castle is in the middle of a residential estate. Although, if I were one of the neighbours, I don't think I'd watch too many horror films – a spooky castle on my doorstep would be quite enough.

Over in Falkirk, Torwood Castle is a ruined L-plan structure from the 16th century. It was originally owned by the Forresters clan, briefly falling into the hands of the Ballie Clan, and then back to the Forresters again. The castle is thought to have been built for Sir Alexander Forrester. In 1957 it was bought by Gordon Millar who worked on restoring it and created the Torwood Castle Charitable Trust to maintain it. As a Scottish history enthusiast, Millar dedicated fifty years of his life to restoring the castle, and now that he has passed on the future of the castle is uncertain. The trust ended in 2015. However, friends of Millar have been working to reinstate the trust and stop Falkirk's only standing castle to fall into disrepair. It's a fascinating building and hopefully Millar's wish will be fulfilled.

Finlarig Castle was built by 'Black' Duncan Campbell in the early 17th century. It sits on a mound between River Lochay and Loch Tay just north of Killin in Stirling. It was built in 1629 as an L-shaped tower-house and was visited by the legendary Rob Roy MacGregor in 1713. Black Duncan at one point owned

seven castles across Scotland. He was known as 'Black' due to his shrewd, ruthless dealings. On the grounds of the castle is a pit where it is thought that prisoners of noble blood were beheaded – commoners are believed to have been hanged from the oak tree. Today the castle lies in ruins and is overgrown with plant life.

Craigend and Mugdock Castle are both located in Stirlingshire but, as they are only ten miles outside Glasgow, that's the chapter where you'll find them.

Argyll and Bute

One of the great things about exploring Scottish castles is the random facts you discover. In this chapter I've found something that – aside from their association with George Harrison – Paul McCartney and Monty Python have in common. Both have filmed at castles in Argyll and Bute. Saddell Castle and Castle Stalker were both used in a music video and film by the famous Beatle and comedy troupe respectively.

To kick off our trip to Argyll and Bute, we were thrilled to stay in a real life 500-year-old castle. Even though I've been crazy about castles for years, I'd never stayed in a proper one. I have stayed in hotels with the odd turret and even drawbridge, but once inside they always feel like standard hotels. I had never quite had the experience of staying in an authentic castle, and so I was delighted when married couple Stef and Simo invited us to stay at Kilmartin Castle in Kilmartin Glen.

The drive from Edinburgh was full of spectacular scenery as we passed by Loch Lomond and Loch Fyne. As we turned into a housing estate when we reached Kilmartin Glen, I was sure we had taken a wrong turn. But just as we were about to turn around, I spotted the front gate and Kilmartin hove into view, its turrets and towers making a magical silhouette against the quintessential Scottish scenery.

Stef and Simo bought the property in 2015 and have since turned it into a tiny boutique hotel with just four en-suite bedrooms for guests. They previously lived in Dubai but fell in love with Scotland's west coast after a trip there in 2014. It turns out that the couple had the same thoughts as me when staying

The fantastic breakfast set up at Kimartin Castle.

in a 'castle' in that it never actually felt like one once inside. And so, when they saw that 16th century Kilmartin Castle was up for sale, they decided to quit their jobs and create an authentic experience for guests.

It really feels like sleeping in an old castle when you stay at Kilmartin.

After our stay, I can confirm that they have absolutely succeeded. The castle is 500 years old and, despite the years of renovation, it retains its traditional charm. There are winding stone steps and sloping ceilings aplenty, but none of the coldness you'd expect in a stone building of this age. Every measure has been taken to ensure that it is warm and comfortable for guests while keeping the original features. For example, Simo explained to us that they managed to install underground heating while keeping the ancient stone floors. The stone was painstaking lifted piece by piece, but the effort was well worth it.

During the Covid-19 lockdown of 2020, the kitchen flooded, so they had to dig out French drains – a bit like a moat around the building. When the work was being done, the couple could see how the castle was built with no foundations but with large footing stones stuck directly into the bedrock. They also found some interesting bottles from the 18th and 19th centuries and even got a metal detector.

Kilmartin Castle was built when Mary Queen of Scots was on the throne in 1550. It was originally constructed for John Carswell, the Rector of Kilmartin. After he translated John Knox's *Book of Common Order* into Gaelic, he was promoted to Bishop of the Isles before moving to nearby Carnasserie Castle. Kilmartin was then passed to the Campbell Clan, with whom it stayed for 200 years.

The surrounding Kilmartin Glen is also steeped in history. It's hard to walk 100 yards without passing an ancient Pictish burial ground. My husband went for a morning run during our stay and commented that there were burial grounds and highland cows everywhere you looked. Spotting one such monstrous beastie staring at him did his personal best no harm.

On our way to dinner at nearby Tayvallich, at the fabulous Tayvallich Inn, we passed by the Crinan Canal where my husband excitedly pointed out that a scene from the 1963 James Bond film *From Russia with Love* was filmed. It actually doubled for Turkey. It's amazing what you can discover on a Scottish road trip.

While in the west of Scotland, we decided to take the opportunity to see Carnasserie Castle, where John Carswell lived after he left Kilmartin. Carnasserie lies less than ten minutes north of Kilmartin and is now in ruins. Carswell lived in the 16th century tower house until he died in 1572 and the castle was passed to the Earl of Argyll. It was then sold to Donald Campbell of Auchinleck in 1643. During the 9th Earl of Argyll's invasion of 1685, the castle was burned by Lachlan

Maclean of Torloisk, and the castle has never been the same since. It remains roofless, but is a great spot to explore. Stef and Simo have documented on their Instagram page the similarities between Kilmartin and Carnasserie. Both castles once belonged to Carswell and there is definitely a resemblance.

Another castle close by is Kilchurn. Built in the mid-15th century, this also belonged to Clan Campbell. Kilchurn – pronounced Kil-Hoorn – was the first castle built for the Campbells, who for over two centuries dominated the central Highlands. They used the castle until they became Earls of Breadalbane and then moved to Taymouth Castle, abandoning Kilchurn. The castle was originally built on a small rocky island in Loch Awe which was barely bigger than the building itself. It could only be accessed through an underwater causeway – the water level in Loch Awe changed in 1817 so the castle is now sitting on a long peninsula. A single-storey dining hall or 'laich hall' was added to the five-storey tower house in the early 16th century, and in the second half of the century chambers were added to the north of the tower house and the parapet was remodelled with circular corner turrets. In 1614, Sir Duncan Campbell, known as 'Black Duncan', had the south range of the castle rebuilt and enlarged. Black Duncan also constructed Finlarig Castle.

The clan tried unsuccessfully to sell the castle to the government, but it was damaged beyond repair in 1760 when it was struck by lightning and was abandoned. Local builders apparently looted the place for stone too, which made it even more of a ruin. Today it can be accessed by boat from Loch Awe pier or on foot from the A85. It is one of four castles on Loch Awe, the others being Fraoch Eilean, Innisconnel and Fincharn. Fraoch Eilean and Innisconnel are both on small islands and are only accessible by boat. Fincharn sits near Ford on the south-west shore of the loch and is thought to have been built some time around 1240.

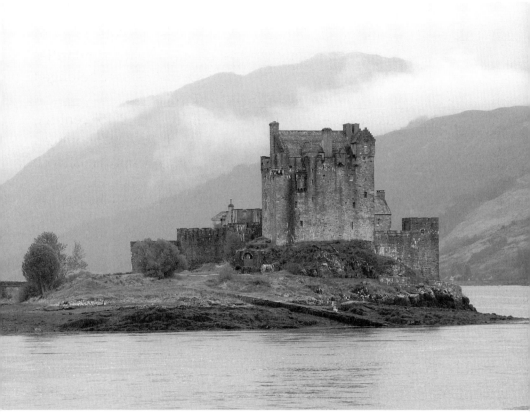

Kilchurn Castle is in a ruined state and sits on a rocky peninsula at the northeastern end of Loch Awe.

The castle is now owned by Historic Environment Scotland and is open to the public during the summer. It never recovered from being abandoned and lightening damage has left it in ruins, but the tower remains.

En route to Kilmartin we had to stop at Inveraray, which has been the headquarters of Clan Campbell for many centuries. Sitting on the shores of Loch Fyne, Inveraray Castle is a stunning piece of Gothic Revival architecture and is the ancestral home of the Duke of Argyll, chief of the clan.

The first Lord Campbell, Sir Duncan, wanted to make the clan as powerful as possible and so moved the family seat from Loch Awe to Inveraray. This gave them access to the Firth of Clyde

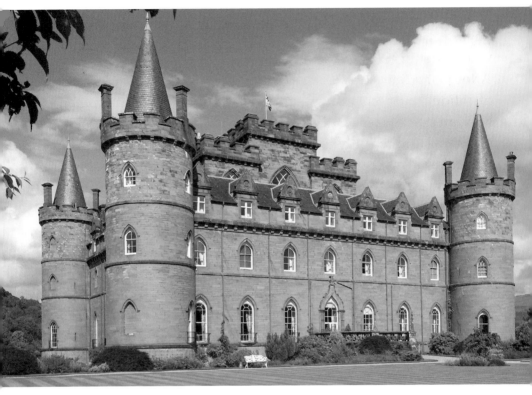

Inveraray Castle is one of the earliest examples of Gothic Revival architecture.

and the sea and was successful in making them one of the most powerful families in Scotland for years to come. To make sure the family had the best views, the whole town of Inveraray was demolished and rebuilt along the road. Just imagine the amount of red tape involved in getting planning permission for that today.

A castle has been on the site since the 1400s but the beautiful palace-like building we see today was started in 1743. Inveraray can be seen on screen in the 2012 Christmas episode of *Downton Abbey* in which it portrayed the fictional 'Duneagle Castle'.

One of the more infamous duchesses to live at the castle was Margaret Campbell, who was involved in a scandalous public divorce from Ian Douglas Campbell, the 11th Duke of Argyll,

in 1963. According to a biographer, the duke tricked her into paying to restore the family home of Inveraray and the castle is where they spent most of their time and was their family home. After just a few years of marriage, the duke accused Margaret of infidelity upon finding some suspect photographs in their Mayfair home. This resulted in a very public divorce. Margaret's story was told recently in the BBC dramatization, *A Great British Scandal* and Inveraray featured heavily. The current duke and duchess live at the castle with their three children. Due to the Covid-19 pandemic of 2020, they were alone for the first time in the castle for months without any staff or guests, which must have been a haunting experience.

Haunting being the operative word. In 1644 the first castle on the site was burnt down by the Marquis of Montrose and, although the duke escaped, his harpist was thought to have perished. The ghost of the harpist has been reported wandering through the rooms in the present castle dressed in Campbell tartan and there have also been reports of his music being heard in the library. Apparently he mostly appears to women. If I were the current duchess, I don't think I'd leave my room. Another curious incident occurred in 1758 when a physician in the grounds of the castle reported a 'ghost battle' in the sky where he could see Highland soldiers attacking a French fort. A few days later two ladies walking in the grounds reported seeing the same thing. It was then discovered that there was an attack in Ticonderoga in Canada where 300 men of the Black Watch regiments, which included Campbell clansmen, died in an attack on a fort by French troops. They must have been trying to get the message home somehow.

Another must-see in Argyll and Bute is Castle Stalker. This four-storey tower house sits on a tidal islet on Loch Laich, an inlet off Loch Linnhe, and can be seen from the A828 between Glen Coe and Oban. Although popular, it can be tricky to get to.

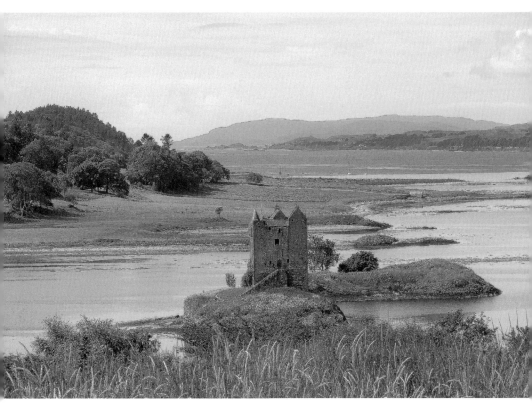

Castle Stalker was also featured in Monty Python's Holy Grail as Castle Aaaaarrrrrrggghhh.

Technically, it can be accessed on foot when the tide is low, but this is not recommended as it can be dangerous, and the castle is privately owned. You can arrange a tour and access by boat, although the onshore café and visitor centre at Castle Stalker View is much easier to get to and is a great place to stop. It's impossible to take a bad photo of this majestic tower surrounded by water sitting on one of the most beautiful spots in the country.

For those wondering about the name, it's thought to be called Stalker as James IV of Scotland stayed there for various hunting or stalking expeditions in the 15th century; although Monty Python fans might know it by another name – Castle Aaaaarrrrrrggghhh – from the 1975 film *Monty Python and the Holy Grail*. They will remember John Cleese using his

best French accent to taunt King Arthur from its battlements, accusing him, among other things, of his mother smelling of elderberries. The castle was also the inspiration for 'Castle Keep' in the 1993 Children's book *The Boggart* by Susan Cooper.

Another ancient castle near Oban is open to guests. Sitting on the shores of Loch Creran, guests at Barcaldine Castle are able to enjoy spectacular views of the snow-topped Glen Coe mountains. The castle was another built by Duncan Campbell between 1601 and 1609 and was attacked in 1692 during the massacre of Glencoe. The family's principle home moved to Barcaldine House in the late 19th century and so the castle was abandoned. It is known as the Black Castle due to its bloody history. The brother of Duncan, Donald Campbell, who was Laird of Barcaldine, was brutally murdered there in the 1600s in the Glencoe Massacre by Stewart of Appin. Various guests to Barcaldine who have stayed in the Caithness Room have reported waking in the night to a feeling of pressure on their back or legs as if someone is sitting on them – probably not a very pleasant experience. It's been voted one of the most haunted places to stay in Scotland, so if you're into the paranormal, it might be one for you.

Dunstaffnage Castle, meanwhile, is a partially ruined structure on a platform of rock at the south-west of the entrance to Loch Etive. Dating back to the 13th century, it's one of Scotland's oldest stone castles and was built by the MacDougall Lords of Lorn. It's another that was held by the Clan Campbell since the 15th century and they extended it by adding a new house over the old west range in 1725 while the other parts of the castle were rotting. The Campbells moved out after an accidental fire in 1810 and the castle was inhabited by tenants until 1888. The castle's owner was the Duke of Argyll, who carried out some restoration work in 1903 which resulted in a court case with Angus Campbell. As the 20th hereditary Captain, it was argued

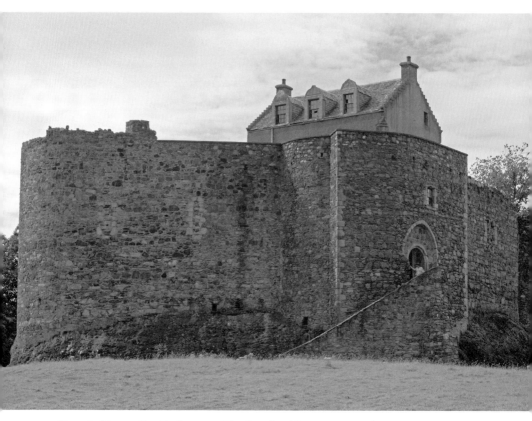

Dunstaffnage Castle is one of Scotland's oldest stone castles.

that he had the right to live at the castle despite the Duke of Argyll owning it. However, the restoration was delayed due to the First World War and the duke and the 21ˢᵗ Captain agreed to hand the castle over to state care in 1958. As a Harry Potter geek, I was excited to visit this one as it sits on Loch Etive – a filming location for *The Deathly Hallows Part One*.

With all the of lairds and ladies, I had to wonder how these titles are achieved today. The owners of Dunans Castle offer an easy route to laird or ladyship. As the former seat of the Fletcher Clan, Dunans Castle is in Glendaruel on the Crown peninsula. There was a structure on site in 1590 but the mock castle we see today was constructed in 1864. In 2001, while it was being used as a hotel, it was ruined by fire, and the current owners have found

a novel way to restore it. The castle is currently owned by Dunans Castle Limited and they also run the Scottish Laird website. To preserve the castle, which is in very poor condition, the owners are offering 'Laird or Lady packages' where anyone can buy a square foot of land in the grounds of Dunans as well as gaining the decorative title of 'Laird' or 'Lady' of Dunans. The titles are perfect for those with a love of Scottish heritage, and although they are just decorative – you won't have anyone bowing to you – it's a nice way to raise funds to preserve this historic building.

Another one in a ruined state is in the picturesque village of Tarbert Loch Fyne. Tarbert Castle overlooks the centre of the village on a hillside. It's thought to date back to the 11th century but was rebuilt and extended by Robert the Bruce in 1325 before falling into royal possession. By the 15th century it was owned by the MacDonalds, but was taken back into royal hands in 1490 by James IV, who upgraded it again with the rectangular, four-storey Tower House. The Tower House was still in use until the early 18th century but was abandoned around 1760 and became a ruin with some of the stone stolen to build the nearby harbour. Today it's a fun ruin to explore. The town of Tarbert is built around East Loch Tarbert and extends over the bridge which connects to the Kintyre peninsula.

Now, I obviously can't write 'Kintyre' without Paul McCartney and Wings' huge sentimental hit *Mull of Kintyre* popping into my head. Loathe it or loathe it slightly less, I was delighted to find out that a local castle was actually used in the music video. Saddell is a 16th century castle that served as the bastion of the MacDonald family. The castle is seen in the video with the Campbeltown Pipe Band marching along the beach. The song was Christmas number one in 1977 – I wonder if locals are sick of it yet? The white lady and ghostly monk said to haunt the castle were not caught on film.

Dunoon Castle in Dunoon on the Cowal peninsula (lots of peninsulas in Argyll and Bute) was once an important

Very little remains of Dunoon Castle. It once sat upon a cone-shaped hill around 80ft high.

stronghold thought to date back to the 11th century. Although the remains are scant, a trip to the top of the 80-foot hill it sits on is worth it for the view across the town. The castle was a royal residence in the 14th century. It was abandoned in the 17th and its stone were extracted to build the 19th century Castle House. It is thought to originally consist of three circular towers in a triangular shape, but not much can be seen if you visit today.

For those who enjoy walking, Gylen Castle is a great option. It's located on the island of Kerrera, which is a quiet place inhabited by only about thirty people. The island can be accessed by a small foot-passenger ferry. The castle is at one end of the island and was, at one point, in a great position as Kerrera was part of a major marine route for vessels sailing between the mainland and the Inner Hebrides. The castle is thought to have been built in the late 16th century by Duncan MacDougall and was only occupied for seventy years before it was attacked

by Covenanter forces and left to ruin. There is a lovely circular walk around the whole island and the castle always looks splendid framed perfectly by the sea, shoreline and cliffs.

Kilmahew Castle is near Cardross village – a ruined structure currently owned by the Catholic Church. It was built at some point in the 16th century by the Napier family who owned it for many generations until it was inherited by George Maxwell when he assumed the name of his grandfather, John Napier of Kilmahew. The castle was originally a four-storey tower house, but modifications around 1744 where thought to have been made by architect John Douglas. More gothic alterations were made in the 19th century by the owner, Alexander Sharp.

There are some castles in Argyll and Bute that are little more than legend today. Ardencaple Castle near Helensburgh was built in the 12th century and belonged to the MacAulay Clan. The castle has been completely destroyed with only a standalone square tower remaining which, to look at, you would never guess was part of a much larger building. The MacAulay Clan were once rulers in the area. They united with other families in the 16th century and strengthened the castle. However, the clan's luck began to change when the eighth Laird, Aulay, used it to pay off gambling debts by selling it piece by piece. It fell into ruin but was rescued by none other than the Duke of Argyll, who restored it to the grand castle that we can see in photographs. Another MacAulay then purchased it and wanted to turn it back into the centre for the family. She lived there until her death in 1931. The Royal Navy took ownership of it during the Second World War and gave it to a naval housing complex and most of the castle was demolished. However, one battle tower still stands and has been used as a navigational mark for shipping in the Clyde. Because of its new use as a lighthouse, the tower has been called Ardencaple Castle Light.

Although Argyll and Bute itself is anything but castle-lite.

Ayrshire and Arran

When I visited Arran, I was heavily pregnant. I was joining my family on a short holiday but, as I had to work the day they travelled, I had to get the last ferry from Ardrossan alone at night. It goes to show just how many disaster movies I've seen as I spent the whole journey sussing out the other travellers and trying to figure out in my head who would be the most proactive if something went wrong. Being so pregnant and useless, I knew that my role in my fictional film would be the pathetic damsel in distress who would rely on everyone else to save me. It was quite an eerie experience to be on the very last, half-empty ferry across the dark water but, luckily for me, my hormone and fatigue-induced daydreams did not come to fruition and I made it safely across the water to Arran.

Arran is wonderful and a place I would highly recommend for a Scottish holiday. Like some of the other Scottish islands, it's easy to imagine that you're not in Scotland at all.

Whisky tours, mountain walks, green glens and sandy beaches. Of course, we had to see what castles the island had to offer. There are three in total ranging from the vast Brodick Castle estate to the ruined structure of Kildonan, with Lochranza somewhere between the two.

Brodick Castle was our first stop. Described as a 'quintessential island castle', the estate is surrounded by mountains and has a fantastic story. The stronghold we visited was built in 1844 but there has been a castle on the site since the 5th century, since its days of being under the control of the King of Norway. During the Wars of Independence,

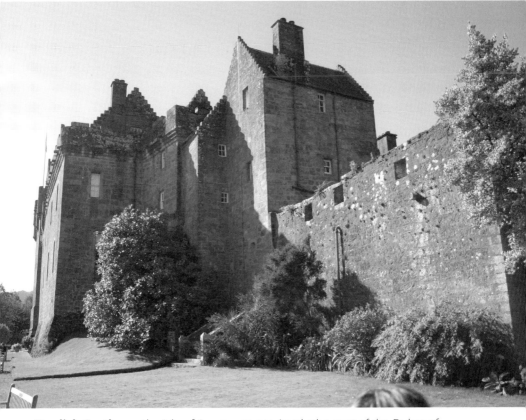

Brodick Castle, on the Isle of Arran, was previously the seat of the Dukes of Hamilton.

Brodick was taken by the English army but was one of the first castles to fall to James Douglas, Lord of Douglas, in 1307 when he dislodged the English on the order of Robert the Bruce. However, it was badly damaged and rebuilt by the Earl of Arran in 1510 as a tower house.

Because of its position overlooking the Firth of Clyde, it's been an important fortress over the years. Since 1503 it has served as an ancient seat of the Dukes of Hamilton. The Hamilton family rebuilt the damaged castle in around 1510 but it was damaged again in clan battles in 1528 and again by Henry VIII's forces in 1544. It fell into English hands once more in 1652 when the troops of Oliver Cromwell used it as a barracks. At this time it

was also extended by building an artillery battery to defend the Firth.

In 1656, William Douglas, 1st Earl of Selkirk and the new Duke of Hamilton, used the castle as a base for hunting trips and the castle remained in use as a sporting estate in the following years. The 10th Duke used the castle as his home and the 11th tripled the size of it in 1843 to the plans of architect James Gillespie Graham, who is also famous for Duns Castle.

Today the castle is owned by the National Trust for Scotland and is open during the summer, with the country park open all year round. With its long and complex history, it's safe to say that some secrets are still being discovered. During restoration work in 1977, a secret staircase was discovered that led to a room that no-one knew about. Now fitted out as the castle dungeon and filled with mannequins dressed as prisoners sitting behind bars, we found it pretty spooky. It reminded me of the Pirates of the Caribbean ride in Disney World, only considerably more frightening as it was based on fact.

It was no surprise to hear that there were some supernatural guests. There have been reports of a ghostly man sitting in the library, a grey lady who apparently succumbed to the plague, and a white deer that is only seen when the clan chief of the Hamiltons is near death.

On our visit, my young niece Ebba was brave enough to go alone on the children's tour of the castle and grounds. She recalls that the garden was very big, and thought there was real fruit in the fruit bowl. High praise indeed from an 8-year-old. I'm surprised she wasn't traumatised by the dungeons and ghost stories. Even if you're not as interested in castles as me, the estate is worth a visit thanks to its extensive gardens, woodland, waterfalls and play areas for children.

Actors Minnie Driver and Tom Wilkinson graced the halls of Brodick Castle in the 1998 film *The Governess*, and the castle has been featured on £20 notes issued by the Royal Bank of Scotland.

Another on Arran is Kildonan Castle in the village of Kildonan. It's a lot smaller than Brodick and a lot less grand. The castle gets its name from Saint Donan, who is thought to be buried on the island, and it now stands as a ruin. This 13th century tower sits on the cliffs and overlooks the island of Pladda and entrance to the Firth of Clyde – the perfect defensive position. It was built by the MacDonalds, Lords of the Isles, and was mainly used as a hunting lodge by kings of Scotland. It was once owned by the Hamilton family but was left to ruin as the family used Brodick much more frequently. Although called a castle, it's really more of a fortified tower house, and the remains are roofless and covered with ivy.

The third castle on Arran is Lochranza, which sits on the northern part of the island on Lochlanza, its striking image reflected in the water on calm days. Most of it was built in the 16th century but it is thought to have been built in the 13th century by the MacSween family, who were the lords of Knapdale. Today, a plaque in the castle grounds explains that the ground-floor entrance to the hall house was heavily defended and those inside could shoot at enemies from the murder hole in the ceiling. The timber stair leading to the first floor could also be hauled up for extra protection. In 1371 the castle was owned by Robert II, King of Scotland, and used mainly as a hunting lodge. It was another used by Cromwell in the 1650s and, by 1705, owned by the Hamiltons. As they owned all the other castles on the island already, they sold it to the Blackwood-Davidson family for their principal seat. But it had fallen into ruins by the end of the 18th century.

In the 1960s it was used as a model for the castle in *The Black Island* in the English translations of the Tintin adventure. It was also featured on a Channel 4 show in 2010, *Dom Joly and the Black Island*, as Kisimul Castle. And it has its own blend of Arran whisky.

Back on the mainland, Ayrshire as a whole has almost 200 castles to explore, so definitely too many to squeeze into one trip.

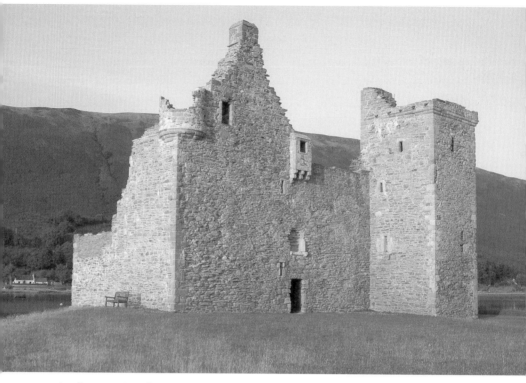

Lochranza Castle is an L-plan fortified tower house on the northern part of the Isle of Arran.

The first on my list was one that I have been most excited to see for myself: the super-colourful Kelburn Castle in Fairlie, Largs.

I thought Aberdeen's Craigievar Castle with its pink hues was impressive, but Kelburn is in a different league. It has every colour you could imagine, thanks to the Brazilian graffiti artists, twins Otavio and Gustavo Pandolfo, known as Os Gemos, along with Nina Pandolfo and Francesca Nunca. The art was created when the owner, Patrick Boyle, the 10th Earl of Glasgow, realised that the plaster facing needed to be replaced in 2007. His children persuaded him to brighten up the otherwise grey castle and invite artists in to work their magic. The team from Brazil used 1,500 cans of spray paint to create the colourful cartoon designs that adorn much of

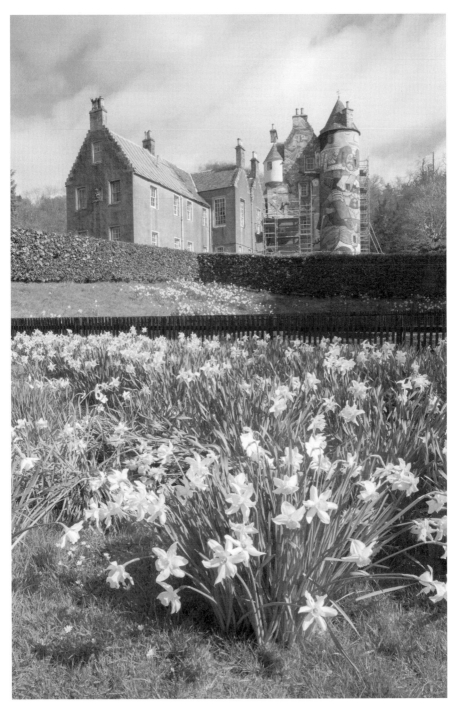

Kelburn Castle was painted in 2007 and is now recognised as one of the world's top 10 examples of street art by Tristan Manco.

the building. The artwork cost £20,000 and has been named one of the world's top 100 examples of street art, putting it on a par with Banksy's work in LA and the Favela Morro Da Providencia in Rio de Janeiro. Not the kind of creation you'd expect to find in Ayrshire.

Before it was the work of art we see today, the castle was your typical grey/brown stone castle. It was first built in the 13th century, exact date unknown. It was standing during the battle between the Scots and Norwegians in 1263. Serving as the seat of the Earl of Glasgow, the very first structure on the site was made out of wood, but that was replaced in the 1200s with a stone Norman keep which is still partly in existence today. The tower house was built in the late 16th century and the gardens and orchards created in the 17th. The first Earl of Glasgow was David Boyle in 1703 and he doubled the size of the castle by adding a mansion house to the original. The 6th Earl of Glasgow, George Boyle, added the north-east wing in 1880. He also ran up huge debts building churches across Scotland. The 7th Earl was Governor of New Zealand in 1892. This has resulted in links between the Kilburn Estate and Kelburn in New Zealand. Many of his souvenirs are still on display at the museum on the estate.

On our visit, I didn't realise how huge the estate was. It comes with its own forest, waterfalls and over 2000 acres of land to explore. It's easy to get lost when trying out some of the many walking trails around the estate. There is also a witch's cottage, magnificent gardens, playparks and a museum.

The 10th Earl, who commissioned the artwork, had to be granted permission by North Ayrshire Council and Historic Environment Scotland. It was granted on the condition that the graffiti would be temporary and be removed after three years. It's now been fourteen years and the Earl is campaigning to keep it.

When it debuted in 2007, it attracted worldwide media attention, and TV broadcaster Dermot Murnaghan commented that the Tower of London could do with a similar makeover.

It is one of many castles and country parks in the region. Another huge, opulent castle to visit is Culzean Castle in Maybole, South Ayrshire. Sitting on top of a cliff, it is more of a palace than a castle. It was constructed by David Kennedy, 10th Earl of Cassillis, on the site of a previous castle. You can tell by glancing at it that Kennedy was keen to show off his wealth. The magnificent building towers above the gardens and beaches. It really is a sight to behold. Its beauty has not gone unnoticed as it has been used on £5 notes issued by the Royal Bank of Scotland from 1972 until 2015 and has featured in various films and TV shows including the 1973 classic *The Wicker Man*, where it was used as the castle of Lord Summerisle played by Christopher Lee, and it was a location for BBC 1's *Antiques Roadshow* in 2021.

There have been reports of several ghosts roaming within the castle. A young woman wearing a ball gown has been seen drifting up the staircase, and a ghostly piper has been heard in the grounds. These paranormal events were exposed on *Most Haunted* in 2002 when medium Derek Acorah claimed to hear the infamous piper.

Like Kelburn, its grounds are complete with playparks and a café. There is also a second-hand bookshop. It receives nearly a quarter of a million visitors a year – the ghosts obviously don't put many people off.

Ten miles from Culzean Castle near the village of Straiton is Blairquhan Castle, which is just as lavish. So much so that the 2006 Oscar-winning film *The Queen* starring Helen Mirren was filmed there, as well as the less-popular 2006 E4 show *Beauty and the Geek*.

Blairquhan was also owned by the Kennedy family. It was sold to Sir David Hunter Blair who commissioned famous Scottish architect William Burn in 1821 to build a brand new castle, after the original, thought to have dated back to 1346, had fallen into ruin.

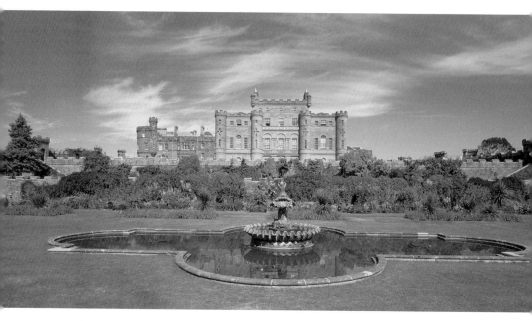

Culzean Castle overlooks the Firth of Clyde in South Aryshire. It's the former home of the Marquess of Alisa, the chief of Clan Kennedy.

The estate has 200 acres of parkland with a walled garden and fruit trees. Today the castle is popular for weddings; the Regency architecture provides a beautiful setting and looks great in any wedding snaps.

Dating back to the 13th century, Dunure Castle is also not far from Culzean. It offers spectacular clifftop views. Dunure is a tiny fishing village that's seen as a bit of a hidden gem, despite the castle being used as a filming location for *Outlander* – the castle was used as the Silkies Island where Jamie finds the MacKenzie treasure. But visiting families will be delighted with the nearby playpark and picnic area.

Dean Castle and County Park is another attraction that offers a fun day out for the family. The 14th century castle sits within the park in Kilmarnock, East Ayrshire. It's been the stronghold of the Boyd family for over 400 years, having first been given to Sir Robert Boyd by King Robert I for his services in the Battle of Bannockburn in 1316. It was designed for defence with

thick walls, few windows, and an original entrance high above ground level. Unlike other Scottish castles at this time, missiles were fired from the battlements at the top of the castle, so there are no arrow slits in the walls. In 1735 it was gutted by a fire but restored again in 1905 using materials from Balcomie Castle in Fife. Far away from the lovely family-friendly atmosphere the castle has now, there was a time when no-one would want to go there. Before the Jacobite uprising, some servants in the castle saw a ghostly severed head rolling on the floor. This might have been a premonition, as the fourth Earl Boyd went on to join the Jacobite rising and was beheaded in 1746.

Today the castle and park are advertised as a free day out for the family, with an adventure playground, café, farm, and free tours of the castle available. Dean is another *Outlander* location, in which it features as Beaufort Castle. It serves as the home of Jamie Fraser's grandfather, Lord Lovat.

Also in Kilmarnock is Craufurdland Castle. The castle is a rebuilt tower house from the 16th century which was added to in the early 1700s when the Lairds' House joined the Tower. Then in the mid-1800s the castle underwent a huge renovation after a period of neglect, William Houison Craufurd creating the Gothic façade we see today, as well as the Georgian library and drawing room.

Now available to stay in as a self-catering property, the castle is set in 600 acres of countryside and surrounded by woodland. The land has been in the Craufurd family since 1245. The current laird and his wife call the castle 'semi-detached' as the family live in the Laird's House side which leaves the Tower House free for self-catering for up to sixteen people. When staying in the castle, guests have the run of the place, and the estate can be used for walks, cycling and fishing. They have a Tree Top Trails adventure course for the braver guests on site.

If country parks and estates aren't your thing, there is Portencross Castle in North Ayrshire. There has been a castle on the site since

the 11th century but the one that stands today is thought to date to the mid-14th century. Portencross is thought to have been the resting place of Kings of Scotland. It was also owned by the Boyd family, having been gifted to them as a reward by King Robert I for their efforts in the Battle of Bannockburn.

Today, the castle offers great views of Arran – where dolphins can be spotted on the Clyde.

In 2004 the castle was featured in the BBC TV show *Restoration* as a local community group were working to secure its future. The group, Friends of Portencross Castle, have since been awarded grant support from the Heritage Lottery Fund, Historic Environment Scotland and the Architectural Heritage Fund, to keep it for years to come. The castle is free to enter and run by volunteers. It's a popular spot and has beautiful views across to Arran, and the chance to spot marine life is never one to be missed.

Eglinton Castle is within a country park and is popular with families – kids must never be bored in Ayrshire. Between Irvine and Kilwinning, Eglinton County Park is within the grounds of the old castle estate. The building itself is now in ruins. Once the seat of the Earls of Eglinton, the original castle was burned down in 1528. Another was built on the site 1797 and 1802 in Gothic castellated style and was almost as grand as Culzean. When the foundations were laid, the ceremony was performed by Alexander Hamilton of Grange. Hamilton was grandfather to the (in the words of Lin-Manuel Miranda from the smash hit musical *Hamilton*) young, scrappy and hungry American founding father Alexander Hamilton. *Hamilton* is my favourite musical and I did wonder about the American Treasurer's ancestry when he was described as 'son of a whore and a Scotsman' in the opening song, *Alexander Hamilton*. Now I know.

Dundonald Castle is a 14th century hilltop tower house that overlooks the village of Dundonald. Once the home of

King Robert II, it is known as the birthplace of the Stewart dynasty. Today, the site hosts the famous Dundonald highland games, one of Ayrshire's premier cultural events. There is a visitor centre at the bottom of the hill on the site with a museum in which to learn all about the history of the castle.

If you want to get real value from a castle trip then Rowallan Castle, just outside Stewarton, is the perfect place, as the estate has not one but two castles. The old castle dates back to the 9th century but parts you can see today are from the 13th century. The new castle is a five-star hotel used for weddings and golfers – the estate is home to a championship golf course designed by Colin Montgomerie.

Another one near the city of Ayr in a beautiful setting is Greenan Castle. The 16th century ruined tower house is only a couple of miles outside Ayr and sits on top of a sea cliff. There is a beautiful walk along the beach to reach the castle and you're rewarded with great views if you make it to the top. It was originally built as a lookout post for John Kennedy and visitors today are warned to take care as in 2004 a teenager fell a hundred feet from the castle onto the beach below. He was very badly injured, but miraculously he survived.

The gothic ruins of Kerelaw Castle in Stevenston are fascinating to explore. The castle was owned by the Hamilton family and was actually the childhood home of James Hamilton, the father of one of America's founding fathers, Alexander Hamilton. Yes, that's 'the Scotsman' mentioned in the musical. The castle originally dates from 1191, and it was rebuilt in 1488. It was the family home of the Hamiltons until 1787 when another Alexander – the second cousin of the man on the $10 bill – built Kerelaw Grange House nearby.

Today there are only three walls remaining, but the gothic windows are clear and very atmospheric. It looks like the perfect setting for a horror film. And in 2016, it almost was the setting of a real-life horror when the 'Killer Clown' craze

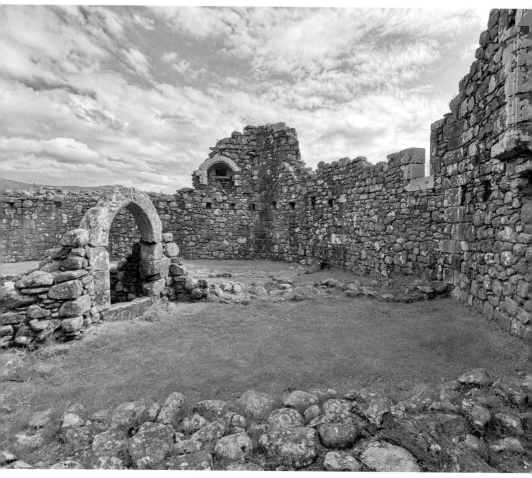

Loch Doon Castle was thought to have been built in the late 1200s.

hit North Ayrshire. A scared dog-walker snapped a photo of a creepy looking clown hiding in the castle ruins and brandishing a shard of glass. The craze, which started in the United States, involves people dressing up like clowns and frightening children and dog walkers. Best to avoid it at night.

Loch Doon Castle is interesting in that it actually changed location. It used to sit on an island in the middle of the loch but was dismantled stone by stone and rebuilt on the side of the loch after the water was raised in the 1930s for a hydro-electric scheme. The 13th century castle was built for the Earls of Carrick

and was surrendered to the English in the Scottish Wars of Independence. It was another one to eventually be owned by the Kennedy family, but was destroyed in the 16th century by King James V of Scotland as part of the policy of reducing the powers of the barons of Galloway. The ruins are still a sight to behold, and obviously worth saving since the whole building was rebuilt at the side of the loch.

Loch Doon dam is interesting to see too. It is the dam the building of which made it necessary to move the castle. Built in 1935 to generate hydro-electricity, it is a freshwater loch and, at seven miles long, is the biggest inland loch in southern Scotland. Ayrshire always has the power to amaze.

Dundee and Angus

I have a particular fondness for Dundee. I will always know it as the birthplace of Oor Wullie, *The Beano*, Desperate Dan and, as my teenage self is quick to remind me, *Shout* Magazine. For me, as a journalist, DC Thomson is a big name as one of the UK's leading media organisations. It is nice to have one based in Scotland, as it is a very London-centric industry. With DC Thomson, the renowned Dundee marmalade, and the city's strong history in the textile industry, it's easy to see why they say Dundee is famous for jute, jam, and journalism. Perhaps it should also be known as the city of *Grand Theft Auto*, as it was here that the hugely successful video-game franchise was born.

But what about castles? I admit that my visits have mainly been for work or to visit friends, but Dundee and Angus boast some pretty impressive fortresses.

Like Glasgow, Dundee used to have its very own castle but unfortunately it is no more. The Castle of Dundee was thought to have been built in the late 12th century at a time when Dundee was a royal burgh created by King William the Lion. It was surrendered to the English and besieged by William Wallace before the battle of Stirling Bridge. It was taken again by the English in 1303 and historians believe that it was destroyed by Robert the Bruce in 1313. The site is not bare however, as centuries later, in 1855, St Paul's Cathedral was built for Alexander Penrose Forbes when he was elected Bishop of Brechin and chose to live in Dundee.

It was generally believed that all remains of the castle were lost forever, as most of the evidence that it existed

was removed in the early 19th century to make way for Castle Street. But in 2018 council staff renovating the former Kennedy's Steak House in that street which had been closed for several years were shocked to discover the foundations of its namesake castle in the basement. The large rock formation continued up the hill towards the High Street and formed the base of the once-dominating castle. Unfortunately this discovery can't be seen by the public as the building now has false walls in place and new flooring in the basement. It's surreal to think that a piece of Dundee's history is hidden beneath an everyday shop.

Although the main castle has been lost to the ages, Dundee still has sixteen other fortresses in the main city.

Broughty Castle sits on the banks of the river Tay, four miles from the city centre in the suburb of Broughty Ferry. The site is thought to have been fortified in 1454 when the 4th Earl of Angus, George Douglas, was given permission to do so, but the castle was built between 1490 and 1496 by Andrew, 2nd Lord Gray, who was granted the site in 1490. Like the Castle of Dundee, it was taken by the English on more than one occasion. It was taken without a shot being fired in 1547, reclaimed by the Scots a couple of years later, and then taken again in 1651. The castle was altered and expanded in 1860 due to the threat of a French invasion. This made the castle into part of the coastal defence system. It was altered again due to German threats in the First and Second World Wars.

Today's castle has been home to a free museum since 1969. If you're up for a steep climb, the spiral staircase to the museum offers visitors the chance to see inside the tower, get great views of the beach and of the River Tay below – which can be a good place for dolphin spotting – and discover the history of the people of Broughty Ferry, its environment and its wildlife.

Not far from Broughty Ferry is Claypotts Castle, a well-preserved tower house built in 1560 in an unusual Z-plan

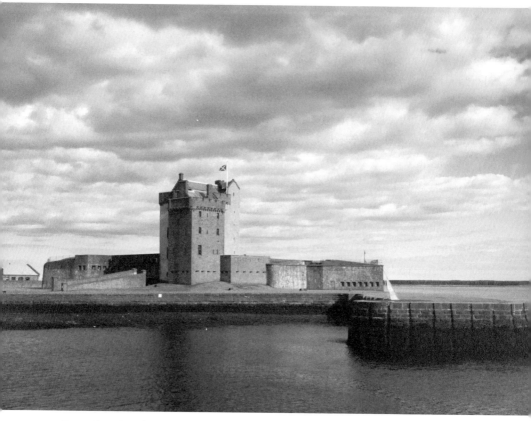

Broughty Castle sits on the banks of the river Tay and the structure we see today was completed in 1495.

with four storeys. Two staircases enabled the owners, John and Eufame Strachan, to have a private apartment in one tower and guests in another.

After John died in 1593, local laird William Graham of Ballunie bought the estate. It was then sold on to William Graham of Claverhouse – known as Bonnie Dundee – an ancestor of Jacobite leader John Graham, Viscount Dundee.

Despite its age, Claypotts is completely intact and beautifully kept to this day. Small compared to other castles of its age, it is situated in the middle of modern housing and can be accessed by phoning in advance. The castle has some fun folklore attached to it. It's said that a Brownie – a bit like a Scottish

elf – lived there and would perform all the household chores while the servants slept at night as long as they left out a bowl of cream. Legend has it that the Brownie eventually got fed up with the lazy staff, especially one maid, and put a curse on Claypotts before leaving forever. Some interesting details include the twelve gun holes around the ground floor which were used as a deterrent – the same way we would use security lights today.

Dudhope Castle has been, until recently, used as a council building and is therefore an integral part of the city. The late medieval tower house was built in 1460, although there was a smaller tower house on the site from the late 13th century. Both were owned by the Scrymgeour family. The castle was extended in 1580 to the L-plan design we see today. When

Clay Potts Castle is a 16-century Z-plan tower house that is now surrounded by modern housing.

John Scrimgeour (the spelling seems to have changed over the years), the first Earl of Dundee, died in 1668, King Charles II ignored the rightful heir and gave Dudhope to the brother of the 1st Duke of Lauderdale, Charles Maitland. Bonnie Dundee – also known as John Graham of Claverhouse who also owned Claypotts – bought it from Maitland, and it is from this castle that he left for Killiecrankie in 1689 where he was killed. The King then gave the castle to Archibald Douglas, and his family owned Dudhope until around 1790.

Since then the castle has had various uses. There was an attempt to turn it into a woollen factory which didn't happen in the end; the grounds were turned into barracks for almost 100 years; and extra buildings have been added including a hospital, officers' quarters, stables and guardrooms. The town council of Dundee attempted to use the grounds for housing at one time but instead they were opened as a park in 1895. It was used again as a military barracks during the two world wars. In the early 1900s the castle was passed on to the corporation of Dundee, which at one stage wanted to demolish it. However, in the mid to late 1980s it was developed into offices, a conference centre, and student accommodation for the University of Abertay Dundee's Business School.

One room inside the office building is called the Scrimgeour Room. The curtains in this room are made from the family's tartan, as arranged by the Scrimgeour Clan Association. At the time of writing, in 2021, the castle is up for sale. Many Dundonians fear that it may be sold to a developer who will turn this beautiful piece of Scottish history into housing or a hotel. I'm with them in hoping that it will be kept as it is.

Mains Castle is a 16th century tower house. It sits in Caird Park in Dundee and has also been known as Claverhouse Castle or Fintry Castle. It is thought to have been built in 1562 by Sir David Graham, the nephew of Cardinal Beaton, and it served as the seat of the Grahams of Fintry until the

19th century. It was eventually passed down to James Key Caird in 1913. He gave the castle and lands to the city to use as a public park – hence the park name today. The castle is now a popular wedding venue with its picturesque turrets serving as a beautiful backdrop to a special day.

But what interests me about Mains is a bit darker. As researching this book has told me, many Scottish castles are haunted. But this one is particularly spooky. I had read a feature in the *Dundee Evening Telegraph* about the apparent hauntings and the writer had her very own paranormal experience while investigating the castle. The writer went to Mains with a Fife-based paranormal team. They brought with

Mains Castle is also known as Claverhouse Castle or Fintry Castle and is supposedly haunted.

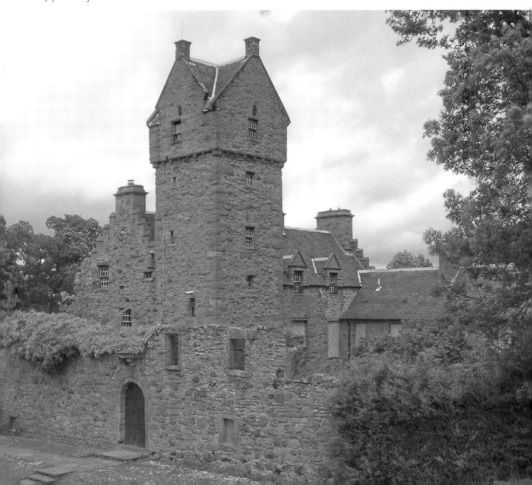

them equipment such as radio scanners and devices that would measure temperature drops or record any sounds that couldn't be heard by human ears. Over the years, visitors have reported hearing the sound of footsteps following them around, and the ghosts of children have been seen in the park. Her experience was frightening. One of the experiments the writer took part in was looking into a blacked-out mirror and inviting spirits to show themselves in her reflection. Although sceptical, she details in the article how she saw her nose grow and eyes change shape until her reflection took the form of an old man and then a sad old woman. Nope. Just nope.

British TV show *Most Haunted* ran an experiment at Mains where guests could take part in a mass ghost-hunting event and then sleep over – I don't think I'd ever be brave enough for that one.

Let's move swiftly away from ghosts (although you're never that far away from them when dealing with Scottish castles) and on to Ballumbie Castle, which was built by the Lovell family. Ballumbie is thought to have been constructed in 1545 and was passed to the Maule family in the early 17th century. It seems to have had a very short life as a working castle and residence as it was considered ruined from as early as 1682. Two original towers still exist but parts of the east and south stone walls were used to construct the nearby stable block as part of Ballumbie House. As the structure is currently in such a bad state, access is not permitted for safety reasons. From a distance, it looks to be covered in overgrown ivy and holds a real air of mystery.

In a similar state is Powrie Castle, another 16th century structure in ruins. The estate was originally known as Wester Powrie and was bought by Thomas Fothringham in 1412. He built an earlier castle on the site but this was destroyed by the Scymgeour family in 1492. The castle there today replaced that one. There was once a curtain wall connecting the old and

newer wings, but this was destroyed, so it now appears as two separate buildings. The newer wing dates from the 17th century and is well preserved, but the older wing or building is in a ruined state. The estate is now privately owned.

One that's a bit different is Balintore Castle in the Angus Glens. It has a great renovation story. The castle had been abandoned in the 1960s due to excessive dry rot. It was falling apart until it was saved from ruin in 2007 by the new owner, Dr David Johnston, who snapped up the building for £80,000. Dr Johnston's renovation journey has been well-documented in the press. He told *The Courier* in 2021 that at one point he was 'discovering new rooms at a rate of one every few days – all 85 of them'. He was still finding new rooms seven years after he bought the place. With so many rooms and so much damage to contend with, it's no surprise that thirteen years on most of the castle is still a building site. The owner has worked tirelessly to source original features of the castle and put them back in their rightful place, as well as searching auction houses and charity shops to find the right furnishings and details to suit the grand, Baronial-style building.

Built in the late 1800s and commissioned as a sporting lodge, a tower house existed on the site since the late 16th century. It was designed by Scottish architect William Burn, who was also famous for designing Dundas and Lauriston Castle in and near Edinburgh, the Edinburgh Academy, and many more buildings in Scotland, England and Ireland. The castle has multiple turreted towers with the main one topped by a balustraded viewing platform.

The main room is the great hall, but the castle also includes a gallery, many bedrooms, dinner service room, butler's pantry, women servants' sitting room, brushing room, library and dining room.

Dr Johnston is living in the castle as he renovates it. I never like seeing a good castle go to waste and I'm sure I'm one of many

who is delighted that this one has been rescued. I can't wait to see how it all turns out – even if it takes another thirteen years.

Away from Dundee, you'll find Brechin Castle overlooking the River Esk. This one has a bit of a hidden gem inside the walls. From the outside, it appears as a grand manor house and that's exactly what it is. It was built for the 4th Earl of Panmure, James Maule, between 1696 and 1711, but inside are the remains of the earlier L-plan tower house which is thought to have belonged to Scottish kings and dates back to the 13th century. The castle still incorporates some cellars of the original tower house. The mansion seen today is well preserved and was constructed in red sandstone. At the top of the east side you can see the coat of arms depicting the Maules and the Hamiltons, as James Maule married the Duke of Hamilton's daughter, Lady Margaret.

The castle is accessed by a single arched bridge which was built and designed by the son of the castle gardener in 1856.

The Maule family owned the castle until around 1900 when it was passed by marriage to the Ramseys of Dalhousie. The Earl and Countess of Dalhousie still live there.

At the time of writing, in 2021, the castle with seventy acres of grounds was up for sale for offers over £3 million – Dundee seems to be the place if you want to buy yourself a castle. Advertised as a 'large family home', anyone willing to invest would also be buying acres of private grounds including the walled garden – said to be one of the finest in Scotland – as well as the Under Gardeners House, the Head Gardeners House, Stable Block and Laundry Cottage, the New Lodge and West Lodge. You would need a pretty big family to use up all of the accommodation and space, but it could be a fantastic business opportunity. All you need to do is find £3 million.

Near Brechin is Edzell Castle, built in the 16th century by the Lindsays, Earls of Crawford. Set within formal walled gardens, this L-shaped tower house was once the meeting place of Mary Queen of Scots and her Privy Council in 1562. The castle was

expanded by Lord Edzell, Sir David Lindsay, in 1604, who also laid out the gardens. The castle now is mainly known for its Renaissance-style walled gardens. The walls are decorated with carvings of the seven virtues on one side and the seven sins on the other. The gardens feature a symmetrical layout of hedges that spell the Lindsay family motto from above, which is *Dum Spiro Spero* (while I breathe, I hope) and 'Endure Forte' (endure bravely).

Although the gardens are perfectly intact and are a popular attraction, the castle is in ruins. It's hard to imagine while strolling in the beautiful landscaped gardens that many residents of Edzell believe that the castle is haunted. Apparently the 'White Lady' has been known to haunt the first floor of the castle. Some, however, think it's not a lady at all but is the spirit of 15th century Earl, David Ogilvy. I wouldn't like to meet them to find out.

In Glamis near Forfar is the stunning Glamis Castle – pronounced Glarms). This is another one with links to *Macbeth*.

Edzell Castle is a ruined 16th century castle with an early 17th century walled garden.

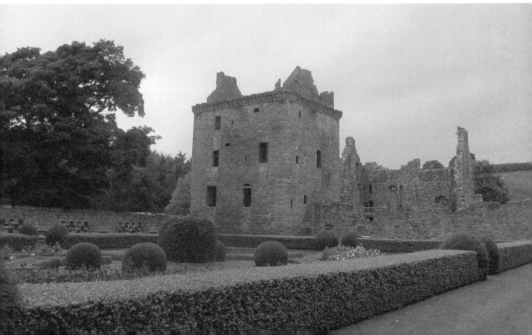

Malcolm II was depicted as being killed by Macbeth at Glamis in 1034. Nothing in the current castle dates back that far, but there was another castle on the site in 1372.

Glamis is known as one of Europe's most beautiful castles. The rectangular tower house was built by the Lyon family in the 14th century. Sir Patrick Lyon was created first Lord of Glamis in 1445. The house was altered and expanded over the years, including the round entrance hall and lower wings.

Glamis Castle was where Lady Elizabeth Bowes Lyon grew up. It was also the childhood home of Queen Elizabeth, the Queen Mother, and the birthplace of Princess Margaret. The castle is currently the home of Simon Bowes-Lyon, the 19th Earl of Strathmore and Kinghorne. Although it is used as a private residence, weddings and other events can be held at the estate and guests can rent luxury self-catering accommodation on site. At the time of writing in 2021, the estate had just introduced its first ever food festival.

Another fascinating fact about Glamis is that, since 1987, an illustration of the castle has featured on the back of £10 notes issued by the Royal Bank of Scotland. Not many of us use cash these days, but I've made a note to visit a cashline so I can try to spot it.

There have been reports of several ghosts on the estate, including the Grey Lady. I've lost count of how many 'Grey Ladies' I've read about in Scottish castles. Why not something a bit brighter? This one was the wife of the sixth Lord of Glamis. She was accused of practising witchcraft against King John V of Scotland. Also a tongueless woman has been seen wandering the grounds with blood spilling out of her mouth; and 'Earl Beardie', the fourth Earl of Crawford, Alexander Lindsay, has been heard yelling and swearing after he died from apparently losing his soul to the devil in a game of cards. Maybe he wasn't very good at bluffing.

If all of that wasn't bad enough, there is an even more frightful tale from Glamis and that's the one about the hidden heir from

the 19th century. A child of Lord Glamis, Thomas Lyon-Bowes, and his wife Charlotte, who was born in 1821, died on the same day. Or so we are led to believe. The rumour was that the child was born deformed and was hidden away in the castle in a secret chamber. The rumours escalated until the midwife who delivered the boy claimed he was in perfect health, aside from his deformity, and was surprised at the news of the death. There was also no gravestone. The boy, cruelly referred to as 'the monster', was the rightful earl but had to be locked away. The boy's room was apparently bricked up after the death and he is now said to haunt the basement and grounds.

A similar grand castle that's now used as a hotel is Ethie Castle in Inverkeilor in Angus. The first stone structure on the site was built around 1300 by the monks of Arbroath Abbey. It was then owned by the Maxwells and later by Scotland's last cardinal, Cardinal Beaton. It later went into the ownership of the Earls of Northesk and is believed to be the inspiration for the fictional castle of Knockwhinnock in Sir Walter Scott's novel *The Antiquary* as Sir Walter was a friend of William Carnegie, 8th Earl of Northesk, and was a frequent guest at Ethie.

Two castles in Angus that are now private homes are Affleck and Airlie. They were both originally built in the 15th century. Airlie was rebuilt in the 19th – and is in very good condition. Affleck Castle was once home to the Affleck family (perhaps ancestors of Ben?) and now stands next to Affleck House on private land. Airlie is a mansion house which can be rented for holidays.

Braikie Castle, a late 16th century tower house, is located between Brechin and Arbroath and now sits roofless but otherwise in decent condition. It was built for Thomas Fraser of Kinnell and passed to the Gray family in the mid-17th century before being passed to the Ogilvie family. It was thought to be still intact in the 1950s but is now without a roof – nice, if you're into astronomy.

Highlands

The Scottish Highlands are a truly beautiful part of the country, and they are probably what people around the world immediately conjure up when they hear the word Scotland. I don't get up there too often, but when I do, I'm always taken aback that I live in a country with such mind-blowing landscapes, majestic mountains, and luscious lochs. Even though I'm Scottish, it's always exciting to see Scotland on screen, and the most otherworldly-looking locations are usually filmed in the Highlands. As a Harry Potter fan, I found it especially exciting seeing the Hogwarts Express trundle over the amazing Glenfinnan Viaduct or Hagrid's Hut set against the magnificent backdrop of Glen Coe.

As a family, we did part of the North Coast 500 and managed to tick off some of the region's most breathtaking castles on the way. Walking over shaky suspension bridges overlooking crashing waterfalls on the route made us feel like we were in an Indiana Jones movie. As Scotland's answer to America's Route 66, the NC500 is a popular choice and offers visitors some spectacular sights to see along the way. We might not have the California sunshine but the ethereal majesty of the Highland landscape more than makes up for it. The North Coast 500 is essentially a loop that begins and ends in Inverness, so where better to start the castle hunt than in the capital of the Highlands?

Inverness Castle was built by various architects in the 1700 and 1800s, and the red-sandstone building sits on a cliff overlooking the River Ness. Like many other 'newer' castles, Inverness was built on the site of a much older structure.

A succession of castles are thought to have stood on the site since 1057 with the original said to have been built by Malcolm III of Scotland and partially destroyed by Robert I (the Bruce). This was in 1296 during the first Wars of Independence. There was an initial English victory and Inverness Castle was taken over by an English garrison a couple of times. Robert I claimed it back in 1308 and deliberately damaged it to stop it being used for military purposes. The castle was rebuilt again in 1412 by Alexander Stewart, Earl of Mar, so it could be used defensively again. James I took up residence while he tried to take control of the MacDonalds, known as the Lords of the Isles. The castle was attacked numerous times during this period but was consistently upgraded and strengthened. In the 1500s the castle came into the hands of the Earl of Huntly. He famously refused Mary Queen of Scots entry. However, the clans Fraser and Munro took back the castle for the Queen and the Earl was hanged.

Inverness Castle was built in the 19th century on the cliff-top site of an 11th-century fortification.

The castle saw various other sieges down the years and the building was obviously the worse for wear as a result. Around 1621, King James ordered that the castle should be repaired, but it wasn't and the current building we see today was built in 1836 on the site of the original. Upgrades have included gas, light and water systems. It you can't travel all the way to Inverness but can get your hands on a £50 note from the Royal Bank of Scotland, you will be able to see it on the reverse side. Until very recently the castle was home to the Inverness Sheriff Court.

Inverness is well known for being near the home of a famous beast, but the legendary Loch Ness Monster isn't the only legend associated with the area and Inverness Castle is said to have some scary creatures of its own. The original castle was built for King Macbeth and was where Shakespeare's Macbeth is said to have murdered King Duncan. To this day the ghost of King Duncan is said to roam the riverside beneath the current castle. I think I'd rather see Nessie.

There are three more striking castles around Inverness, the most northerly city in Scotland. And one is in the perfect position for people to try to spot the famous monster. On the banks of the world-famous Loch Ness sits the iconic Urquhart Castle. There have been seven 'unidentified creature' Nessie sightings this year alone (2021), so you never know. Urquhart has been described as the greatest castle in the Highlands and visitors today can climb the tower to gaze out over the loch to look for a bobbing head or swishing tail as well as explore the prison cell and great hall.

There are records of a castle on the site from as early as the 6th century and there are stories suggesting that it might have been connected to a King of the Picts, Bridei son of Maelchon. There are also records of St Columba, who was said to have worked miracles there on a visit between 562 and 586. In the 12th century, William the Lion was thought to have used the castle

You can experience a glimpse of medieval life at Urquhart Castle and enjoy stunning views over Loch Ness.

as a royal residence, but the first official record for the castle wasn't until 1296 as it was captured by Edward I of England. This marked the start of the Wars of Scottish Independence, which lasted on and off until 1357. It was back in the hands of the Scots in 1298 for a short time until 1303 but, a few years later, Robert the Bruce completed his defeat of the Comyn and marched through the Great Glen, taking the castles of Inverlochy, Urquhart and Inverness. This made Urquhart an official royal residence held by a succession of constables. David II spent the summer of 1342 hunting there – the only king to have stayed at the castle.

Urquhart Castle was in a risky position over the next couple of hundred years. It was raided frequently and fell into different hands. In 1476 it was handed over to Scottish nobleman the Earl of Huntly, who brought in Sir Duncan Grant of Freuchie to restore

order to the castle and surrounding areas. The Grants kept it until 1512. The Macdonald Clan and their allies the Camerons raided the castle in the Great Raid, stripping it of furniture and its gates. The Grants regained the castle after this and spent years restoring it. This seemed to be fruitless however, as in 1688 James VII garrisoned the castle with his own soldiers to oppose 500 Jacobites. When the soldiers finally left, they destroyed the gatehouse to stop Jacobites from taking up residence there and it was never repaired. It was regarded as a romantic ruin by the 19th century and is now in the care of Historic Environment Scotland. It's Scotland's third most visited castle after Edinburgh and Stirling. On our visit I was reminded of Dunottar in Aberdeenshire with the wonderful water views and steep climb.

Just under two hours' drive away from Loch Ness – a very beautiful drive at that – lies Kyle of Lochalsh where we found one of the most instantly recognisable castles in the world, Eilean Donan.

Many people believe that Eilean Donan Castle is on Skye but it's actually on a small tidal island near the village of Dornie in the Highlands.

It was built around the 13th century as a defensive measure to protect against the Vikings, who controlled much of the north of Scotland and the Western Isles between 800 and 1266. Like other castles built around this time, it expanded over the centuries and was thought to be the largest medieval castle in Scotland – the structure took up nearly the whole island. However, by the 14th century, it was about a fifth of its size due to the number of men needed to defend it.

In 1719 the castle was garrisoned by Spanish soldiers who were supporting the Jacobites. The English government sent heavily armed ships to put a stop to the uprising and the bombardment of the castle lasted three days.

It lay abandoned for over 200 years until Lieutenant Colonel John MacRae-Gilstrap bought the island in 1911 and dedicated

Eilean Donan Castle is one of the most recognisable in Scotland.

the next twenty years of his life to its reconstruction. The MacRae family still own the castle today. Sitting on an island where three great sea lochs meet, it is notable for its long-arched bridge and overlooks the Isle of Skye.

The castle was used on screen in the 1986 film *Highlander* as the castle and village of Glenfinnan. The film starred Sean Connery and Christopher Lambert and has become a favourite over the years. It was also a location in the 1996 classic with Ted Danson and Joely Richardson, *Loch Ness,* and it was used as the Scottish headquarters of MI6 in the James Bond movie *The World is Not Enough* in 1999.

A smaller version of the castle made the headlines in 2021 as a Scottish driving instructor created an amazingly realistic model

of Eilean Donan during lockdown. The contours of the island were made by mounting wooden slats on top of one another. It even has real grass. Coaches with visitors come to see the model.

Up in Sutherland you can find the French chateau-style building Dunrobin Castle, which looks like it is made for a Disney film with its majestic turrets and spires. But the structure actually has origins in the Middle Ages. The castle has been home to Earls and Dukes of Sutherland since the 13th century. There has been a castle on the site since the earldom, one of the seven ancient earldoms of Scotland, was created in 1235, although the building visitors can see today mainly consists of additions and gardens added by Sir Charles Barry between 1835 and 1850. Sir Charles, who was one of the architects of the Houses of Parliament in London, was inspired by Queen Victoria's new residence at Balmoral. It served as a hospital during the First World War.

After the death of the 5th Duke in 1963, the earldom and dukedom of Sutherland were separated and the castle became a boys' boarding school.

As well as the castle itself, there is a museum, fine gardens and even a falconry.

Although it looks like a fairytale castle, it does have a dark side, and a ghost is thought to roam the upper floors. The Dunrobin ghost is apparently the spirit of the daughter of the 14th Earl of Sutherland in the 17th century, Margaret Gordon. The story goes that Margaret fell in love with someone her father didn't approve of, so he locked her in the attic of the castle. She tried to escape with the help of a maid but while she was climbing out the window down a rope her father came into the room and Margaret lost her grip and fell to her death.

Near Sutherland in Caithness lies the Castle of Mey which is thought to have been built in the 16th century for George Sinclair, the 4th Earl of Caithness. There was probably an earlier building

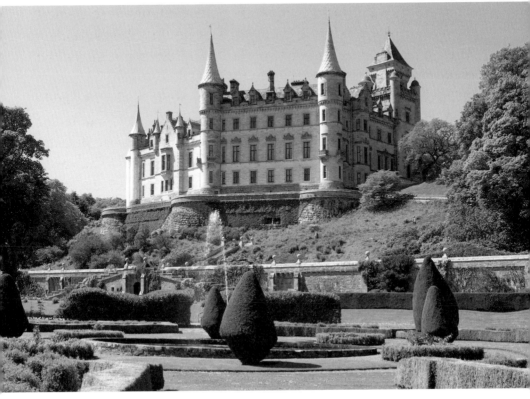

The French chateau-style of Dunrobin Castle makes it look straight out of a Disney film.

on the site. It is not quite as grand as Dunrobin, but Tudor Gothic alterations made in the 17th and 18th centuries make it a particularly striking building. George Sinclair's son William inherited it and founded the Sinclairs of Mey, giving the castle its name but it later become the seat of the earls and the name changed to Barrogill. It stayed with the Earls until the early 1900s when it was bought from outside the family and then became an officers' rest home during the Second World War.

It had a new lease of life in 1952 when it was purchased by the Queen Mother, who wished to refurbish it as a holiday home. The castle was made watertight and liveable, was supplied with electricity and water for the first time, and reverted to its original name. The Queen Mother visited every August and

October from 1955 until her death in 2002. In 1996 she opened the Queen Elizabeth Castle of Mey Trust which opened the castle and garden to the public. This is still the case today. It's a popular spot for tourists; Orkney can be viewed on a clear day and the castle is captivating.

Also in Caithness is the spooky structure of Old Keiss Castle, which forms a formidable silhouette over Sinclair's Bay. It was built in the late 16th century or early 17th century for George Sinclair, the 5th Earl of Caithness, but looks to have replaced an earlier fort. It was built as a Z-plan tower house with four floors, an attic and a basement. By 1700 it was described as ruinous and today looks like something out of a gothic horror film. It is not recommended for exploring as it looks like it might crumble into the sea at any moment.

Cawdor Castle in Nairnshire, north of Inverness, is another sight to behold, and another one with a resident ghost. It was inhabited by the Cawdor family for over 600 years and was constructed around a legendary holly tree. The Thane of Cawdor is said to have wanted to build a new castle, and sent his donkey out to roam the district with a coffer of gold on his back. Wherever he lay down to rest would be the location of the new castle. The donkey chose to sleep under a holly tree which is now the base of the old tower. The castle is another to have links to 'The Scottish Play'. The title character in *Macbeth* is made the Thane of Cawdor, but the castle was built years after the 11th century king was written about. It's been expanded many times, and it is particularly renowned for its impressive gardens. The ghost is thought to be the spirit of the daughter of one of the 18th century Earls of Cawdor, Muriel. With a story similar to Dunrobin, the daughter fell in love with someone from a rival clan and her father caught her as she was climbing out her window to meet him. In a rage he chopped off her hands, sending her falling to her death. Various visitors have reported seeing a ghostly, handless woman in a blue dress.

Even by 18th century standards, the actions of the earl seem pretty drastic.

Dalcross Castle, meanwhile, is a restored 17th century tower house standing on a ridge. The L-plan castle was owned by the Frasers of Lovat who built it in 1620 before it was passed to the Mackintoshes. It was later abandoned but was restored in the 20th century and reoccupied by descendants of the Mackintosh lairds. Today the owner of Dalcross has modernised the interior for guests while it maintains the essence of the historic building. It's the perfect place to stay while exploring the Highlands.

You don't have to be a laird or earl to stay in a castle now and there are various castles you can visit for a truly authentic experience. Tulloch Castle in Dingwall near Inverness dates back to the 12th century. It was owned by the clans Bains and then Davidson and offers sensational Highland views. It was used as a hospital following the evacuation of Dunkirk. It's another castle thought to be haunted by a 'green lady', so guests might not be sleeping alone. The castle has many original period features such as the 250-year-old panelled Great Hall and restored fireplaces and ceilings.

Kilravock Castle, pronounced Kilrawk, lies between Inverness and Nairn and began construction in around 1460. It's been used as the chief seat of the Clan Rose. The name translates to 'church on a rock'. It started life as a 15th century tower with five storeys but was extended in the 16th making the building an L-plan shape. It was extended again in the 17th century, adding the entrance and stairway and making it a very large castle by today's standards. Mary Queen of Scots (she really did get about, didn't she?) visited in 1562, and the 17th laird, Hugh Rose, entertained Bonnie Prince Charlie there before the Battle of Culloden in 1746. In 1787 the castle hosted Robert Burns, and later Queen Mary, the grandmother of the current Queen. Although it's been in the Rose family for many years, it was used as a Christian Centre from 1967. It was given to the Kilravock Christian Trust in 1984.

It used to be a bed and breakfast, but unfortunately the castle is now closed to the public. There was also once a family museum within the castle with contained gems such as the punch bowl used to serve Bonnie Prince Charlie and boots worn at the Battle of Culloden.

One castle you can still stay in is Mingary Castle near Kilchoan. This 13th century structure is nestled on a ridge of rock and overlooks the Atlantic Ocean. It's thought to have been constructed for the MacDougalls or the MacDonalds of Ardnamurchan and King James IV of Scotland used it as a base to fight off Clan Donald in the 15th century. Its strategic location by the water was perfect to serve the interests of the Lord of the Isles against the wishes of the Crown. The Crown found this area of the Highlands difficult to control, but after the assassination of Angus, Lord of the Isles, in 1490, Chief of the Maclans, John Maclan, took on the castle and was very much on the side of the king. King James IV visited in 1493. The castle was besieged in 1515 and again in 1517. In 1588 it was the target of an unsuccessful three-day siege by the ship *San Juan de Sicilia* of the Spanish Armada. After a feud with the Campbells, Sir Donald Campbell took control of the castle in 1628.

After that the castle fell into a ruined state and lay abandoned. For many years it sat empty, until a £2.3 million restoration enabled it to open as a luxury hotel in 2016. With its own drawbridge and four-poster beds, the hotel has proved popular with those wishing to explore the Highlands in luxury. Because of the age and history of the castle, expert stonemasons were called on to help preserve the original features and historic artefacts. Some discoveries included a hidden chapel, 700-year-old graffiti, bricked up windows and even cannonball fragments. Another thing that was found during restoration work was a creepy sealed-up room filled with human bones. Those renovating the castle found the tiny, 6ft high, 6ft wide room by accident; it appeared not to have been opened for 500 years.

The year before the restoration, in 2006, the Channel 4 TV show *Wreck Detectives* filmed at Mingary as they were trying to uncover a shipwreck directly underneath it that dated back to 1644. Many relevant objects have been discovered there, including four cannons on the seabed.

Castle Tioram - pronounced *Cheerum* - sits on the tidal island of Eilean Tioram in Loch Moidart and is arguably the most beautiful castle in the Highlands. The Scottish Gaelic name is Caisteal Tioram, which translates as 'dry castle'. Sitting in the wilderness, the island is only accessible at low tide. Although it's tricky to find, no one who visits regrets the trip as it is so peaceful, remote and magical.

It was built in the 12th century and was a typical 'gally' castle that controls the seaways. Its strategic position allowed the Lord of the Isles at the time to dominate the area. Although we might find it remote today, at the time it was thought of as the centre of the world. It underwent alterations in the 14th and 18th centuries and was the principal stronghold of Clan Rhaidhri.

There are rumours that Christina of the Isles, a 14th century Scottish noblewoman and leading member of the Clan Rhaidhri, may have hidden Robert the Bruce in the castle, which was her home, when he was a fugitive and hunted by the army of Edward I King of England during the First War of Scottish Independence.

I also like to think that the castle was part of the inspiration for J.M. Barrie's *Peter Pan*. The Scottish author visited the neighbouring island of Eilean Shona in 1920 for a summer. The fantasy feel of the place with its tranquil lochs and dramatic wilderness immediately inspires Neverland, the place where children never grow up. The ruined outline of Tioram against the scenery might have been the basis for Barrie's 'Black Castle' from the original screenplay.

Unfortunately the castle hasn't been used for any adaptations of *Peter Pan*, but Tioram can be seen in the opening montage in *Highlander*, the *Homeland* episode.

Shetland

In terms of castles on the Shetland Islands, it's very much a case of quality over quantity. With only four castles, it's one of the least castle-populated areas of Scotland, even though Shetland consists of more than 100 islands.

Shetland is the northernmost of the Northern Isles located off the coast of Scotland. Known as the islands of opportunities, the Shetlands are as close to Norway as they are to Scotland and boast some of the most glorious beaches in the world. Although there are so many islands, only fifteen are populated.

The Shetlands are well known for their prehistoric heritage, and have Viking culture aplenty, with handcrafted, Viking-style longships to admire as well as ancient ruins. To be there really doesn't feel like being in Scotland at all, especially as the Shetlands have such a rich Norse history and are so close to Norway.

Although stone castles became popular in Scotland in the Middle Ages, hardly any were built in Shetland. The Royal Commission on the Ancient and Historical Monuments of Scotland recorded only Castle Holm, and even then only the ruins remain. The two intact castles you can visit today were built by relatives of the Bruce and Stewart families.

Scalloway Castle lies on the Shetland mainland, the largest of the islands. Many castles in Scotland are tucked away with miles of country road to drive or walk along before you spot them, but Scalloway is the opposite of that. It sits proudly among the boats in the harbour and is a sight to behold.

The castle belonged to Patrick Stewart – unfortunately not the beloved *Star Trek: The Next Generation* actor, although I can

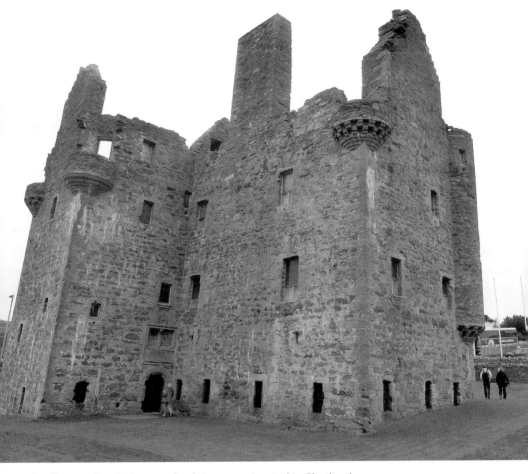

Scalloway Castle is one of only two constructed in Shetland.

imagine the sophisticated Captain Jean-Luc Picard spending his retirement here. This Patrick Stewart was actually the 2nd Earl of Orkney and Shetland. Stewart's father, Robert, was the illegitimate son of King James V and he inherited the title from him. After he was made earl, he began the construction of the castle using his architect Andrew Crawford who also built Muness Castle on Unst, another of the Shetland islands. The castle was not the earl's official residence but was used as a meeting place for the parliament during his rule.

Unlike his thespian namesake, Earl Patrick wasn't the nicest man and was renowned for his oppression of the Shetland people. When building the castle in 1599 he demanded that his landowners contribute workers to its construction, but he offered them no food or drink during the work. He was also known for claiming all driftwood for himself, which was quite a sin on Shetland as there were next to no trees on the islands and driftwood was the only source of timber. People also say that the hair and blood of his tenants went into the mortar to build the castle. He spent a lot of money on the construction as well as other ventures, despite his huge debts. His bad deeds all gave him the nickname 'Black Patie'. Unfortunately for Black Patie, these misdeeds caught up with him as he was eventually executed in Edinburgh in 1615.

The castle L-shaped in plan with a large main tower. An inscription above the door once read, 'Patrick Stewart, Earl of Orkney and Shetland. James V King of Scots. The house whose foundation is on a rock shall stand but if on sand shall fall.'

On researching the castle, I came across something that sounds straight out of Arthur Miller's *The Crucible*. Between 1615 and 1680 Shetland was the scene of witch-hunt mania. Earl Patrick didn't seem to mind these supposed witches on his land, but when his reign was over the new administration wanted to make examples of them. Priests and lawyers of Scotland would hold trials for supposed witches in the Great Hall at Scalloway and those convicted would be strangled or hanged on a rocky outcrop on Gallow Hill in the village and their bodies burned.

Visiting today, guests can tie in a trip to the castle with a visit to the Scalloway museum next door, which is opposite the castle. Run by volunteers, the museum tells the ancient history of Scalloway, times of war and the people. Opening in 1985 on the Main Street, it was Scalloway's first museum and stayed on the premises for twenty years. However, with so many

stories to tell, it was decided that bigger premises were needed and so a larger museum was created next to the castle. It was opened in 2012 by the prime minister of Norway and is run by knowledgeable volunteers.

The now-roofless ruin consists of four storeys and a garret over the main tower. You can still see that the ground level housed a kitchen, store rooms and well, with a hall on the first floor and spiral staircase leading to the upper levels.

With all the nastiness of Earl Patrick and the witch trails and hangings, I was surprised there weren't any ghost stories to come out of Scalloway Castle. Most spooky tales in Shetland seem to be focused on Windhouse – pronounced Windhoose – which is thought to be one of the most haunted places in Scotland.

Although Windhouse is not a castle, you'd be forgiven for thinking it was. Sitting on the island of Yell, the house was built in 1707 and the ruined structure has all the markings of a castle, complete with turrets, battlements and gothic-style windows. It also once belonged to a laird, so it ticks most castle boxes. There have been stories that the house was built on an ancient burial ground and these rumours were bolstered when two human skeletons were discovered just inches under the ground in 2017. Ghostly sightings have included a lady dressed in silk thought to have been a housekeeper who broke her neck falling down the stairs, a servant girl who walks up and down an invisible flight of stairs, and even the spirit of a collie dog. The most recent skeleton discoveries are just the latest of many that have been found over the years. Windhouse was abandoned in the early 1920s and, if you're feeling brave, there is camping nearby.

But back to official castles. The second Andrew Crawford-designed structure in Shetland and the UK's most northernly castle is Muness on the southern coast of Unst, just east of Uyeasound. Crawford also designed Scalloway and Earl Patrick

Stewart's palace in Orkney. The castle was originally built for Laurence Bruce of Cultmalindie in 1598. He was Patrick Stewart's uncle, being the half-brother of his father Robert. Researching the family, it seems that although Laurence Bruce had various disputes with his notorious nephew, he was also known to have oppressed the poor Shetlanders. The disputes climaxed in 1608 when Earl Patrick chased Thomas Black of Whalsay to Muness and tried to besiege the castle. Luckily for Bruce, he was unsuccessful and had to withdraw.

Like his nephew, Bruce was also notoriously mean to the islanders. He had been given the title of Chamberlain of Shetland by Patrick (or possibly his father before him) in 1571 and he used this to exploit the people of Shetland. Bruce raised taxes considerably, making himself very rich and very

Muness Castle is the most northerly castle in the British Isles and was built in 1598.

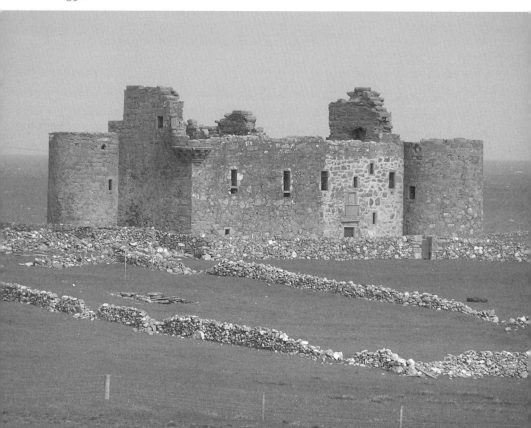

unpopular very quickly. He travelled from island to island with a gang of thugs. He forced people to put them up and feed them so he could eat like a king and not pay.

Laurence Bruce eventually gave the castle to his son in 1612, but it was attacked again in 1627 by privateers from Dunkirk. Although it was occupied after this attack, the Bruce family sold it in 1718, and by the end of the century it had fallen into ruin.

The tower house castle is built in a Z-plan with circular corner towers. The other two corners of the castle have remains of corbelling that would have once supported turrets. Above the entrance there is an inscription:

'List ye to knaw this building quha began Laurence the Bruce he was that worthy man quha earnestly his airis and offspring prayis to help and not to hurt this wark aluayis the year of God. 1598.'

The inscription is similar to Earl Patrick's on Scalloway castle so the two men must have used the same craftsmen. Maybe they didn't hate each other so much after all.

As I'm writing this in 2021, the castle is up for sale. The now grade-A listed building went up for auction with a guide price of £175,000 – which, as an Edinburgh resident, I can tell you is cheap. The sale included 240 acres of land, a Barony title, and mining rights – gold and copper have been discovered in the area. Not bad, as that is the price of a small flat elsewhere in Scotland. Historic Environment Scotland previously ran and maintained the castle as a museum. The ground floor and first floor are in good condition with corbelling supports for small turrets on the east and west corners. And there are some fun architectural details such as the gun loops in the main block and south-eastern tower.

Despite all this, the castle has been proving difficult to sell. The current owner, Gavin Forbes Farquhar, has been trying to

do so for a number of years. Apparently many foreign buyers have been interested, but it seems that the laws in Scotland have put them off. The barony title that was originally offered with the sale has also been questioned.

Whoever does finally buy the castle will have their work cut out. The roofless building has been beaten by the weather since the last conservation work in the 1970s and anyone visiting risks masonry work falling on their head. It would be a pretty amazing project for the right person though, and I can see it being the next luxury B&B on the islands.

While there aren't a huge number of castles on Shetland, there are plenty of other ways to explore the area's rich history. The Lerwick Helly Aa fire festival is now over 140 years old and takes place every year in January. Something that's on many people's bucket lists, the festival is billed as a celebration of Shetland history and showcases the islanders' skills and spirit. A bit like a Scottish/Norwegian Mardi Gras, it's run by volunteers and lasts a whole day and night. Everyone waits with bated breath to see what the head of the festival, known as the 'Guizer Jarl', will wear as representing the Viking chief and what character from the Norse Sagas he will portray. The show is kept secret until the big day. It's not every day you can see crowds of Vikings singing 'From grand old Viking centuries, Up Helly Aa has come...' With a torchlit procession, a burning galley echoes pagan Norse rituals and it's not to be missed.

Sumburgh is home to a fascinating prehistoric and Norse settlement that looks a lot like the ruins of an ancient castle. At Jarlshof Prehistoric Settlement, visitors can delve into more than 4,000 years of human occupation and see where the Neolithic people first came to Shetland in around 2700 BC. As the best-known archaeological site in Shetland, you can still see late Neolithic houses, a Bronze Age village, an Iron Age broch and wheelhouses, a Norse longhouse, medieval farmstead and

a 16th century laird's house. With many nooks and crannies, it's an astonishing site to explore.

Mousa Broch is another captivating old ruin to discover on the island of Mousa in Shetland. It's the best-preserved broch in Scotland and has a winding staircase to the top, around 13 metres high. A broch is a type of Iron Age roundhouse found in Scotland and Mousa. This one is thought to have been constructed in around 300 BC – so it's much older than any castle I've seen, and it features in Norse sagas.

Another of the castles on the Shetland islands is Castle Holm. The remains sit on an islet in the Loch of Strom and are shrouded in mystery. The loch is close to the west coast of the Shetland mainland to the east of Strom and Haggersta. The islet is linked to the shore by a causeway which is partially

Although not a castle, Mousa Broch is a preserved Iron Age round tower and worth a visit when in Shetland.

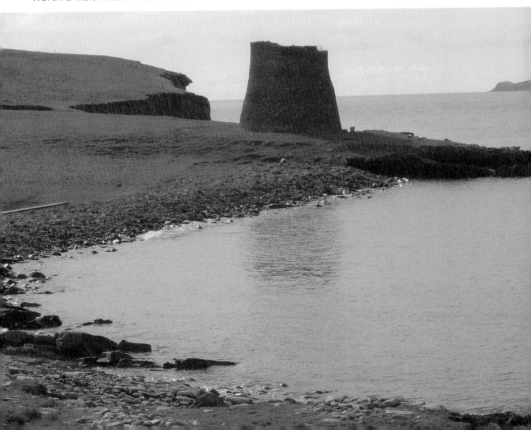

submerged, depending on the tide. Holm is thought to have been built in the 12th century whereas Scalloway and Muness are both 16th century structures. Unfortunately there are very few remains of the castle, just a few low walls. The walls are constructed of rubble blocks and built with shell-lime mortar. It has been suggested that the island was once completely enclosed by a stone wall.

The castle would have been impressive in its day, sitting in the middle of this dark and intimidating loch. Some researchers believe that it may have resembled Cobbie Row's Castle in Orkney, as both castles seem to have a small, rectangular tower. There is also a 12th century chapel in close proximity to both castles; strongholds around this time typically had private chapels.

The remains of Castle Holm sit on an islet in the Loch of Strom and Haggersta.

Some of the magic of the Shetland Islands has been encapsulated in the 1937 Michael Powell film *The Edge of the World* starring John Laurie, who became a household name as Private 'We're doomed, doomed!' Fraser in *Dad's Army*. It was filmed on what must have felt like the edge of the world on the far-flung island of Foula. The film was originally inspired by the true story of the depopulation of St Kilda in the Outer Hebrides in 1930. The island's majestic hills and sheer cliff faces were perfectly suited for the romantic adventure. The distinctive arch of Gaada Stack can be seen during the opening of the film and sets the scene.

Another sight you might be lucky to see while exploring the islands are the world-famous Shetland ponies. For 4,000 years the adorable creatures have roamed the hills and moors. Although they appear to be wild, they are actually owned and tended to by local crofters. Thanks to the unrestricted lifestyle on the islands, these ponies have evolved into a unique and hardy breed beloved by locals and tourists alike. They can usually be found in the West Mainland, Scalloway, Tingwall, Dunrossness and Unst, so there are plenty of opportunities to spot them.

The last castle on the islands isn't really a castle at all but more of a tower. Also known as Mucklaberry Tower, Vaila Tower looks almost cartoonish. The crenelated folly was built in the early 19th century and was probably used as a lookout tower for lairds to oversee their smuggling activities when shipping in goods.

The island of Vaila – which is old Norse for valley – is south of the Westland peninsula of the Shetland mainland. The tower is thought to have been restored in the 1890s. It is two storeys in height and symmetrical, with closely spaced windows, parapet and turrets.

The island of Vaila is also home to one of the finest mansions in Shetland – Vaila Hall, which was built by Herbert Anderton who owned the island in the 1890s and is thought to be the one who restored Vaila Tower. Vaila Hall also looks like a castle, complete with turrets, battlements and even a flag.

Orkney

Like Shetland, Orkney is a group of islands in the Northern Isles of Scotland famous for its gorgeous sandy beaches, rugged cliffs and rich Norse history. Orkney is smaller than Shetland but it has more castles than Shetland – seven rather than four. That is still a small number, but it is another case of quality over quantity.

Kirkwall is the only town in the Orkneys and serves as its bustling capital. It's the Mainland Orkney island, also known as Pomona or Hrossey, which a third of the islanders call home. The town takes its name from the Norse name Kirkjuvágr, later changed to Kirkvoe, Kirkwaa and finally Kirkwall. It has three of the seven strongholds in Orkney.

In the heart of the Orkney capital is the Bishop's Palace, which was built in the 12th century around the same time as St Magnus Cathedral in the centre of the town. It was built in the style of a Royal Norwegian palace and had a tower house with a large hall above storerooms for the private home of the bishop. Bishops were very important figures in medieval times and required an impressive home to accommodate royal guests near their cathedral.

There is much history attached to the building as King Haakon IV of Norway died at Kirkwall Castle in 1263 and this marked the end of Norse rule over the Outer Hebrides. The building fell into ruin shortly afterwards and was completely abandoned by 1320. The ruins look like a small castle. In 1526 it was owned briefly by William, Lord Sinclair, before he had to return it to the Bishop of Orkney. In 1540, King James V of Scotland visited Kirkwall and garrisoned his troops in both the palace and

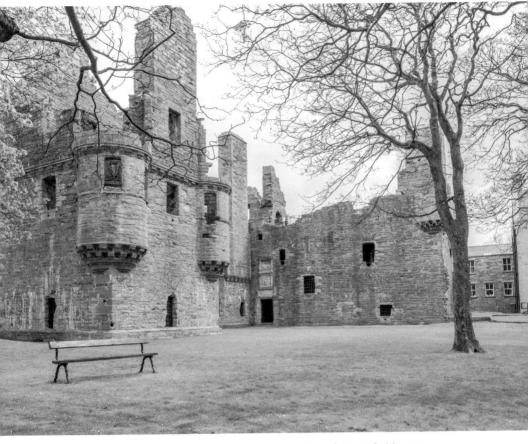

The Bishop's Palace was built at the same time as the adjacent St Magnus Cathedral in the middle of Kirkwall.

Kirkwall Castle. The last of Orkney's medieval bishops was Bishop Robert Reid (died 1558), who began restoration of the castle and added the round tower called Mossie Toor. The castle was passed to the 1st Earl of Orkney, Robert Stewart, in 1568, and then to his son Patrick.

Opposite the Bishop's Palace is Patrick Stewart's other beloved residence, the Earl's Palace. Patrick planned to add it to the Bishop's Palace. Patrick began construction of the Earl's Palace in 1607. The reason Earl's Palace was built in the first place was because Patrick felt that the Bishop's Palace wasn't good enough for him. Patrick wanted to make Earl's Palace the

epitome of comfort, beauty and luxury. But he built up massive debts doing so and was arrested shortly after its completion in 1607. He was imprisoned in 1609. Patrick managed to cause disorder even while a prisoner, as he organised a revolt against King James VI and ordered his supporters and son Robert to capture the Palace of the Yards, St Magnus Cathedral and Kirkwall Castle, but they were forced to surrender after two months. He was executed in Edinburgh in 1615. The Earl's Palace then became home to the Orkney bishops. In the early 16th century the palace was left to ruin, and by 1745 the roof had been removed. It has remained that way ever since.

When visiting today, you can go right to the top of the roof, where you can see from the remaining stonework how grand it must have been. There are two large sections next to each other that form an 'L' shape, and there is still the grand stone staircase. Venturing into the great hall, you can still see the elaborate high-vaulted windows and two huge fireplaces – the hall was once described as one of the finest state rooms of any castle in Scotland.

There are actually two earl's palaces on Orkney. As well as the building in Kirkwall, there is another with the same name on the island of Birsay. Birsay is an important place in Orkney as it hosts the remains of a Pictish settlement, with evidence of Viking buildings.

Kirkwall Castle, also known as King's Castle, was built by Henry Sinclair, Earl of Orkney, when he was given the title of earl in 1379 by King Haakon VI of Norway, who ruled Orkney at that time. It was the original residence of Robert Stewart – who we know as the illegitimate son of King James, half-brother of Mary Queen of Scots and father of Patrick Stewart. Between 1569 and 1574 towers, a grand staircase, and four wings surrounding the main courtyard were built in the Renaissance style. There is an inscription above the entrance dated 1574. From what we know of the Earls of Orkney the castle was built

for grandeur. It had painted ceilings and bright wall-hangings. But thanks to the Earl's harsh rule over the people of Orkney, it was also used as a fortified residence with gun holes in every wall. It was only used for a short time, as the Stewarts' reign came to an end in 1615 when Robert's son Patrick was arrested. By 1700 the roof of the castle was gone and the whole building lay in ruins.

In its heyday Kirkwall Castle was known as one of the strongest castles in the region, so much so that cannonballs were said to split against its walls. This strength was tested in the early 17th century when Patrick Stewart, 2nd Earl of Orkney, fought with Laurence Bruce, Sheriff of Shetland. After Stewart was arrested, his son Robert rebelled against King James VI and occupied Kirkwall Castle as well as the Earl's Palace and Bishop's Palace. George Sinclair, 5th Earl of Caithness, led the royal troops against the rebels and Kirkwall surrendered. In 1614 the Privy Council of Scotland ordered the castle to be destroyed so it couldn't be used as the centre of a rebellion again. The ruins stood until around 1742 when James Douglas, 14th Earl of Morton, gave the stones to the Town Council to use for a town house and jail. By 1865 there was only a 55-foot section of wall remaining, and that too was eventually removed, to make way for Castle Street.

Some remains of the castle were uncovered by the Orkney Research Centre for Archaeology (ORCA) during some road infrastructure work in the centre of the town in 2019. Three walls were discovered, including a possible curtain wall and two main castle walls, as well as some cobbled surfaces. Digs in the 1980s also revealed huge stone walls that may have been part of the castle's foundations. These discoveries give a great insight to the castle's layout since nothing remains above ground. It's amazing that, after all these years, remnants are still being found. The castle is free to visit today and is still fascinating to explore.

Over in Balfour, on the island of Shapinsay, lies one of the most beautiful buildings on all of the islands of Orkney – Balfour Castle. Balfour is the name of the village on the island; it has a picturesque harbour and streets. The castle dominates the south-west end and, because of its size, it's the first and last thing that visitors see when crossing on the ferry to and from Kirkwall. The building consists of around 7 turrets, 12 exterior doors, and 52 rooms. The interior has been described as looking like a French château.

The castle was built for David Balfour, who inherited the land from his grandfather Thomas in 1846. Edinburgh architect David Bryce was hired to create the castle and it was completed in 1848. There was an original house on the site called Cliffdale

Balfour Castle is a historic building on the southwest of Shapinsay.

and some of this still exists within the castle. The castle stayed in the Balfour family until 1960, when the last family member died.

It was recently used as a luxury hotel and held the title of the most northernly castle hotel in the world. It's now used as a private residence, but visitors still get a great view of it when crossing on the ferry.

At just over a square mile, the island of Wyre is one of the smaller inhabited islands in Orkney. It was part of Norway for over 600 years and is home to one of the oldest castles in all of Scotland. Cubbie Roo's Castle was built around 1150 and is named after the Viking Kolbein Hruga, who is said to have lived there. It's strange to think of a Scottish castle with such

Orkney contains some of the best-preserved Neolithic sites in Europe.

a strong Norwegian history. Even stranger is that there are no Norse castles at all in Scandinavia and Cubbie Roo's is one of only two to have been unearthed in the UK.

The castle was mentioned in the *Orkneyinga Saga*, which is a narrative of the history of the Orkney and Shetland islands and their relationship with Norway and Scotland. The original saga was written in Norse in the 12th century. It's thought that the last Norse Earl of Orkney, Earl John, was murdered in Thurso and the culprits fled to Wyre, taking refuge in the castle. When visiting the castle today, the foundations are clear to see and explore along with some stone steps and clearly defined rooms.

Another fascinating tiny island on Orkney is Eynhallow, which translate as Holy Island. It is not inhabited. It was abandoned in 1851 when there was a suspected outbreak of typhoid. It is reminiscent of the fictional Scottish village of Brigadoon, as visitors can only access the island one day a year. Although not a castle, the centrepiece of the island is Eynhallow Church, which dates from the 12th century or even earlier and may have formed part of an early Christian monastic settlement. The roof is thought to have been torn down when the island was abandoned, but otherwise it is reasonably well preserved. The island is shrouded in Orkney folklore. It is thought to have been the original home of the Finfolk, who were shapeshifters feared by mortals. I didn't visit this mysterious place and, as captivating as it is, I am in no hurry to do so.

Noltland Castle on the island of Westray in Orkney looks like a typical 16th century Scottish castle and has a colourful history. Guides often encourage guests to count the gun-holes in the stone, but few manage to catch all seventy-one of them.

Westray has only 600 or so residents, but it is a fascinating place to visit. Some archaeological sites date back to 3500 BC and there are the remains of some Viking settlements, as well as magnificent sea cliffs. Excavations on the island continue and have so far revealed more than thirty Neolithic or Bronze

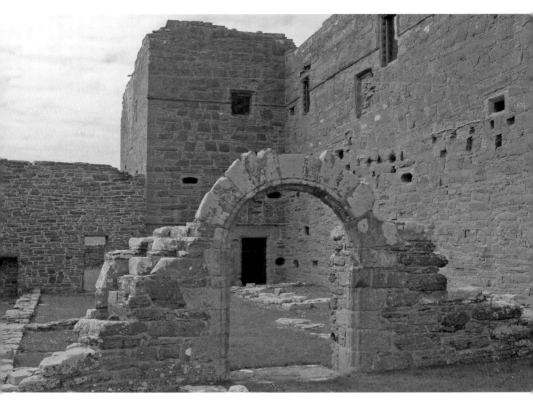

Noltland Castle was built between 1560 and 1574. Guests are encouraged to count the 71 gun holes.

Age buildings. In 2015 a large subterranean building from the Bronze Age was discovered in a good state of preservation. It is thought to have been a sauna.

Noltland Castle is just outside the main village of Pierowall. It has a Z-plan form but was never finished. It was built by Gilbert Balfour, who was given the land by his brother-in-law, Bishop of Orkney Adam Bothwell, in 1560. Balfour was Sherriff of Orkney and Master of the Royal Household to Mary Queen of Scots. He was also thought to be involved in the plot to kill Queen Mary's second husband, Henry Stuart, Lord Darnley. He inscribed a bible verse over the entrance to the castle: 'WHEN I SEE THE BLOOD I WILL PASS OVER YOU IN THE NIGHT.'

He had already been implicated in the murder of Cardinal Beaton in St Andrews in 1546, and following Queen Mary's arrest in 1567 he fled to Noltland Castle as he continued to support her. But the castle was seized by Robert Stewart, the first Earl of Orkney, an opponent of Queen Mary's supporters. Stewart was made to hand the castle back to Balfour in the early 1570s. Balfour was executed in Sweden in 1576 and the castle was seized again by Stewart's son Patrick.

The seventy-one gun holes in the stone of the castle is by far the largest number of any Scottish castle. They would make the castle intimidating to intruders and a good place for Gilbert Balfour to hide out.

By 1606 the castle was back in the possession of the Balfour family and was sold to Sir John Arnot, Lord Provost of Edinburgh. But during the Wars of the Three Kingdoms in 1650, Royalist officers took the castle after they were defeated at the Battle of Carbisdale, and local Covenanters captured and burned it. By the 19th century the castle was in a ruined state and is now maintained by Historic Environment Scotland.

Today, the ruins are thought to be haunted by 'The Boky Hound', a dog who lived at the castle and belonged to one of Gilbert Balfour's brothers, Sir David, around the time of the Crusades. Sir David, a notorious drunk, lived there with his wife. His wife soon grew tired of him going hunting all day and coming home inebriated, and took the rather drastic action of murdering him. When Sir David arrived home one day and demanded a drink, she brought him one laced with poison, but just as he was about to take a sip his pet dog jumped up on him and spilled it. Not realising that his furry friend had just saved his life, Sir David killed the poor dog with his sword. Several years later Sir David was in Turin on crusade when he heard a dog howl. He promptly collapsed and died. His wife was found dead in the castle at the very same time. Ever since these strange occurrences, people have reported seeing a phantom dog in the

castle. It is believed to howl whenever there is a death in the Balfour family. A ghostly canine certainly makes a nice change from various white, red and grey ladies.

Noltland Castle is not the only haunted building in Orkney. Skaill House, which is described as a castle but isn't really, hit the headlines in 2018 after a photographer seemingly caught an apparition on camera at the window of the building when there was nobody there. Skaill House overlooks the Bay of Skaill on Orkney's west mainland coast. It was built in 1620 for the Bishop of Orkney of the time and added to over the centuries. Earlier inhabitants also left their mark. The southern wing of the house was built on a pre-Norse burial ground and several Bronze Age burial mounds have been found nearby. Perhaps it's no wonder that ghosts have been spotted. There have also been reports of strange noises, smells and things moving on their own. If that doesn't faze you, the house is open as a tourist attraction, has self-catering apartments, and offers a unique venue for weddings.

Another structure that's worth a visit is Hackness Martello Tower and Battery. These buildings are part of the extensive military remains on the island of Hoy. Built in the early 19th century, the tower and battery were created to provide defence for British convoys during the Napoleonic Wars. French and American warships were attacking British and Scandinavian merchant ships travelling around Orkney. Today the battery includes reconstructed living quarters and you can get a fantastic view by climbing on top of the towers.

Another must-see while in Orkney is the Old Man of Hoy. This mysterious 449-foot sea stack is an amazing natural wonder created by the erosion of a cliff. It's several hundred years old but will not be around forever as it will collapse into the sea soon or later. It's popular with mountaineers, being first climbed in 1966. In 2017 someone even completed a tightrope walk to and from the summit.

The site is so other-worldly that is was recently featured in the 2016 Steven Spielberg film *The BFG*. A popular spot for filming, Hoy was also used as a location for the 1939 film *The Spy in Black*, a follow-up to British director Michael Powell's Shetland flick *The Edge of the World*. Starring Sebastian Shaw, *The Spy in Black* is a racy spy thriller set during the First World War and Orkney is used as the naval base for the British fleet. The movie version of the 1985 novel *A Twelvemonth and a Day* was also filmed in Orkney. And the 1989 movie *Venus Peter* is a story of childhood in a fishing village. Although the book is set in the East Neuk of Fife, the islands of Orkney provided the perfect environment to recreate the 1920s/30s feel of the story.

Outer Hebrides

I always think the Outer Hebrides seem further away than they are. Don't get me wrong, they are not exactly on Edinburgh's doorstep, but I was pleased to discover that a flight from the capital to Stornoway airport on the Isle of Lewis takes only just over an hour.

The Outer Hebrides are sometimes known as the Western Isles and are an isolated island chain off the west coast of mainland Scotland. Residents on these islands have traditionally made a living by fishing, weaving and with livestock, although renewable energy is a big up-and-coming business. I've always found the group of islands fascinating as they are packed full of stone structures, medieval churches, and breathtaking scenery. Some archaeological sites, with their Celtic roots running deep, are open to the public to explore. When looking at images of the Outer Hebrides, you'd be forgiven for thinking you were looking at photos of somewhere in the Caribbean. The beaches are some of the most beautiful in the world, with clear blue seas and white sands.

Despite living in Scotland my entire life, I know very little Scottish Gaelic – or any kind of Gaelic for that matter. In fact, I only know one word, *Slainte*, which basically translates to *Cheers*. This is despite the best efforts of Scottish television when I was younger. I have the utmost respect for trying to keep the language alive, but I found nothing worse while bored as a kid than finding an episode of *Postman Pat* on TV and realising that he was speaking Gaelic. Today's kids, who can stream anything ever made at the touch of a button, will never know my pain.

In the Outer Hebrides, however, Gaelic is still used a lot, which will confuse many an English-speaking Scot. It is sometimes known as the Gaelic heartland, with street signs being in the native tongue, the occasional English sign accompanying it. Locals are always happy to translate, but a phase book might not be a bad idea. Another thing you'll need when exploring the islands is a car. There is a bus service, but this won't allow you to experience everything the islands have to offer.

With all the history, I was surprised to learn that there are only seven castles on the islands – the same number as Orkney – but each and every one is a treat to explore.

The biggest island of the Outer Hebrides is known as Lewis and Harris. The Harris end is separated into North and South Harris with the north being known for its mountains and the south for its beaches, especially Luskentyre and Scarista. It is known for its miniature fjords and the luxury clothing brand and knitwear company Harris Tweed. It's also home to Amhuinnsuidhe Castle, where visitors can spend the night.

Originally used as a hunting lodge, Amhuinnsuidhe Castle is new compared to others in Scotland, having been built in the 19th century. Its original name was Fincastle and was built in the Scottish baronial style by architect David Bryce between 1864 and 1867 for the 7th Earl of Dunmore, Charles Murray. Some of Bryce's other works include Fettes College in Edinburgh and Balfour Castle in Orkney. The owner, Charles Murray's mother, Lady Catherine, set up an embroidery school and encouraged the Harris Tweed brand.

One of the coolest things about Amhuinnsuidhe (pronounced *avin-suey*) is that it was the place which inspired *Peter Pan* author J.M. Barrie. The Scot wrote another of his famous plays, *Mary Rose*, while staying at the castle in 1912. Based on the Celtic legend of faeries and Tír na nÓg, the land of everlasting youth, it is the story two strange disappearances of Mary Rose from a small Scottish island. The first one is when Mary Rose

Amhuinnsuidhe Castle is a large private house on Harris built in the Scottish baronial style.

visits the island aged 11 with her father and disappears while he is fishing. She's gone for several weeks and reappears just as suddenly as she vanished with no memory of where she went. As an adult, she travels to the island again with her husband and young son and disappears again, but this time for decades. When she returns, she has no memory of what has happened and has not aged a day. The story clearly shares the theme of not getting older with *Peter Pan*.

While staying at Amhuinnsuidhe, Barrie will not have seen the friendly ghost of Lady Sophie Scott, former resident thought

to roam the halls after she died in 1937 and was buried within the castle. But she has certainly spooked more recent guests, including the cast of *Call the Midwife*. The Christmas special of the popular TV show was filmed around the Outer Hebrides in 2019 and the cast stayed in the castle. Show boss Heidi Thomas said at the time that the castle 'was complete with a ghost and a dinner gong' and 'resembled the setting of a murder mystery'. Although the cast raved about the castle and how lovely their experience was, one of the actors, Laura Main, had the Lady Sophie room, which nobody told her about until afterwards. However, they were told the ghost is friendly, so no one was too spooked.

Another TV link with the castle is that Rosemary Shrager, who appeared in *I'm a Celebrity...Get me Out of Here!* and *The Real Marigold Hotel*, once ran a cookery school there.

Today the castle is a luxury hotel which is popular due to its romantic seaside location with views to South Harris and the islands beyond. Some TripAdvisor reviews describe staying at the castle as like being guests of a family. The castle is also a family home.

Ardvourlie Castle was also built for Charles Murray, the 7th Earl of Dunmore, as a hunting lodge, in 1863 – I don't know how many hunting lodges this chap needed. The building sits on the banks of Loch Seaforth and was once owned by the famous aeroplane manufacturer and pioneer Thomas Sopwith, whose company built the famous First World War fighter the Sopwith Camel. It was soon forgotten about by Charles Murray and overshadowed by the much grander Amhuinnsuidhe Castle. Over the years it has had many owners and been updated and improved, including a new wing created from an old workshop; but period features remain. In 2009 the property was up for sale for £695,000. The price included thirteen acres of land with a mix of woodland, open hillside, courtyard and lawns complete with sandstone steps leading down to the stone jetty on to the loch.

One of the most famous structures on the northern part of the island, the Isle of Lewis, isn't a castle. The Calanais Standing Stones (or, in Gaelic, *Clachan Chalanais* or *Tursachan* Chalanais) are an arrangement of standing stones in a cross pattern which were erected over 5000 years ago. This predates Stonehenge in Wiltshire by 2000 years. They are thought to have been the focus of a ritual activity in the Bronze Age and are near the village of Callanish. The great thing about them is that they are a free attraction and guests are able to get up close – unlike Stonehenge in both respects. They inspired animators from Disney, with the stones featuring in the *Brave* tour of Scotland.

The Isle of Lewis has a castle to explore – not quite as old as the stones. Lews was built between 1844 and 1851 for Sir James Matheson to use as a country house. Matheson had bought the whole Isle of Lewis in 1844 with his fortune from the Chinese Opium Trade, getting rid of over 500 families in the process and packing them off to Canada. The castle was designed by Glasgow architect Charles Wilson.

The castle and estate remained with the Matheson family until it was bought by philanthropist and politician Lord Leverhulme in 1918. He gave it away to the people of Stornoway parish in 1923. The castle was then used as accommodation for the air and ground crew of 700 Naval Air Squadron in the Second World War. After the war, in the 1950s, it was used as accommodation for students of Lews Castle College. Then it was left abandoned for years until in 2011 it was awarded £4.6 million by the Heritage Lottery Fund for conversion into a museum and cultural centre. It opened to the public in 2016, and in 2017 a property company opened apartments in the castle so visitors can now stay there. The apartments are all unique in character and offer sweeping views of Stornoway Harbour, where guests might be lucky enough to see bobbing seals.

It was also in 2017 that Lews made it through to the final of Channel 4's *Great British Building Restoration* competition. The

Lews Castle casts a striking silhouette on the Stornoway skyline.

castle was named joint winner of the Victorian category with Mount Stewart in Northern Ireland. The judges were impressed with the restoration in the gothic revival style, along with more modern ideas such as the painted starry ceilings and pink touches.

When the castle opened after its renovations in 2017, some former staff from its days as a residential college in the 1950s were invited along to tell their stories of living within the walls. The luxurious bedrooms used to be the living quarters for the kitchen, laundry and domestic staff, where it would be four ladies to one room. In a news article from the *Stornoway Gazette* at the time, a couple of the ladies joked about moving fast up and down the spiral staircase as 'that's where the ghosts were'.

The museum has some of the famous walrus ivory Lewis Chessmen which were discovered on Lewis in 1831. It was great to see these remarkable chess pieces again. As a teenager, I had a part-time job at the National Museum of Scotland in Edinburgh where some of the pieces were on display – the rest are at the British Museum in London.

The gardens of Lews Castle were on Channel 5's *Secret Scotland* in 2020. The programme looked at a link between a hand-painted fern mural in the castle and a plant species that grew in the gardens and conservatory. The garden was restored as part of the funding from the Heritage Lottery Fund. The murals of the ferns were said to have been displayed in Lady Matheson's morning room with the plants themselves growing mainly in the conservatory where the museum is now. Ferns were very popular in the Victorian age and the murals are now the only remaining evidence of this fern species.

Apart from Lews, the Isle of Lewis doesn't have any other castles, but it is home to a chapel. Located in the crofting village of Aignish, east of Stornoway, lies St Columba's Church Ui – *Eaglais na h-Aoidhe* in Gaelic. The ruins of this structure are one of the most important archaeological sites on the island as it was the main church in the medieval period and the burial place for the chiefs of the Macleod and Mackenzie clans. It is thought to have been built in the 14th century but was extended in the 16th on the site believed to be the cell of St Catan, a contemporary of St Columba. It is now open to visitors and was last used for worship in 1829.

The second largest of the Outer Hebrides, South Uist, has two castles. It also has a nature reserve and lots of archaeological sites to explore, and is the only place in the British Isles where prehistoric mummies have been discovered.

The first castle is Calvay, which sits on an islet near the island of Calbhaigh, from which it is linked to a causeway. Not much is known about the now-ruined structure except that it may have

been built by the MacRuarie family of Garmoran or possibly the MacNeils of Barra. Bonnie Prince Charlie is thought to have hidden there in June 1746 while running away from the Duke of Cumberland's troops after the Battle of Culloden, the final conflict of the Jacobite rising of 1745. Today there is not much of the castle to see, just some low, jagged walls.

The other castle on South Uist is Ormacleit Castle – sometimes spelled Ormalcate – a ruined mansion house built in the 18th century by Allan Macdonald, chief of Clan Ranald. The first Ormacleit was built in the 16th century by another Allan Macdonald, the 9th chief of the clan, and parts of this original building may still be present today. It's thought to have been one of the last true castles to be built in Scotland. In 1715 Macdonald was killed in the Battle of Sheriffmuir and his castle burnt down on the same day. The chief of Clan Ranald's seat was then moved north and the castle abandoned. When visiting today, you need to be aware that the structure is not safe and so it's very much a case of 'look but don't touch'.

Another thing you must check out while on South Uist is Dun Torcuill, a 2000-year-old prehistoric island fort, or broch. It is known as one of the most distinctive ancient monuments in Scotland. The tiny island is connected to the shore by a causeway and the broch occupies the south-east and largest portion of the island. A broch is essentially an Iron Age drystone hollow-walled structure found in Scotland and Dun Torcuill is the best example. It is not a castle, but the ruined structure could easily be mistaken for one. Visiting today can be problematic, and you have to be confident enough to tread across slimy stones to reach it. But many people do. So interesting are the ruins that, in 2019, some illegal excavations took place at the site. The tower was damaged during the illegal dig so it's no wonder people were upset.

Over on a small island just off Barra is the spectacular Kisimul Castle, which was used as the chief seat for the Macneils of

Kisimul Castle is also known as the 'Castle in the Sea'.

Barra. One of the best ways to get to Barra is by plane. The plane may be barely larger than a family hatchback, but passengers are in for a treat when landing as the plane touches down on the beach at Cockle Strand. It's a wonderful place to visit and the most southerly of the inhabited Outer Hebrides islands.

The Macneil family are thought to have settled in Barra in the 11th century, and the first Macneil to be made lord was Gilleonan Macneil in 1427. It was he who, most likely, had the castle built.

The island was a Viking stronghold in the 11th century. The Macneil clan may have been involved in piracy, which may be why the castle is in the middle of the sea.

The castle was abandoned when the island was sold in 1838. The building deteriorated until the remains were purchased by the new chief of Clan Macneil, Robert Lister MacNeil, in 1937. Macneil attempted to restore the castle while his family used it as a holiday home – I wonder how comfortable it was. In 2001 it was leased to Historic Scotland – now Historic Environment Scotland – for 1000 years for the princely annual sum of £1 and a bottle of whisky.

In 2013, members of Clan Macneil and Historic Environment Scotland raised £200,000 for the castle to undergo conservation and archaeological work in the hope that it would uncover clues to castle life in the Middle Ages. The work unearthed some interesting items, including what is thought to be some Iron Age pottery, flint cores and animal bones.

To reach the castle you have to hop on a boat from Harbour Bay on Barra, which adds to the excitement. The boat takes you right to the entrance of the building, so you basically step off the boat and into the castle. You enter a small courtyard that almost looks like a mini village where you can see the now-blocked-up original entrance. There are many plaques dedicated to various Macneils over the centuries.

Sometimes known as the castle in the sea, the Gaelic name is *Caisteal Chiosmuil,* which translates to 'castle of the rock of the small bay'. Makes perfect sense.

The last castle to explore is over in Torlum on the Isle of Benbecula which sits under North Uist. In Gaelic, Benbecula is known as *Beinn na Faoghla,* which means 'mountain of the ford'. The island has only one hill, Rueval, which is used as a stepping stone between North and South Uist. Like its sister islands, Benbecula has several beautiful lochs, making it the perfect place to fish for brown trout. Bird watchers will be

excited to spot buzzards, hen harriers, short-eared owls and golden eagles.

Borve Castle, also known as Castle Wearie, and *Caisteal Bhuirgh* in Gaelic, dates between 1344 and 1363. Of all the castles I've researched and visited, this is the only one I've found that was built for a woman. Amy MacRuairi was the first wife of John, Lord of the Isles, and the castle was built for her.

Daughter of Ruairi, Chief of the Clan Ruairi. She married John of Islay in around 1337 and had three sons and one daughter. As her brother, Ranald, was killed in 1346, the lands of Garmoran, Uist, Barra, Eigg and Rum were given to Amy. When John divorced Amy to marry Margaret Stewart, daughter of Robert and heir to the Scottish throne, he retained her lands and her children were removed from his line of succession. The castle was originally built on a small islet in a tidal loch but this has long since been filled in with deep, wind-blown sand.

After Amy owned the castle, the next we know about it is in 1715, following the failed Jacobite rising, when the castle was abandoned. It was occupied by the Clanranalds up until that point. In the 14th century the castle was known as one of the most important in the Outer Hebrides.

Today only two upper floors of the building can be seen above ground level. The basement level is completely covered by sand and collapsed masonry. Originally it was a rectangular shape and had a doorway at the first floor. Looking at it now, it's hard to imagine that is was once in the middle of a loch. Lush green grass now surrounds it. It's also now right at the bottom of someone's garden – more impressive than your average rockery.

History buffs will be interested to hear about the Bonnie Prince Charlie Trail in the Outer Hebrides, and especially Benbecula. The prince was famous for hiding in the Outer Hebrides for several months following his defeat at the Battle of Culloden in 1746. There was a bounty of £30,000 on his head.

Locations for the trail are available from Visit Outer Hebrides and include the island of Eriskay, where the prince had his first landfall in Scotland on his first visit to the islands, Nuton House in Benbecula where the captain of Nuton first heard of the Prince's arrival on the island following his escape, and Rarnish on the same island where he returned after a failed escape bid from Stornoway.

He may have had a huge bounty on his head, but hiding out in the Outer Hebrides certainly must have given the Bonnie Prince a taste of paradise.

Perth and Kinross

Perth and Kinross is home to more than 200 castles. Famous for its extensive woodlands, many of these structures are surrounded by forests and wouldn't look out of place in a book of fairy tales.

Perth was once the capital of Scotland and it once had its own castle. Perth Castle was built in the 12th century as a royal residence. In 1160 King Malcolm IV was besieged there by Ferchar, Earl of Strathearn, and other earls. After the destruction of the Royal Palace in 1210 it became the residence of Scottish kings, but a flood in 1290 led to the castle being reconstructed. It was rebuilt, then it was surrendered to the English on various occasions, and eventually it was captured by King Robert I of Scotland in 1313 and he ordered it to be destroyed so that it couldn't fall into English hands again.

The area where the castle once sat is now home to, among other things, the Perth Museum and Art Gallery and the Perth Concert Hall. Although Perth Castle is no more, there are plenty more in the region to discover.

Balhousie Castle on Hay Street may not be as impressive as Perth Castle undoubtedly was, but it looks pretty good to me. Built in 1631, it is thought that its origins go back another 300 years. It served as the seat of the Earls of Kinnoull. It was more or less abandoned in the early 19th century but was restored again between 1862 and 1864. The restoration meant that the castle was essentially rebuilt on a larger scale in the Scottish baronial style you see today. Only the original rubble walls on the east side remain. In 2009 it was bought by the Regimental Trustees of the Black Watch for the regimental

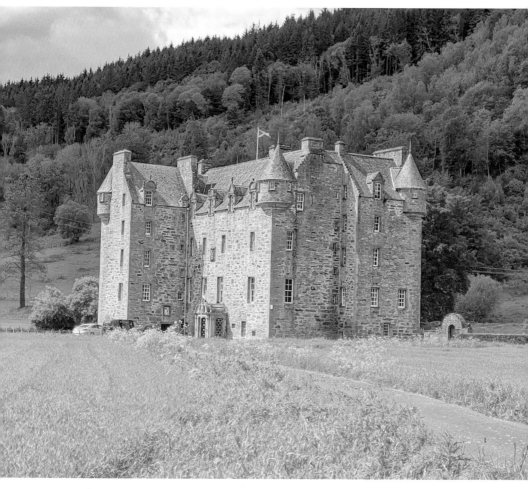

Castle Menzies is a spectacular sixteenth century castle and is the ancestral seat of the Clan Menzies.

headquarters and museum. The museum now tells visitors the story of this world-famous regiment.

Probably the most famous castle in the region is Castle Menzies, near Aberfeldy in the Highlands of Perthshire. Castle Menzies is near the site of Weem Castle, which was destroyed around 1502. Built in a Z-plan shape, the castle is the seat of Clan Menzies and was constructed in the 16th century. It's been in the Menzies family for over 500 years and one of its claims to fame is that Bonnie Prince Charlie stayed there for two nights

on his way to the Battle of Culloden in 1746 in the second Jacobite rising.

The castle was extended in 1840 with a new wing. Between 1855 and 1858 it was home to Duleep Singh, the last maharajah of the Sikh Empire after his exile from the Punjab.

The castle caught fire in 1878 when owners Sir Robert and Lady Menzies were away. The fire was caught early enough, however, and was quickly brought under control. In 1903, Sir Neil Menzies inherited the castle, but when he died without an heir, the contents were auctioned off, and the castle itself – along with the estate – sold in 1918 for £69,000, which, in terms of property, is the modern equivalent of maybe £20 million.

In later years, the castle has come back into the care of the Menzies who thoroughly restored and refurbished it in the 1950s. Restoration work by the Menzies Clan Society began in 1972 with a £40,000 project and took ten years to complete. The Menzies Charitable Trust was set up to look after the castle in 1994.

When visiting today, you can see that the rooms are not overdone but are instead laid out exactly as they would have been in the 18th century. The bedroom that Bonnie Prince Charlie stayed in is a particular highlight. And if you're interested in strange goings on, you might be lucky and have a guide who is willing to show you some paranormal activity on the castle laptop or who can tell you some ghostly tales. It's been said that the meat cellar is haunted by three grumpy women thought to be witches.

The original seat of Clan Menzies, however, is Comrie Castle which sits on the banks of the River Lyon. The 16th century building lies in ruins today and is thought to have replaced an older castle that was destroyed in a fire in 1487. The castle was probably constructed after the Menzies Clan arrived in the area, but after the blaze they relocated to Castle Weem before

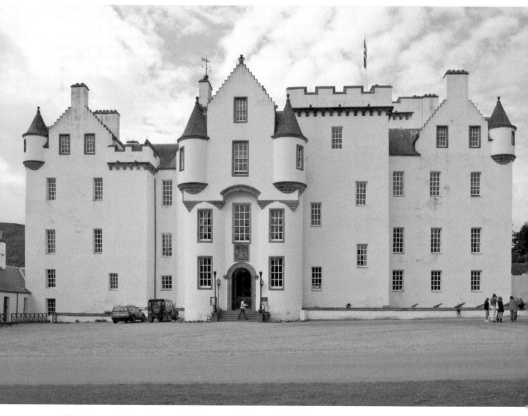

Blair Castle has been the home of the Atholl family for over seven centuries.

building Castle Menzies. Comrie was abandoned but later used again as a residence for junior branches of the clan.

Blair Castle near Pitlochry is particularly striking. Reminiscent of Neuschwanstein Castle in Bavaria, the bright white turrets and towers wouldn't look out of place in Germany. It is near the House of Bruar, the shopping pitstop on the A9, so after shopping for fancy cheese and tartan and tweed, it's the perfect place to explore. The grand estate is beautiful both inside and out.

Guests start their journey in an entrance hall which tells the story of the castle from its medieval days through to the elegant Victorian stately home that it is today. It has been the family home of the Dukes of Atholl for several centuries. The hall is

like a mini museum; it is full of armoury, including a shield used at the Battle of Culloden.

The castle is thought to have started life in 1269 when the Earl of Atholl's neighbour, the Lord of Badenoch, began building it on the Earl's land when he was away on crusade. The Earl, David I Strathbogie, complained to the King that the neighbour was squatting on his land. But he chose to incorporate the squatter's tower into the castle when he built it himself. The title of Earl of Atholl passed to the Murray family in 1629 and has been in the family ever since. The castle was taken by Oliver Cromwell's army in 1650 and was held by the Jacobites for some time before they abandoned it and it was seized by Lowland Clan Agnew. The Jacobites attempted to get it back, but left to fight the British government forces at the Battle of Culloden.

Queen Victoria and Prince Albert stayed at Blair Castle, and the room they stayed in can be visited today. The furniture in the room was bought especially for the visit. It was there that the Queen granted permission to establish the Atholl Highlanders, a ceremonial infantry regiment.

The castle has seen numerous changes over the years. The 2nd Duke helped to transform it into a Georgian mansion rather than a castle and changed the 16th century banqueting hall into a magnificent Baroque dining room. In 1985 half of this room collapsed due to woodworm in the supporting beams, but it has now been restored. There was another small disaster in 2011 when a fire broke out in the clock tower which caused its roof and second floor to collapse into its first floor. The clock tower was restored in 2012. The Atholl Gathering Highland Games takes place every year and are very popular with guests. There is also camping available on the 2500-acre estate with Centre Parcs-style lodges available for families to rent.

I was not surprised to discover that Blair has been used as a filming location over the years. It was used in the 2015 TV

movie *The Last Duke* and a 2017 episode of *Victoria* starring Jenna Coleman which is about Queen Victoria's famous visit to the castle. Although the castle isn't being used, the area near Blair Atholl is currently a filming location for a new *Star Wars* TV show for Disney starring Ewan McGregor, who is reprising his role as Obi-Wan Kenobi. I always thought Perthshire had an other-worldly feel about it. The *Trainspotting* star is originally from Perth – perhaps he'll drop into the castle for afternoon tea after a hard day swishing his lightsaber.

Drummond Castle near Crieff is perhaps more famous for its gardens than the building itself. The estate has been owned by the Drummond family since the 14th century and the castle started life as a tower house constructed over several years by the 1st Lord Drummond of Cargill, John Drummond, from around 1490. The castle was extended in 1605 by the 4th Lord Drummond and the first terraced garden was added in the 1630s.

The gardens are so stunning and immaculately maintained that they feature in the 1995 film *Rob Roy* starring Liam Neeson and Tim Roth. The castle has featured in a number of other films including the 1996 movie *The Bruce* with Bob Carruthers and David McWhinnie, and the 2005 movie *Man to Man* with Joseph Fiennes and Kristin Scott-Thomas. More recently, the gardens have been used as a location for *Outlander* in season two, where they doubled as the gardens of Versailles.

Today the castle is not open to the public, but the gardens are and offer fantastic views of the castle and surrounding countryside. Located near the famous Crieff Hydro hotel, the gardens are a popular holiday stop.

For anyone looking to get married in the region, Megginch Castle is a popular choice. The beautiful 15th century castle was once the family home of Cherry Drummond, the 16th Baroness Strange, and remains in the Strange family today. Although a

Drummond Castle's stunning gardens have starred on the silver screen.

private, family home it is available to rent for weddings. It has a unique 18th century courtyard complete with a pagoda doocot, which is perfect for standing under for fabulous photos. There is also a 19th century formal garden with an ancient orchard to explore. The orchard was once featured in the BBC programme *Beechgrove Garden*.

If you're more interested in ruined structures, Perthshire has you covered.

Evelick Castle are ruined remains in the Carse of Gowrie, Perth. The late 16th century tower house served as a residence for the Lindsay family, who were granted a baronetcy in 1666.

The name 'Evelick' was thought to have been first used in 1497 by David Lindsay, who then owned the estate. Today the tower stands three storeys tall but some of the upper walls have collapsed, as have a few internal walls. One interesting feature of the tower house is the number of gun loops in the masonry: one for nearly every window.

Over in Kinross-shire sits the 16th century tower house Cleish Castle. Built by the Colville family, it was restored and remodelled in the 19th century and again in the 20th. It was first restored in the Scots baronial style by Edinburgh architect John Lessels. In 2001 the western extension was replaced. Mary Queen of Scots is thought to have lived at the castle for a time after she escaped from Lochleven Castle in 1568.

In 2016 the castle was up for sale for offers over £1.5 million. That would buy you eight bedrooms, grand formal reception rooms, beautiful gardens, two paddocks, tennis courts, a ruined cottage and a unique painted ceiling by Scottish artist Jennifer Merredew. Buyers would also benefit from the castle's oldest yew tree walk with 400-year-old trees, thought to be Scotland's oldest.

Burleigh Castle is a roofless building just outside the village of Milnathort that was built for the Balfour family around 1500, replacing the original timber manor house on the land.

The castle served as a good stopping-off point for royalty. Mary of Guise is thought to have come to dinner in 1540 before heading on to Falkland Palace, and James VI of Scotland was a regular visitor when his son, Sir Michael Balfour, lived in the castle. The castle is an excellent example of Scottish baronial architecture and, despite being roofless, is in great condition. It's currently owned by Historic Environment Scotland and keys can be obtained from the Burleigh Castle Steading houses for those who wish to explore.

Another ruin near Pitlochry, in considerably worse nick than Burleigh, is the intriguingly named Black Castle of Moulin,

which sounds like it's straight out of *Game of Thrones* or *Lord of the Rings*. Not much remains of this one but I had to mention it purely for the name. It was apparently built in 1326 by Sir John Campbell, Earl of Atholl, who had been given the land by Robert the Bruce. It was originally built on an island in a loch but that has since been drained. It was occupied until the early 16th century until it was abandoned and set on fire due to fear of plague.

Loch Leven Castle is also in a ruined state and sits on an island in the middle of the water. This 14th century castle is said to be haunted by Mary Queen of Scots, and for good reason. In May 1562 she arrived to recover after she fell from a horse. She visited again in 1565 as the guest of Sir William Douglas of Lochleven and held an interview with the Calvinist preacher John Knox. Then, two years later, she was imprisoned at there from June 1567 until May 1568; after the Battle of Carberry Hill she had surrendered to her noblemen who opposed her marriage to the Earl of Bothwell. She was held prisoner by Sir William Douglas, who she had been a guest of only a couple of years earlier. While at the castle she miscarried twin babies who were burnt in the grounds, and she was forced to abdicate as Queen of Scots and give the royal title to her infant son, James.

By the 18th century, the castle had become a ruin. Today is it managed by Historic Environment Scotland and can be visited by taking a 12-person ferry across the loch.

A better-preserved 16th century castle is Elcho Castle, a tower house just above the south bank of the River Tay. It's a Z-plan building which was built for the Wemyss family around 1560. It served as a country house for the laird and lady, who had their main residence at Wemyss Castle in Fife. It was disused by the 1700s and was given to state care in 1929. At the time of writing in 2021, the castle is closed to guests for site inspections. Based on reviews online, this castle is a great one to visit when

Loch Leven Castle is where Mary Queen of Scots was imprisoned.

open, as guests can go right to the top for fabulous views. It is also associated with more than a few paranormal stories. People have reported an icy feeling on the grand staircase, as well as a squeezing of their chest. According to guides, the place is haunted with a 'White Lady' who is said to have been burnt when her dress caught fire.

Another haunt to check out near Perth is the 15th century Huntingtower Castle, just on the edge of the city. It was built in in three stages and is famous for its intricate painted ceilings. The castle is known for the sightings of 'Lady Greensleeves', who was Dorothea, the 1st Earl of Gowrie. The story goes that

she was in love with a servant in the castle until her mother, the Countess, caught them together. Dorothea heard her mother coming across the bridge to the tower and so tried to make her way down the roof. She apparently made the jump and the two eloped the next day. Although no-one knows what happened to them, there have been sightings of a girl in a green silk dress at the castle at dusk. It's said that seeing her is a warning of an imminent disaster. In the 1930s a traveller reported seeing the lady and drowned the next day. On the other hand, the water in nearby St Conval's Well is supposed to have the power to heal, but anyone who collects water must do so in complete silence and leave behind a token, such as a coin or charm.

Huntingtower Castle is also well known as being the place where Mary Queen of Scots and her husband Lord Darnley sheltered during the Chaseabout Raid in 1565, a rebellion by Mary's half-brother James Stewart.

The castle was built by the Clan Ruthven and was known as the House of Ruthven. Fun fact: John Ruthven, 3rd Earl of Gowrie, and his brother tried to murder the king in 1600 and the family name Ruthven was outlawed by parliament for forty years as a result. The castle name change was a direct result of this law.

The castle looks like one big building, but it was actually built as two separate towers that stand about 3 metres apart with a garden that links them, The Murray family took over the castle after the Ruthvens were disgraced and turned it into something more akin to a country mansion.

Perthshire boasts its very own fairy-tale castle: Taymouth Castle sits in a 450-acre estate just outside the village of Kenmore. It was constructed in the 19th century, and so is relatively new compared to others, but is built on the site of 16th century Balloch Castle. Some of the remains of Balloch are still inside Taymouth. Balloch Castle was demolished by the

Campbells of Breadalbane to build the new castle on the site. The design of the castle is lavish neo-Gothic.

The most famous story from Taymouth is about the blue sapphire stone set into a ring that once belonged to the Grahams of Inchbrakie. In the 17th century, the Laird of Inchbrakie saw a crowd of people getting ready to drown a woman they thought was a witch. The crowd was being led by one of the Campbells of Glenorchy, who owned the castle. The Laird recognised the woman as his old nurse and tried to save her. Although he didn't succeed, the woman threw him the stone as a thank you, telling him that he would always have good fortune if the stone remained with him. She also told him that the Campbells would never have a male heir, and this turned out to be true as the one who was leading the witch hunt died childless in 1640.

The castle is now a private residence, but has its own golf course which is a good way to get up close.

To the south-east of the Bridge of Earn is a castle shrouded in mystery. Balvaird Castle is thought to have been built in the 15th century, but no-one knows for sure by whom. It looks to have been extended over the years. It is one of few Scottish castles built in this period with refined architectural details such as corbels in the form of carved heads, as well as an elaborate wall-cupboard known as an aumbry. Unfortunately only the exterior can be viewed, but it's still interesting to explore.

If you'd like to stay in a castle in the region of Perth and Kinross, Tullibole Castle is a 17th century building which is now a bed and breakfast. Sitting in the Crook of Devon, it was built in 1608, although there is evidence of a castle on the site from 1304. The castle that stands today was originally built as a 16th century tower house before being extended in the 18th century.

The Moncrieff family have owned it since 1740. They were heavily involved in the Crook of Devon witch trials and sent

eleven people to their deaths believing they were witches, with cursing a horse among the supposed crimes. In 2012 a memorial was unveiled at the castle to commemorate this.

Despite its dark past, the castle now provides a beautiful setting for weddings as it is complete with a 9th century ruined medieval church, a maze and a 150-yard moat. There are rooms within the castle used for B&B and a detached self-catering property for larger groups.

Scottish Borders

An area where defensive structures are most important is the Scottish Borders. Being so close to England means that having an armed castle ready to go is pretty handy. I'm no stranger to the Borders. With a husband from the English side in Berwick-upon-Tweed, we're often in the area and even got married there. Unfortunately not in a castle but the historic Dryburgh Abbey in St Boswells, the burial place of Sir Walter Scott and Field Marshal Haig.

The region borders my hometown of Edinburgh with the English counties of Cumbria and Northumberland and is generally a hilly and largely rural area, with the River Tweed running thought it west to east. It's a beautiful part of the world and has its fair share of strongholds to explore.

Floors Castle in Kelso always ranks top of the list of castles to visit, and it's easy to see why. Despite living just over an hour away, I visited only recently. Known as Scotland's largest inhabited castle, it is first and foremost a family home. Overlooking the River Tweed, it opened to the public in 1977 and is home to the Duke of Roxburgh and his family. As family homes go, it's on the large side, with 55,000 acres of land and 200 rooms.

We were greeted by an extremely helpful guide who was happy to tell some family stories. We were told that the 8th Duke married a young American heiress in 1903 and she was largely responsible for the interior décor we see today. Many of the vibrant paintings and tapestries came from her home in Rhode Island and she had a massive effect on the look of the home.

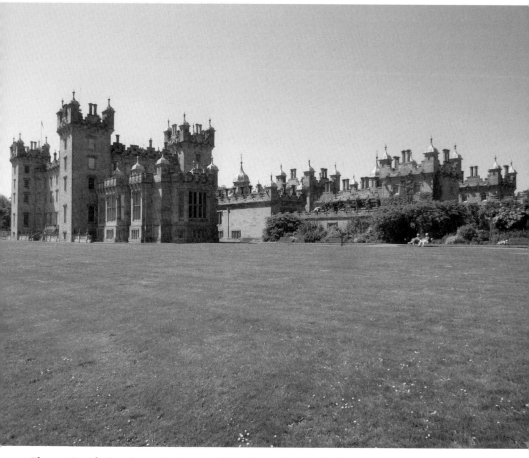

Floors Castle has been the home of the Innes-Ker family for over 300 years.

To celebrate the 300ᵗʰ anniversary, an exhibition commemorating the life of the first Duke and the construction of the castle has been put together. Some of the items on display include 300-year-old letters from the duke to his mother as well as a payroll list of workers during the construction of the castle.

Floors is like something straight out of *Downton Abbey* and I was expecting it to have been featured in countless TV shows and films, but the only ones I could find were *Greystoke: The Legend of Tarzan, Lord of the Apes* from 1984 and an episode of *An American Aristocrat's Guide to Great Estates* from 2020 on Amazon Prime. Hollywood is surely missing a trick here.

However, I did catch an episode of *Border Life* on ITV that featured the castle on the run-up to its 300th anniversary in 2021. The 11th Duke, Charles Innes-Ker, who took the helm of the castle just before the coronavirus plague hit in 2020, has made a few changes to ensure that visitors come back again and again. He managed to open a new shop despite the pandemic, with local produce its biggest selling point. The next project is to put a new roof on the entire castle, so that it remains a fixture in the community for years to come. The Duke, who is an old Army friend of Prince Harry, recently married at the castle in 2021. It must be nice not to have to pay for a venue.

It's not easy to keep a building this size heated, but Floors has considerable green credentials. Biomass energy heats the entire castle and grounds. It also has a fund for local environmental projects, so sustainability is high on its agenda.

The much older Hermitage Castle in Liddesdale, Roxburghshire, is also a popular choice for visitors. It is known as one of the most sinister and atmospheric castles in the country. It's not the easiest to find. The nearest village is Newcastleton. Visitors have to travel along narrow country roads, but the trip is worth it. Its perfect rectangular shape and striking archway are something to behold.

It was constructed in the 13th century and was once known as the 'guardhouse to the bloodiest valley in Britain' – the valley being Liddesdale, which is known for its turbulent history.

The castle was built by Nicolas de Soules (or de Soulis) out of wood. Even without the arrival of a big, bad wolf, this was soon replaced by stone, and the castle was passed to William de Soulis in 1320. William de Soulis was not the most appealing of characters. Apart from being involved in a plot to kill Robert the Bruce, he is said to have practiced the black arts, kidnapping local children and using them in blood rituals at the castle to summon an evil 'redcap' – a kind of murderous goblin. He was eventually killed on the orders of King Robert the Bruce.

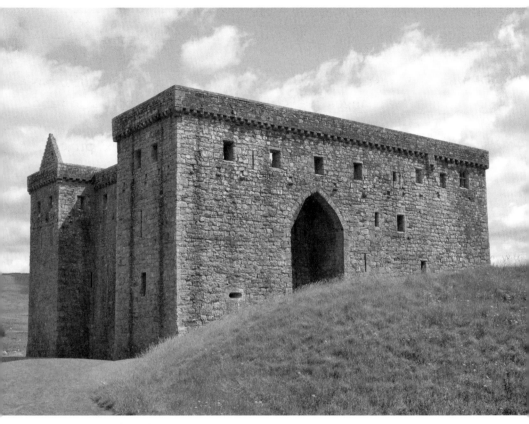

Hermitage Castle is semi-ruined castle described as 'the guardhouse of the bloodiest valley in Britain'.

Because of its Borders setting, it played a key role in the War of Independence, and it has changed hands various times from Scotland to England. But was primarily built to protect Scotland from invaders. Like many other Scottish castles, this one is thought to be haunted. Many of the Lords who owned the castle over the years either died under strange circumstances or they committed suicide. This has led many people to believe that the castle is cursed – possibly due to the black arts performed by de Soulis. One of the ghosts is apparently Mary Queen of Scots. The story goes that Mary rode to the castle to be with her lover Lord Bothwell, who had been wounded in battle. The two have reportedly been seen holding hands while strolling around

the grounds. We visited on a bright day with children running around so did not feel any eerie atmosphere.

Hermitage Castle has been seen on screen in the 1971 film *Mary Queen of Scots* starring a wealth of British talent including Vanessa Redgrave, Glenda Jackson, Timothy Dalton, Nigel Davenport, Patrick McGoohan, Trevor Howard and Ian Holm.

A strangely named tower house, also in Roxburghshire, is Fatlips Castle. It apparently got its name because of members of the house kissing female visitors on the lips – something that was not considered decent at the time and still isn't, depending on who's kissing you. It was built in the 16th century by the Turnbulls of Barnhill who owned the nearby Barnhills Tower and Farm. It sits at the top of Minto Crags above the River Teviot. Sir George Elliot acquired the castle in 1705 and his family eventually became the Earls of Minto. The castle was restored in 1857 and the interior was redone as a shooting lodge and private museum between 1897 and 1898. It was in use until the 1960s. It's quite a climb to reach the top, but you're rewarded with outstanding views of the surrounding countryside.

Jedburgh Castle is one that looks grand but tells a different story inside. A castle on the present site was built for David 1st, fought over during the Wars of Scottish Independence, and demolished by Sir James Douglas of Balvenie in 1409 – apparently due to the Scots being so sick of the English trying to take it. In 1820 another castle was built there to be used as a prison. Not just a facility to lock people up, it was also used to punish inhabitants with torture. The torture was known as Jedburgh justice – hang them first, ask questions later. The prison closed in the late 1870s but the stories of torture live on, and mysterious pipe music has been heard coming from the castle.

The stories of hauntings reached the ears of TV paranormal investigators *Most Haunted*. They investigated Jedburgh in a 2008 episode. The stories are taken seriously in the neighbourhood,

Jedburgh Castle Jail was built on the site of an older castle and is now open to the public as a museum.

meaning many locals don't like to go there and staff try to avoid the top floor. In the TV investigation, I watched in horror as Yvette Fielding and her team screamed their way through the night as doors opened of their own accord and electrical equipment drained of battery with no explanation. Let's just say that I'm glad I tuned in *after* my visit.

Smailholm Tower is near where my husband and I got married at Dryburgh Abbey. It was apparently the playground of Edinburgh-born Sir Walter Scott, who used to come here while visiting his grandfather as a boy. Sir Walter spent

much time in the area for his health, and the tower provides the setting for his popular ballad *The Eve of St John*, as well as appearing in *Marmion*. Because of his poetry, Sir Walter's uncle restored the tower, making it safe in 1800. The tower has featured in more modern literature too, including the children's novel *In the Keep of Time* by Margaret J. Anderson and *Smailholm* by C.L. Williams.

The tower sits on top of the crag of Lady Hill and offers splendid views across the countryside. It was built by the Pringles, a prominent local family, in the first half of the 1400s, and on a clear day visitors can see Bamburgh Castle 33 miles away in Northumberland.

If you're looking for luxury castle accommodation in the Scottish Borders, then look no further than Thirlestane Castle in Lauder. The castle is thought to date back to the 12th century when a large border fort was built on the site to defend the approach to Edinburgh from the English. The castle has changed considerably since then, having been rebuilt in around 1590, remodelled in the 1670s, and enlarged in the 1840s. The castle belonged to the Maitland family, who were prolific in Scotland, and it belongs to them to this day. The guided tours come highly recommended, as do the afternoon teas which will make you feel like part of the powerful Maitland family. Indeed, you may see more members of the family than you care to on your visit, as the ghost of Sir John is thought to haunt the building. John Maitland was the 2nd Earl of Lauderdale and had the castle remodelled in 1670, and many people believe that he never left. Guests have reported an eerie chill in the evenings and sometimes footsteps can be heard. There is one bedroom thought to be more haunted by John than others. I'm sure they don't advertise which one.

Neidpath Castle is an L-plan rubble-built tower house that overlooks the River Tweed and now serves as a wedding venue. There was probably an older castle on the site, but the site was

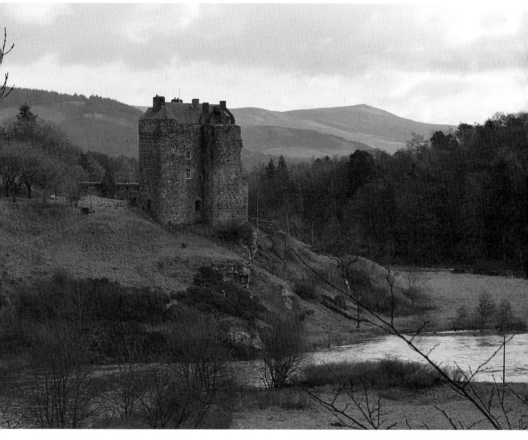

Neidpath Castle is said to be haunted by the ghost of Jean Douglas, the youngest daughter of William, Earl of March.

acquired by the Hay family and William de Haya is thought to have built the current castle in the late 14th century. It was another that was visited by Mary Queen of Scots in 1563, as well as by her son James VI in 1587. It was attacked by Oliver Cromwell's army in 1650 and was apparently given up without a fight. In the 1660s the 2nd Earl of Tweeddale remodelled it and added some outbuildings. In the 18th century the castle received more alterations from the 2nd Earl of March who inherited it, but by 1790 the upper storeys of the wing had collapsed. It later became a possession of the Earls of Wemyss and the family still own it.

It was once visited by Sir Walter Scott and is said to be haunted by the ghost of Jean Douglas, who the famous author refers to in his poem *The Maid of Neidpath*. Jean was the youngest daughter of the Earl of March and was forbidden to marry a man not considered worthy of her – I've heard this before. Her lover was sent away and Jean became ill and wasted away in his absence. When he returned, he didn't recognise her, and she died of a broken heart. Cheery stuff. Her ghostly figure has been spotted wearing a long brown dress with a white collar.

The castle featured on the screen in the 1998 TV film *Merlin: The Quest Begins* starring Jason Connery, as well as the reality docu-series *Sam and Colby* in 2019, where the YouTube stars stay the night in the apparent 'haunted' castle.

Less than five miles from my husband's English hometown of Berwick-upon-Tweed is Ayton Castle. The original castle was a peel tower – a small, fortified keep usually built along the border. Owned by the Home family, it was taken by the English in 1497 and then replaced by a mansion which burnt down in 1834. The castle that stands today was built in the 19th century in the Scottish baronial style with red sandstone. Some say it's the finest example of the Scottish baronial style. It is one of four I know designed by architect James Gillespie Graham, the others being Brodick, Torrisdale and Duns. Mark Twain visited the castle in 1873; the American author loved the fireplace mantel in the dining room so much that he bought it and sent it back to America where it still sits in the Mark Twain House & Museum in Hartford, Connecticut. Huck Finn would surely approve.

Another structure in Berwickshire is the extraordinary Hume castle. In the nicest possible way, it reminds me of the kind of castle you might find in a children's play area complete with plastic knights. I think it's because the towers are so perfectly symmetrical that, to me, it doesn't look quite real. After

researching the castle, this does make a bit of sense as it was rebuilt as a folly – decoration only – after lying in ruins due to being captured by the English on a number of occasions. The last time was in 1651 when Oliver Cromwell's army attacked it and destroyed it rather than taking it for their own. It was restored in 1770 and again in 1985 to allow it to be opened to the public. The original castle was owned by the Home Clan – pronounced *Hume* – since 1214 and today is owned by the Hume Castle Preservation Trust. It's worth a trip now to marvel at the perfect towers and to get fantastic views of the borders. You'll just have to remind your children that it's real and not to expect plastic slides and climbing frames hidden within.

In terms of grand buildings, Duns Castle in Berwickshire is a real showstopper, but is more of a historic house than a castle. The land for the castle was given to the Earl of Moray by Robert the Bruce in 1314 after the Battle of Bannockburn. The Earl erected the peel tower in 1320, which remains in the castle today with 8ft thick walls and the serving as the current dining room. The gothic style of the present castle was thanks to architect James Gillespie Graham again, who transformed it from an L-shaped structure in 1791. It was important in the First Bishops' War in 1639 as it housed General Alexander Leslie, 1st Earl of Leven, who had his army stationed nearby blocking the English from advancing into Scotland. The castle is now available to rent. It has 12 bedrooms and 7 cottages on site so sleeps up to 54 guests. It sits in the middle of a 1200-acre estate and is the seat of the Hay family. Today it is a popular location for weddings; former Liverpool and England striker Robbie Fowler was married there. It was used as a filming location for the 1997 film *Mrs Brown* starring Dame Judi Dench and Billy Connolly. *Mrs Brown*, also filmed at Balmoral Castle in Aberdeenshire, is based on the true-life relationship between Queen Victoria and John Brown, a royal servant. It is thought

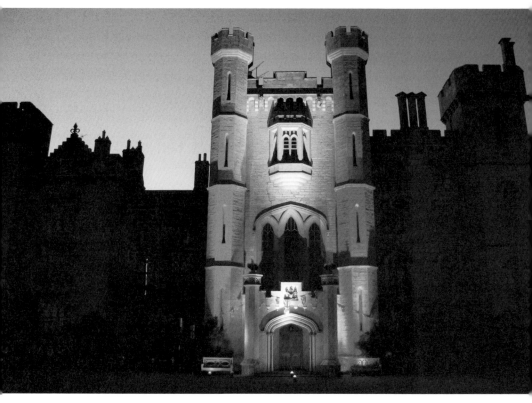

Duns Castle is the centrepiece of a beautiful 1200-acre estate and has been the seat of the Hay family for over 300 years.

that parts of the castle date back to the 14th century and, like many others, has had reports of hauntings. Alexander Hay, who died at the Battle of Waterloo in 1815, is said to drop by Duns from time to time.

There is little left to see of Fast Castle, near the village of Coldingham. It would once have been a formidable sight, sitting on a hill on a peninsula overlooking the North Sea with cliffs up to 45 metres high on either side. It would have been accessed by a drawbridge over the narrow ravine. It would have consisted of a courtyard and keep. Only part of the foundations and some of the courtyard walls remain today, but the sight is still impressive. I imagine it in its heyday to look like Dunnottar in Aberdeenshire but on a smaller scale.

It has been owned by the Home family, the Douglases and the Earls of Dunbar. It is said to have inspired Sir Walter Scott in his description of the fictional 'Wolf's Crag' in his 1819 novel *The Bride of Lammermoor*. Fast Castle is also mentioned in Nigel Tranter's trilogy of historical novels, *The Master of Gray* series, as well as *Mail Royal*.

Another ruined tower is Cessford Castle between Jedburgh and Kelso in Roxburghshire. This mid-15th century L-plan castle was once the stronghold of the Kers/Kerrs – notorious Borders raiders. Built by Andrew Ker in 1450, the castle was perfect for defence as the angle of the building was enclosed by a single-storey gatehouse and surrounded by a 'barmkin' – which is a wall protecting the castle. The design of the castle was so successful that English troops were only able to gain access by escalading the walls. It was eventually besieged in 1523 by the Earl of Surrey – who famously defeated the Scots at the Battle of Flodden, and who said, 'It might never have been taken had the assailed been able to go on defending.' The castle was abandoned in 1650 by the Ker family for the infinitely more comfortable Floors Castle, where the family remain today. Some materials from Cessford may have been taken to help build Floors.

Most ruined castles around Scotland are in that state due to sieges or battles or are just weather-beaten after years of abandonment, but there is one near Peebles that was never finished to start with. James Douglas, 4th Earl of Morton and Regent of Scotland, began the construction of Drochil Castle in 1578, but was executed by King James VI three years later when the castle was only half finished. The fact it was never completed is a shame for many reasons. One is that the design is very different from similar buildings in the 16th century. Most castles at that time were built as a single tenement with rooms having windows on both sides and entering through each other. However, Drochil went against this and had a large corridor on

each storey which divided the two towers with rooms being separate and having windows on one side only – a bit like a modern home. In 1686 it was bought by William Douglas, 1ˢᵗ Duke of Queensberry, and it is still owned by a descendent of his. It was never completed and fell into even more ruin when stone was taken to build the adjacent farm. It's protected as a scheduled monument today and guests of the next-door Drochil Castle Farm can stay at the B&B and marvel at the unfinished wonder.

Greenknowe Tower in Gordon is a reasonably well-preserved 16ᵗʰ century structure. The L-shaped tower was once surrounded by marshland. This helped enormously with defence, although it was actually built as a residence by James Seton in 1581. His initials, along with those of his wife Janet Edmonstone, are inscribed above the door. In the 17ᵗʰ century it was sold to the Pringle family of Stichill who added to the building. It was occupied until the 19ᵗʰ century, and fell into state care in 1937. The castle is in great condition despite no longer having a roof and is fab for exploring. Visitors can climb right to the top and explore all the rooms with free entry. When hearing the name 'Greenknowe' my husband immediately reminded me of a scary children's book series by Lucy M. Boston, which was later made into a TV drama in the mid-1980s, called *The Children of Green Knowe*. The thought of the statue of St Christopher coming to life during a thunderstorm and the sound of a long-dead child crying in the night still traumatise him to this day. He was pleased to discover that there doesn't seem to be a connection – Green Knowe translates to Green Hill so could be anywhere. But there have been reports of people feeling as though they are being watched while visiting, so it still has the spooky factor.

Kirkhope Tower in Ettrick Valley in Selkirkshire is very remote and is known as a Scottish peel, one of the small fortified tower houses that stand at various points along the border. It was built

in the 16th century and was once owned by the Scotts of Harden, ancestors of Sir Walter Scott. It became a ruin in the 18th century but was restored in the 20th and used as a private house. It was sold as a private home in 2019 for a bargain price of £280,000. For this, the new owners now get to live in a Category A-listed tower house overlooking Ettrick Valley with a barrel-vaulted room, three bedrooms and an acre of land. That amount of money won't even get you a flat in certain parts of Edinburgh so sounds like a pretty good deal to me.

Inner Hebrides

I must admit that writing a book about Scottish castles has improved my geography no end. I hadn't given much thought to the Inner Hebrides before, and would think of the islands individually rather than as a collective.

The Inner Hebrides, or the inner isles, are made up of 35 inhabited islands and 44 which are uninhabited. Skye, Mull and Islay are the largest and also have the biggest populations. The difference between the Outer and Inner Hebrides is basically that the inner islands lie closer to mainland Scotland so are easier to reach and don't feel quite as 'otherworldly' as the outer islands can. Although, it must be said, Edinburgh still feels like it's worlds away when you're on Mull.

The Isle of Mull, like all the other southern islands, is in the Argyll and Bute Council area, but I think they're worthy of their own chapter. The northern islands, including Skye, are part of the Highland Council region.

Mull is home to one of the region's most famous castles. Castle Duart is known as the MacLean castle, just as Cearlaverock in Dumfries and Galloway is known as the Maxwell castle.

A hopelessly romantic photographer with the last name MacLean told me that he proposed to his wife at the castle as a way of asking her to 'join the family', which I thought was very sweet. My other friend Deborah (also a MacLean) travelled recently and was welcomed 'home', just as my family were at Cearlaverock.

Apparently, if your family name is one attached to a castle in Scotland, you can legally live there if you ever find yourself to be homeless. I don't know how true that is and I'd rather not

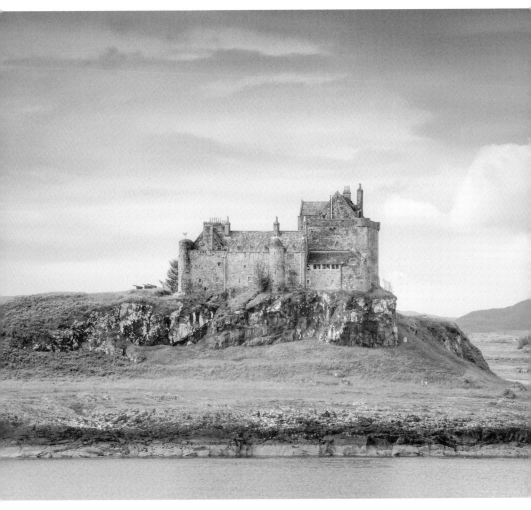

Castle Duart dates back to the 13th century and is also known as the MacLean Castle.

find out, but in 2019 the Scottish government did publish a list of all unclaimed Scottish estates, which included 435 unclaimed castles. Anyone with the last name of a long-lost owner could be entitled to claim them. I checked and, unfortunately, there are no Maxwells on the list.

Duart Castle, *Caisteal Dhubhairt* in Gealic, dates back to the 13th century. It is thought to have been built by Clan MacDougall around that time but fell into the hands of the MacLeans in

the 14ᵗʰ century. It's thought to have been Lachlan Lubanach MacLean who built the first stone castle around 1370.

It wouldn't be a Scottish castle without some murky history. In the 16ᵗʰ century the MacLean and Campbell families became allies when Lachlan Cattanch of Duart married Margaret Campbell but, due to them being unable to conceive a child, Lachlan had his wife chained to a rock in the channel to try to drown her. A passing fisherman heard her cries and rescued her, and the Campbell family retaliated and murdered Lachlan in his bed. The partnership between the two families didn't last long and the islet where Lady Margaret was chained – Lady's Rock – can be seen offshore. There are a few dark tales like this associated with the castle and, like many others, there have been reports of ghostly sightings. The headless spirit of Ewan MacLean is said to ride through Glen Mhor near the castle.

Duart Castle sits atop a rocky outcrop called Black Point at the end of a peninsula over one of the most important marine crossroads in western Scotland, with ships passing en route to Mull or Oban. The position of the castle is perfect for defence because and would have been useful in the Viking raids of the 800s had it been around at the time.

In 1653 a taskforce of Oliver Cromwell's arrived at the castle in six ships, but the MacLean family had already fled to the neighbouring island of Tiree. Three of those ships were lost in a storm, including HMS *Swan*, the remains of which are thought to still be at the north of the castle in the Historic Marine Protected Area. In 1691 the castle was surrendered by Sir John MacLean, 4ᵗʰ Baronet, to Archibald Campbell, 1ˢᵗ Duke of Argyll. The Campbell Clan completely demolished the castle and scattered the stones, which allowed Donald MacLean to use them for a cottage near the castle. In 1751 the castle was abandoned and descendants of Archibald Campbell sold it in around 1801. Owners thereafter kept it as

a ruin until 1911 when a MacLean bought it again. Sir Fitzroy Donald MacLean, the 26th Chief of the Clan MacLean, restored it.

Over the years, a number of famous actors have graced its halls as it has been featured in several Hollywood movies, such as 1999's *Entrapment* (Sean Connery's character has MacLean ancestry on his mother's side), 1971's *When Eight Bells Toll* starring Anthony Hopkins, and 1945's *I know Where I'm Going* starring Wendy Hiller.

The castle has been called a modern-day money pit as the current Sir Lachlan Hector Charles Maclean of Duart and Morvern inherited it from his father in 1990 and has been renovating ever since. If you visit today you'll almost certainly see some form of scaffolding.

Duart isn't the only castle on the Isle of Mull, there are six in total. Moy Castle was built on land that belonged to another MacLean, Hector Reaganach Maclean, 1st Laird of Lochbuie and brother of Lachlan Lubanach MacLean of Duart. Construction began in 1360 and is thought to have finished around 1494. It's now known as the historic seat of Clan Maclaine of Lochbuie – which is a separate clan from the MacLeans of Duart. I know, I'm confused too.

This castle comes with the grim tale of the headless horseman, who is said to haunt the grounds and is a legend on Mull. The story goes that in 1538, Ewan Maclaine and his wife were not satisfied with the amount of land they had inherited, so Ewan fought with his dad. A battle ensued and Ewan's head was chopped off while riding his horse, which proceeded to carry the decapitated body for two miles. The ghost of the headless horseman has been seen riding in Glen Mor, and legend has it that whenever a MacLaine is about to die the ghost will appear at Moy Castle. The castle was abandoned in 1773, but after many years of neglect it is finally being restored. Between 2006 and 2015, work to stabilise the

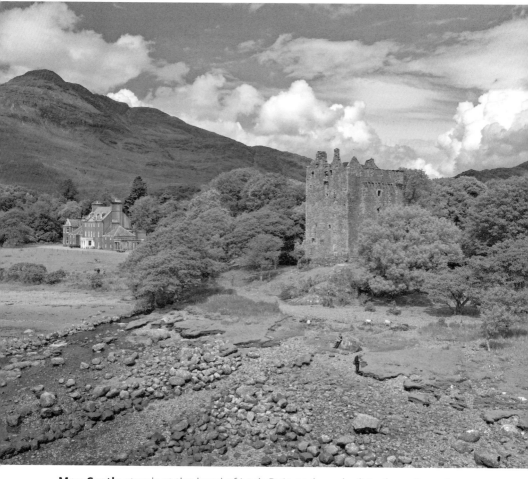

Moy Castle stands at the head of Loch Buie and was built in the 15th century.

interior and exterior stonework was carried out to preserve the building and, as of 2020, the work continues.

Moy Castle was, as was Duart, used on screen in the 1945 romantic film *I Know Where I'm Going*.

Aros Castle, which can also be called Dounawyse Castle, is a ruined 13th century structure near the town of Salen. This was another owned by the MacDougall Clan. It was once their stronghold before it fell into the hands of the MacLeans. Today there is hardly anything to see. The area is overgrown and all that remains of the castle is basically a wall.

A similar one is Dun Ara Castle, thought to have been the stronghold for the McKinnon Clan. It sits on a rocky outcrop, at the bottom of which are eight other ruined structures thought to be associated with the castle. Again, there is little to see today.

Glengorm Castle, near Tobermory, is a different story. It is in such good condition that it's now used as a bed and breakfast. The 18th century building is called a castle but is really a country house. It was built in the Scots Baronial style for James Forsyth of Quinish. Forsyth wasn't the nicest man in the world: to make way for his new home, he evicted all the tenants on the estate and burned down their homes. The cottages' thatched roofs created a blue smoke over the town as they burned, which is where the name Glengorm – which means blue glen – comes from. The castle is now owned by the Nelson family. It is run as a bed and breakfast, as are some self-catering cottages on the estate, and has fabulous reviews. On a clear day you can see all the way to the Outer Hebrides.

The last castle on Mull that is definitely worth a visit is Torosay. It lies just south of Craignure. It was originally called Duart House, which was confusing to many thanks to the nearby Duart Castle, and so it was changed to Torosay. The castle was built in 1858 for the Campbells by architect David Bryce, who created more than 200 buildings in his career including Edinburgh's Fettes College. In 2012 the castle was sold to a Swiss buyer which brought to an end the family's 147-year ownership. It was sold by Chris James, the fifth laird of Torosay Castle, for £1.65 million. The castle apparently needed over £1 million worth of repairs, so he was probably glad to be rid of it. Today, unfortunately, it is closed to the public, although the beautiful landscaped gardens can be visited.

Over the sea to Skye, you'll find several spectacular structures to explore. Many people assume that Eilean Donan is one of

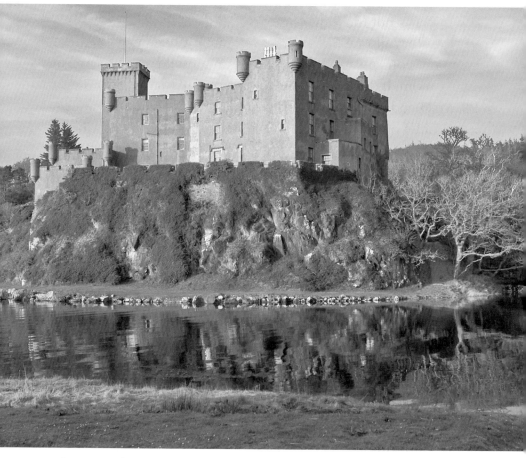

Dunvegan is the oldest continuously inhabited castle in Scotland.

them but it's not quite (it is actually on a separate tidal island). However, it's so close and famous that it's usually included on the 'what to do in Skye' tourist lists.

One that definitely is on the winged isle is Dunvegan Castle, the only Highland castle to have been lived in by the same family for over 800 years. The Chiefs of Clan MacLeod have owned it since its construction in the 1300s. The smaller castle was added to in the 14th century when a four-storey tower house was built with more modern architecture. The 8th Chief of the Clan MacLeod was Alasdair Crotach, who added the fairy tower around 1500.

The tower is not the only reference to fairies in the castle as it holds the story of one of the most fascinating flags in Scotland. Even today you can see an old piece of material hanging in the drawing room. It doesn't look like much, but it's actually the flag of the MacLeods and is special for many reasons. The story goes that the Chief of the Clan fell in love with a woman who turned out to be a Celtic fairy princess. She begged her father to let her marry him and he agreed, but she had to return to her fairy life at the end of one year. When the time came, she left and made her husband promise not to let their young son cry. There was soon a feast in the castle to help the chief forget about his wife, and the baby's nursemaid, who wanted to join the fun, left the young baby alone in his room. The baby woke up and was upset to be left alone, but when the nursemaid arrived back she saw a woman comforting him and wrapping him in a shawl before vanishing into the night. When the boy was old enough to talk, he told his father that his mother came to comfort him. He said that the shawl was magic and would provide help three times if they needed it. This shawl was used as the flag and many believe that the magic was real. Hundreds of years later, when the clan were under attack by the MacDonalds, the MacLeods fled to the beach. There they took out the fairy flag and, all of a sudden, there were many more of them, enough to slaughter the MacDonalds. Then they safely stored the flag away. The second time it was used was when a plague killed many cattle. After the flag was waved, all the sick cattle were miraculously restored to health. In recent years, men fighting in the Second World War would carry photographs of the flag in their pockets, and the most recent chief, John MacLeod, admits that he was carrying a photograph of it when fighting the Mau Mau in Kenya in the 1950s.

The castle today looks quite different to how it did in the 14th century, as in the late 18th century the 23rd Chief began to remodel it to the mock-medieval style we see today.

Even without the amazing legends and myths attached to it, it's remarkable to see as it overlooks Loch Dunvegan surrounded by beautiful gardens and waterfalls. Inside the walls, visitors can see the fairy flag as well as some Jacobite relics and family heirlooms.

The castle has been used on screen. The 2008 romantic comedy *Made of Honour* starring Patrick Dempsey and Michelle Monaghan was filmed extensively in the grounds of the castle.

Also on Skye is Duntulm Castle, which sits on the Trotternish Peninsula above the seas of Little Minch. It's currently in a ruined state and is thought to date back to the Iron Age, although no-one is clear on that. The MacLeods built a castle there in the 14th century. The Clan entertained King James V of Scotland when he visited in 1540. However, it fell into the hands of rivals, the MacDonalds, some time in the 1600s. It was used as their seat until it was abandoned in the 1700s. The reason it was abandoned is pretty grim. It's said that a nursemaid accidentally let the young son of the chief fall out of a window to his death on the jaggy rocks below. As punishment, the chief set her adrift on the sea in a small boat to meet her fate. Many believe the site is now haunted by her ghost. And the nursemaid isn't the only one. Some believe that the castle is haunted by the ghost of Hugh MacDonald, the cousin of Donald Gorm, the 9th chief of Clan Donald, who planned to kill his cousin to become chief himself. He apparently wrote one letter to an assassin and the other to the chief asking him to attend a dinner, but, unfortunately for him, the letters got mixed up and his plot was discovered. He was captured in 1601 and thrown in the dungeon, where he went mad before he died. He is now said to haunt the castle, screaming madly.

Armadale Castle was another home to the MacDonalds. It was built as a mock-castle in 1815 in the Scottish baronial style, for show rather than defence. It was partially destroyed by fire in 1855. A central wing was replaced. The MacDonald

family abandoned the castle in 1925 and it is now in a ruined state, although the gardens surrounding it now house the Clan Donald Centre as well as the Museum of the Isles.

Another castle on Skye is Castle Moil Skye – otherwise known as Caidteal Maol. It is located in the small village of Kyleakin and is thought to have been built by Vikings. It was once the ancient seat of the Mackinnon Clan. It is said that the 4th Mackinnon Chief, Findanus, married the Norse Princess 'Saucy Mary', and together they extracted tolls from passing ships. The three-storey tower house that we see today was built on the Viking site in the late 1400s and became the Mackinnon stronghold. It has been abandoned since 1601, but the ruined site can still be visited on a trip to Skye.

Dunscaith Castle, which sits on a large rock overlooking Loch Eishort on the Sleat Peninsula, was built for defence for Clan MacLeod around the 13th century. The climb up to it is not for the faint of heart, with sheer drops into the sea on all sides. This is another castle on Skye shrouded in myth, as the mythical warrior queen Scathach was thought to have her base at Dunscaith. The castle is even named after her, as Scathach means Shadowy and Dun Scaith translates to 'Castle of Shadows'.

Over on the Isle of Rum, there was a castle for sale at the time of writing (2021) for the princely sum of £1. Kinloch Castle has been up for sale for years with no success. As the castle now needs at least £20 million worth of repairs, the owners – NatureScot (formerly Scottish National Heritage) – are keen to find a buyer. It was built as a home for textile tycoon Sir George Bullough in 1897. His father had bought the island as a shooting estate. There was an older castle near the site constructed by Lachlan MacLean. The castle has been described as an example of pre-1914 opulence. Bullough was a bit of a playboy and very extravagant. Over the century, the castle has fallen into a bad state, with dry rot, leaks and woodworm infesting the entire

property. It was briefly used as a hostel until 2015 and the Kinloch Castle Friends Association was set up in 1996 to help secure its future.

On the southernmost island, Islay, there are five castles. Dunyvaig and Finlaggan are the most well-known.

Dunyvaig Castle, near Port Ellen, was at one time a defence structure for the chiefs of Clan MacDonald, who were known as Lords of the Isles at the time. The castle was built on a much earlier pre-historic fort and the surviving remains are from the 13th to 16th century. In 2019, Islay Heritage completed a major excavation to document the castle's turbulent history. The excavation of the site uncovered the seal of Sir John Campbell of Cawdor (c. 1576-1642), who had taken ownership of Islay in 1615. The Campbells and the MacDonalds fought constantly over the castle in the early 17th century until the Campbells finally won out. Today it is in a derelict state but worth a visit for the magnificent views across Lagavulin Bay.

Finlaggan Castle, also known as Eilean Mòr Castle, was a fortified house on the small island of Eilean Mòr, two kilometres to the northwest of Ballygrant on Islay. It was another owned by the Lord of the Isles. The castle stood beside a chapel on the island which is now linked to the shore by a causeway. It served as the chief seat for the Clan Donald and Lord of the Isles from the 13th century, until James IV of Scotland took over the lordship in 1493. The Lords had descended from a 12th century prince called Somerled and were independent of the Scottish crown; Finlaggan acted as the centre of this island empire.

The site was investigated in an episode of Channel 4's *Time Team* in 1995, and today guests can go to the visitor centre in the summer months to learn all about it.

Another fortress of the Clan MacDonald is Loch Gorm Castle, which lies in ruins on Eilean Mòr in Loch Gorm. The ruins are thought to date back to the 16th or 17th century and can be viewed from the side of the loch. It's in such a state and covered

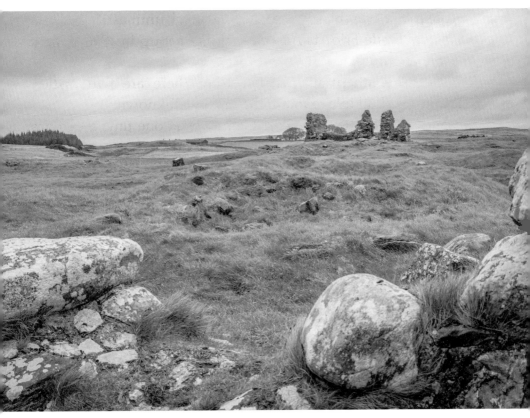

Finlaggan was once the centre of the Lord of the Isles but little remains today.

in vegetation that it can't be visited today. Many people who go to Islay don't even know it's there.

More of a stately home than a castle, Kildalton Castle was completed in 1870 for distiller John Ramsey. Located near Port Ellen, it was built in the Scottish baronial style but has since been abandoned and is now in ruins. It's still an incredibly striking building however, and even comes with a good ghost story. Apparently, many years ago there was an employee of the Laird who lived at the castle who would leave the island for long periods at a time. But even when he was travelling, people reported seeing him wandering around the castle. He's since been spotted, long after he died, with a terrier dog following him. Spooky stuff.

Lastly on Islay is Dunlossit Castle near Port Askaig. It sits on top of a hill overlooking the port and was once the home of a billionaire banker and landowner. It's now a private residence, but Dunlossit estate can be visited for fishing and other activities.

The Isle of Raasay is a small island between Skye and mainland Scotland and has one castle. The name of the island comes from the Norse word 'Red Deer', and it was one of the Inner Hebridean islands that became part of the Norse Kingdom of the Isles in the 8th century following Viking expeditions.

Brochel Castle was built on top of a volcanic plug on the eastern side of the island as a courtyard castle surrounded by a curtain wall. It was built by Calum, the first chief of the MacLeod Clan, after he acquired the island of Raasay in the 16th century. By 1617 it was no longer in use and became derelict. It's now in a ruined state, and with only around 200 people living on Raasay, it will probably stay that way.

Acknowledgements

Clara Bessos
Barnaby Blacker
Stef Burgon
Jemma Hawkes
Dan Hawkes
Simon Hunt
Tom Maxwell
Catherine McCaskie
Chris McGinley
Maj McGinley
Coreena McIntosh
Deborah McLean
Iain McLean
Claire Montgomery
Gordon Morrison
Laura Smith
Gemma Tunesi
Alexi Venerus
Becky White
National Trust for Scotland
Visit Scotland